Collagraph Printmaking

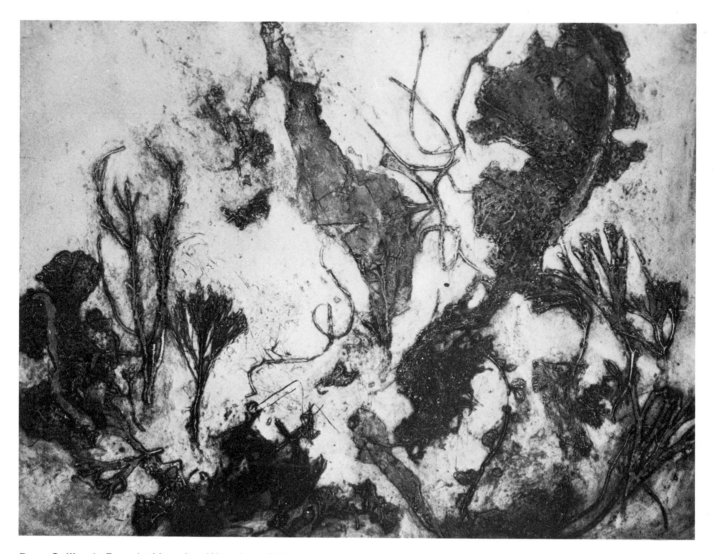

Deep Calling to Deep by Mary Ann Wenniger. 30″ x 36″. Dried seaweed glued with polymer medium to untempered Mason-ite. The plate was itaglio-inked with a mixture of burnt umber, phthalo blue, and phthalo green. The top was re-inked with raw sienna mixed with white. After the plate was intaglio-wiped, a 1″ soft rubber roller was used to add warm surface color. This print was printed in one run-through on the press.

Collagraph Printmaking

By Mary Ann Wenniger

Photographs by Mace Wenniger

WATSON-GUPTILL PUBLICATIONS / NEW YORK

PITMAN PUBLISHING / LONDON

First published 1975 in the United States and Canada by Watson-Guptill Publications,
a division of Billboard Publications, Inc.,
One Astor Plaza, New York, N.Y. 10036

Library of Congress Cataloging in Publication Data
Wenniger, Mary Ann.
Collagraph printmaking.
 Bibliography: p.
 Includes index.
 1. Collagraph printing. I. Title.
NE2232.W46 1975 760 74-28324
ISBN 0-8230-0665-4

Published in Great Britain by Sir Isaac Pitman & Sons Ltd.,
39 Parker Street, Kingsway, London WC2B 5PB
ISBN 0-273-00904-4

First Printing, 1975

Designed by Jim Craig and Bob Fillie
Set in 11 point Vega by Publishers Graphics, Inc.
Printed and bound by Halliday Lithograph Corp.
Color printed by Sterling Lithograph

I dedicate my book to the gift of hands—
the working hands that have made this book
and the hands of reader-artists.

Acknowledgments

Among those who have assisted in the preparation of this book, special thanks are due to:

Anne and Will MacLeod for their work in preparing and photographing the demonstrations in Chapters 7 and 15 and the last demonstration in Chapter 9.

Jim McLean for photographing the demonstrations in Chapters 10 and 17.

Don Holden, Diane Casella Hines, and Ellen Zeifer for their editorial encouragement.

Donald Stoltenberg for introducing me to the collagraph medium, and for his initial help to me in writing this book.

Zone V Photographers Workshop, Watertown, Massachusetts, for their perfection in photodeveloping.

Garnsey Dillon for lending me the electric typewriter on which I wrote this book.

Nina Wenniger and Priscilla Singleton for their patient typing.

My interested children, my supportive husband, and all my printmaking friends who gave so generously of their time and ideas.

Contents

1.
Introducing the Collagraph

In this book I have tried to describe visually and in writing how you can make a collagraph plate and print it on etching paper. You can enjoy exploring this new graphic medium, as I did, while avoiding some of the pitfalls I have experienced.

First, I will briefly explain what the collagraph plate and collagraph print are. The *collagraph plate* is a collage of different materials that are firmly glued to a block such as wood or Masonite. This block, or plate, is then inked, wiped, and printed on damp paper to create a variety of tones, lines, shapes, and embossments. To print with this plate, you use an etching press which is made of a flat bed and two rollers, something like the old-fashioned washing machine wringer. The impression created on the paper by this process is called the *collagraph print*.

The history of the collagraph begins in the 1950's, when the permanent acrylic glues came on the market, and printmaker Glen Alps coined the world "collagraph" (also sometimes spelled "collograph"). At the same time, there were several artists in different places who were experimenting with making collages that would print like etchings. Dean Meeker in Wisconsin used the acrylic polymer mediums to build up his Masonite plates; he would then cut into the plate to print figures. Donald Stoltenberg in New England, frustrated with his attempts to get softly modulated effects with aquatints in an etching studio, experimented with adding textured materials to metal etching plates instead of biting into the plates with acids. The story goes that he gave his printmaker friend Charles Wadsworth an excited call when he found the perfect material to create rich areas of tones—silk organza. The minute pores of this fabric could be filled with thinned-down acrylic polymer medium and thus hold the right amount of etching ink to create light or dark tones when the plate was wiped after inking.

The field of making collagraphs is still wide open for experimentation. Lines and textures can be built up in as many ways as you can imagine. Also, the range of tones you can get in a collagraph print is amazing.

Colors can be blended on one plate, or several plates can be printed to create a single image of one or many colors, and both methods produce luminous colors. Broad, built-up areas can be inked again with a roller after the first inking is wiped. Many of the artists whose work is reproduced in this book use broad gelatin rollers to create wonderful color effects. Such color effects give the collagraph print the richness of oil paintings and the visual crispness that make graphics so popular today.

Please keep in mind that the methods of building and printing collagraph plates described in this book are not the only methods in existence—you will, as every artist does, develop ways of inking, wiping, and printing that may not be covered here but which work well for you. Remember: take my suggestions and use them your own way to create effects *you* want.

The following reproductions of collagraph prints will suggest some of the effects that are possible for you to achieve now that you are about to start making collagraphs.

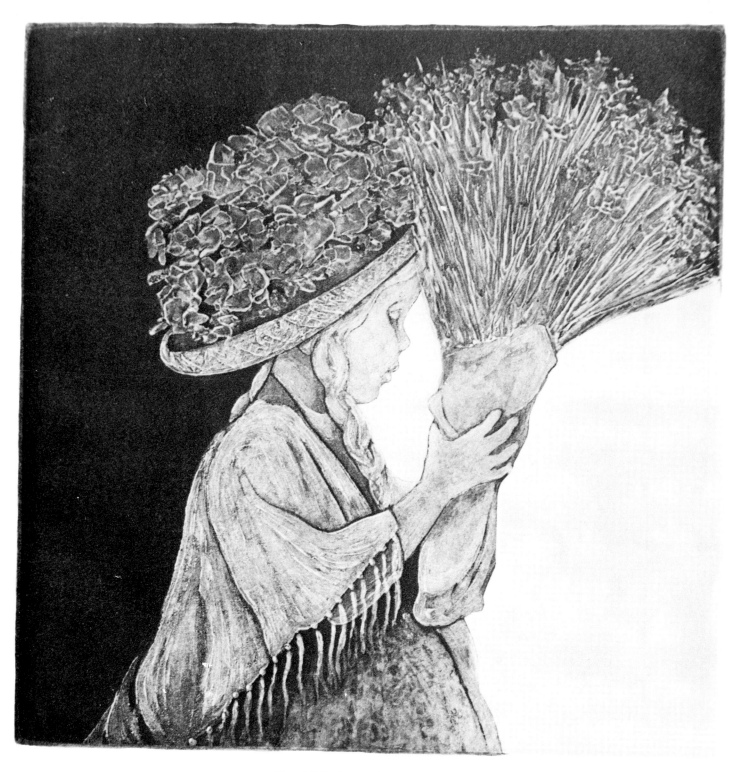

Floral Offering by Glenda Tall. Here is a print that demonstrates the flexible uses of modeling paste and gel. The light background is Mylar, which is very smooth and wipes clean; the dark background is organza.

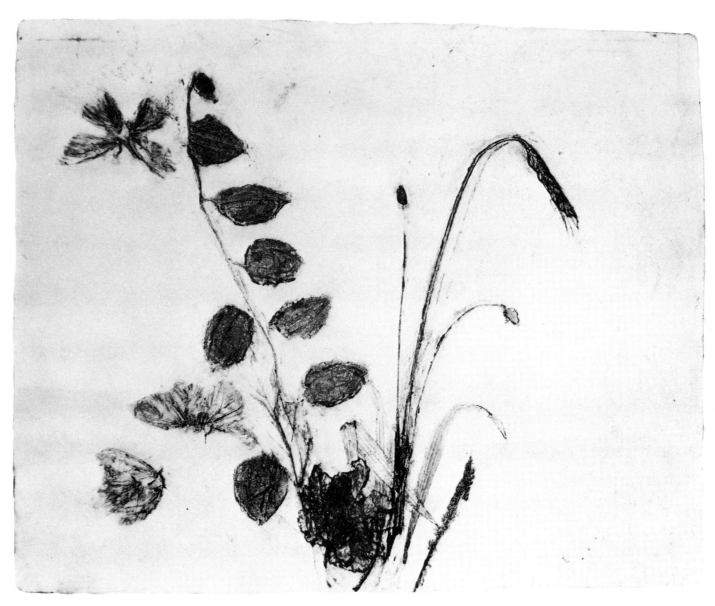

Autumn by Mary Ann Wenniger. The plate for this collagraph print is tempered Masonite to which slices of plant materials have been glued with gel polymer medium. Tempered Masonite was used for the plate because its smooth surface will be almost completely ink-free after inking and wiping. The over-all tone in the background is due to heavy (# 3) burnt plate oil which was added to the blue-green to make the ink harder to remove.

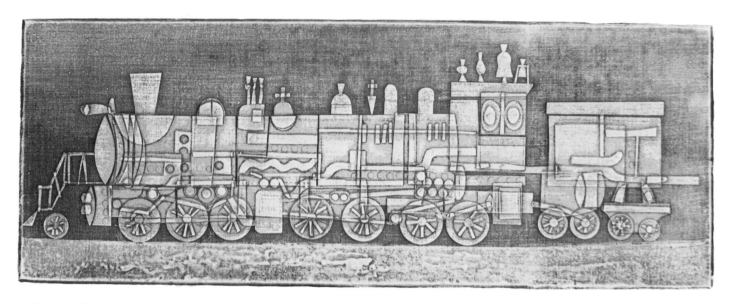

Locomotive by Lee Ferrara. The artist devised this whimsical invention by using different kinds of tapes that could hold varying amounts of ink. Some tapes, like Mystic, wipe completely clean and hold ink only on the edges of each piece. Other tapes, such as cloth tapes and masking tapes, do hold ink when the plate is inked and wiped.

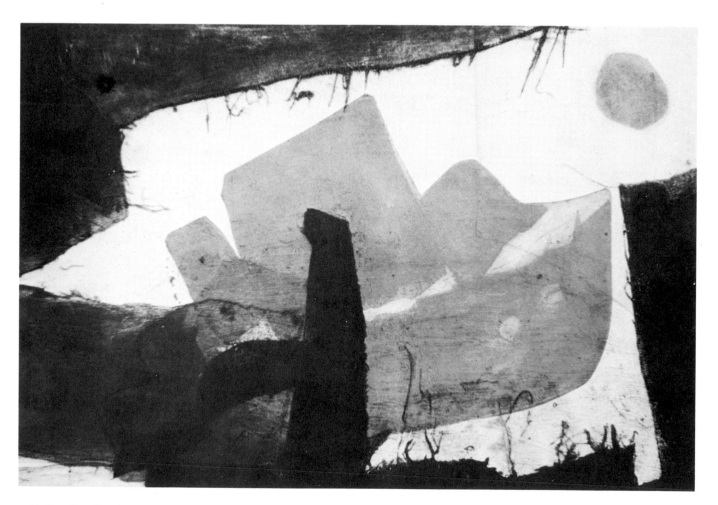

Mother Tug Resting by Mary Ann Wenniger. This collagraph was created by printing three plates. First I inked and wiped the background plate, a rectangle, with black etching ink. The second plate, cut to the shape of the tug and covered with organza, was inked and wiped with bright red etching ink. The third plate, the sun—an abstract shape with a circle of organza—was added to hold the raw sienna ink. The plates were printed in succession by drawing their outlines on plastic with Magic Marker. The plastic was turned over on the press, and I used the outlines as registration guides. (See Chapters 10, 12, 13, and 14 for details on registration.)

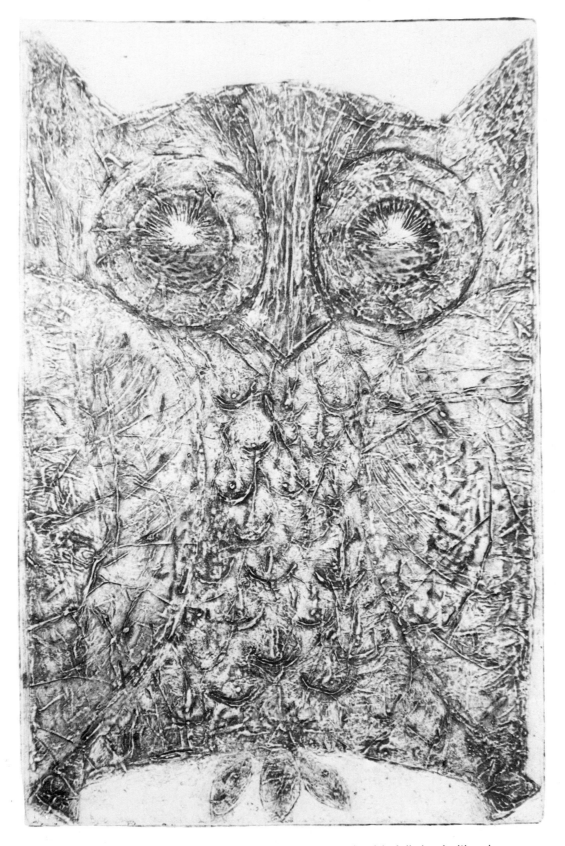

Owl by Lee Ferrara. The plate for this winsome print was made of tin foil glued with polymer medium onto untempered Masonite. Ferrara shaped and pushed the foil into surface patterns with her fingers and a small knife.

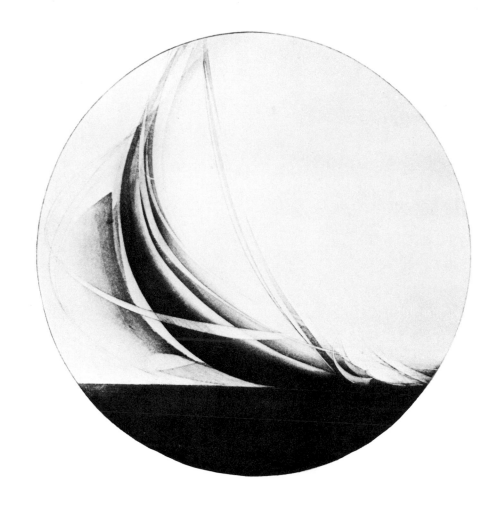

Sail Tondo by Donald Stoltenberg. This collagraph print demonstrates the subtle variations of tone that can be achieved by using an organza background glued onto the untempered Masonite block, or plate. The artist has used tape to block off areas of organza as he filled the lighter, open areas with several coats of polymer medium—the more the holes in the organza are filled, the less ink the organza will hold, and the lighter that area will be when wiped.

View by Mary Ann Wenniger. For this print, I glued very thick scraps of fabrics onto a Masonite plate, making sure that the edges of the pieces were lined up. The fabrics were so absorbent that I had to add many coats of the polymer medium, letting each coat dry before adding another. I did this to prevent the material from absorbing excess ink that would ooze out during the printing process.

Reflections by Aire Maya Schann. This active but highly organized print was made from a Masonite plate that was built up by adding more polymer medium to certain areas so that they would hold less ink, resulting in a medium-tone print. The artist has also glued shiny tapes to the center of the plate, creating whole areas which hold no ink at all and thus provide highlights.

Kafka's Kastle by Anne MacRae MacLeod. The fluid motion of this print comes from allowing the polymer medium to flow into watery shapes. After the first layer dried, the process was repeated. Marble dust added to the polymer created the darker areas.

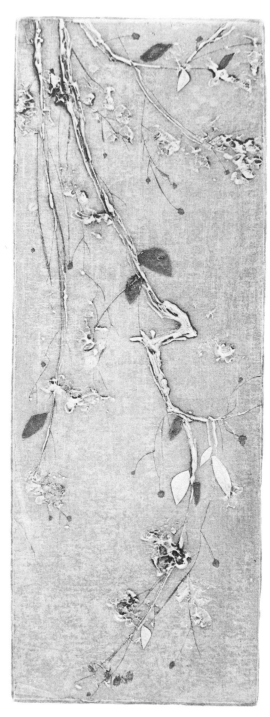

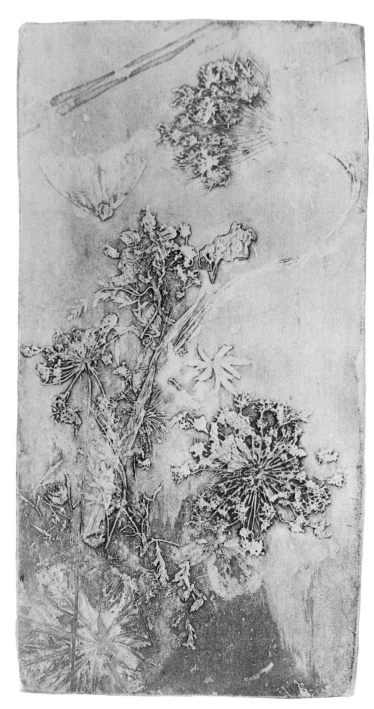

Spring by Betty Savenor. The image on this plate was made with organza filled with enough polymer medium so that the material holds a medium tone in the background when the plate is inked and wiped. Savenor applied gel medium with a brush to build up the raised, light-colored branches, and she glued on paper for leaves. The areas of darker leaves and berries on the plate were blocked out as the background received coats of the polymer medium. The material used to block them out was removed before the plate was printed. As the organza in those areas had no polymer medium to fill up the holes, the leaves and berries held a lot of ink and printed with a dark tone.

End of Summer by Mary Ann Wenniger. The plate for this print was created by gluing real plant materials onto the organza-covered Masonite. One of the weeds used, Queen Anne's lace, was too thick to use for a collagraph, so much of each bloom was cut away, leaving molds which were sanded before printing.

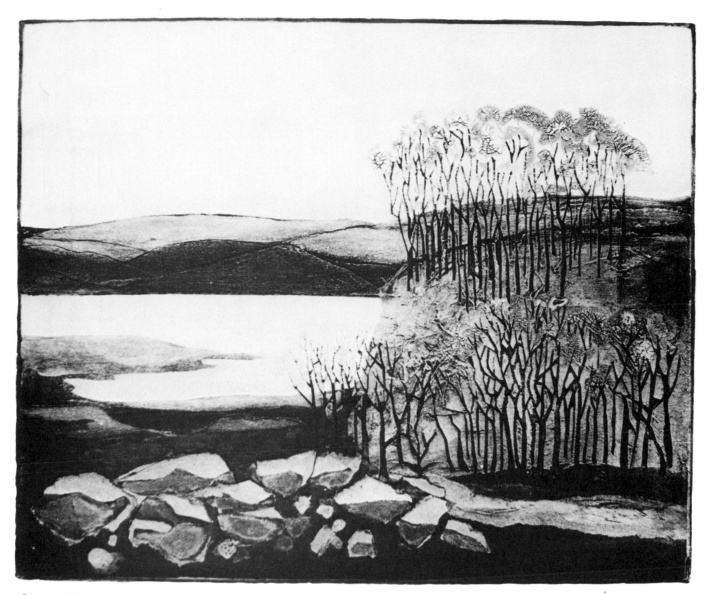

Approaching Dusk by Jan Ehrenworth. This print demonstrates the use of lines incised into the plate. To create the tree trunks, the artist cut through the organza, which had been glued onto the Masonite plate, directly into the plate. The treetops were created by making small liquid pools of the polymer medium, then drying and cracking them by placing the whole plate in a freezer.

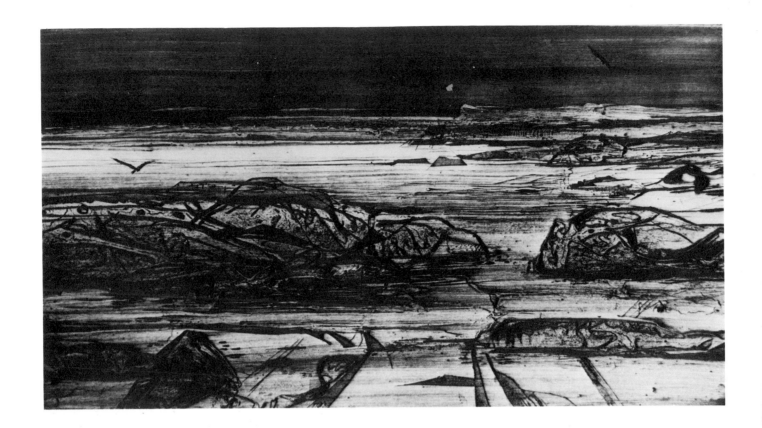

Space by Anne MacRae Mac-Leod. This print combines textures to create an illusion of space and dark stillness. The plate is Masonite, and modeling paste adheres to its surface. As the paste is smooth and holds almost no ink, it defines the light areas. Organza and incised lines cut into the plate's surface create the dark forms.

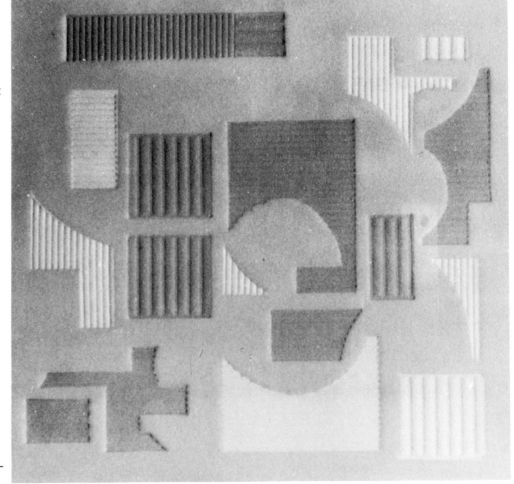

Leitmotif by Jan Ehrenworth. This print represents a completely different trend in the development of the collagraph. Ehrenworth cut several plates of various sizes and shapes out of gesso-covered, polymer-sealed sheets of mat board and rolled colors onto the surfaces. The plates were printed successively so that some emboss the printing paper and some deboss.

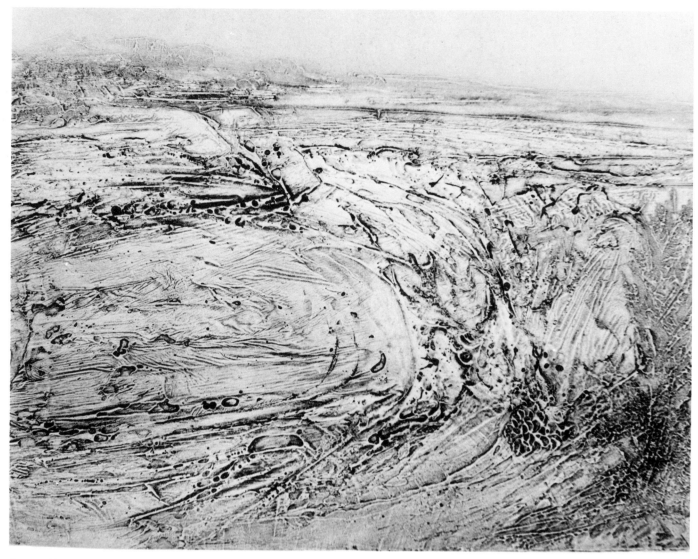

Quarry Wall by Vivian Berman. In this print you can see the use of modeling paste, which is put on the plate with a palette knife and a sponge to create an illusion of depth. Before she printed this plate, Berman sanded the surface to smooth any jagged edges that might have torn the printing paper. Enough edges and crevices remained on the plate to define the dark lines and areas in the final printed image.

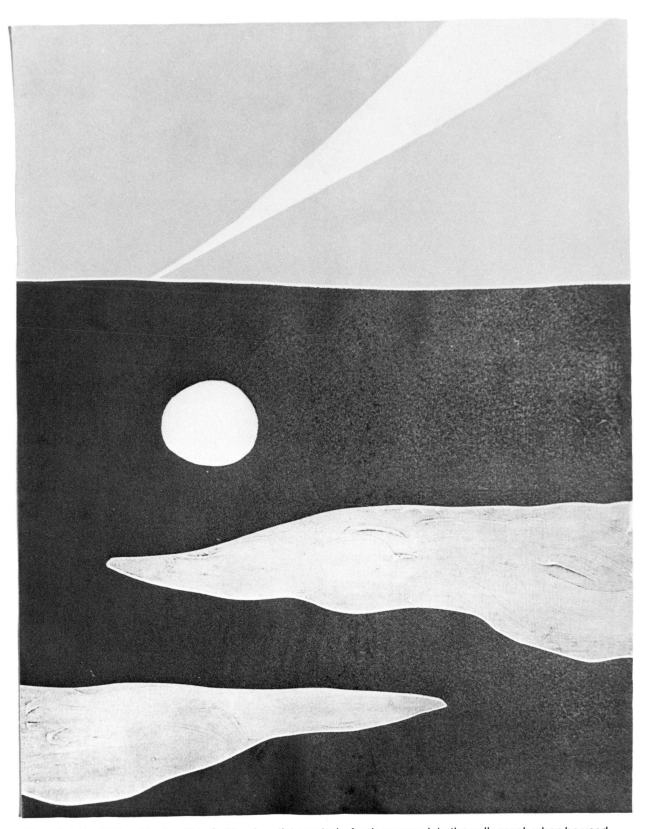

Moonlight by William Keefer. This California artist created a fresh approach to the collagraph when he used untempered, rough Masonite coated with varying amounts of polymer medium and cut into shapes that are inked separately and then reassembled into a rectangle on the bed of the press before printing. The four separate pieces of *Moonlight* were printed all at the same time. Note that Keefer uses thick inks created especially for collagraphs by Ralph Leber Company in Seattle, Washington.

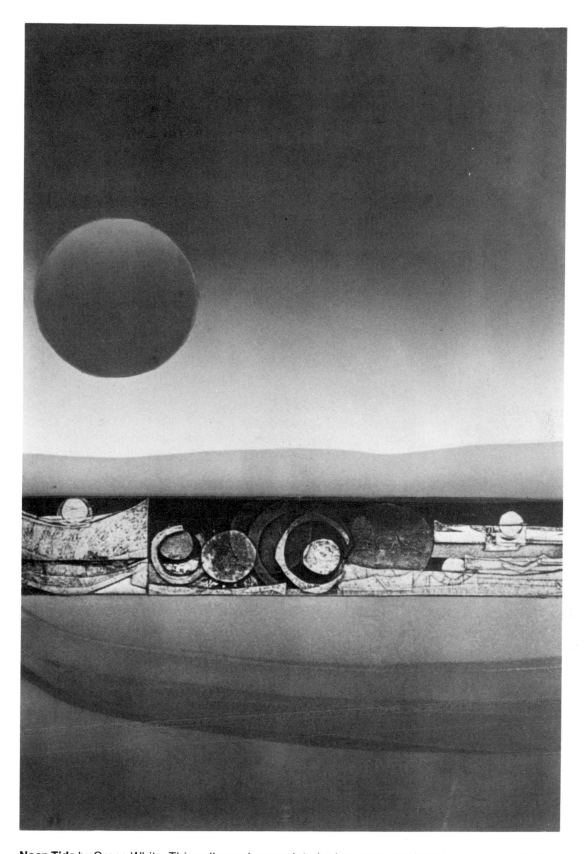

Neap Tide by Grace White. This collagraph was printed using segmented mat board plates. First, the intaglio in the center part of the plate was inked, wiped, and printed. Then the two plates with surface rolls were printed, each overlapping the sections of the image already on the paper. White printed this collagraph in the following way: After the surface color was printed in the conventional way—paper laid on the plates and printed—White laid the printing paper on the bed of the press and dropped the plates face down onto the paper surface, each time overlapping the several small images, until she created the whole image.

2.
Materials and Equipment

The great variety of materials which you can use to create your collagraph plates are easily accessible, inexpensive, and safe for people of any age to use.

But before you start to make your collagraph plate, remember these two important rules: *(1) make sure materials adhere firmly to the plate, and (2) make sure the materials you use are almost hair-thin.* The second rule is arbitrary, but it is the best way to begin. When I made my first collagraphs, I used whole flowers, with string for the stems. I got one oozing, ink-filled print after another. Now I dry the flowers, and take them apart; I construct my plates petal by petal, and use threads for the flowers' stems. Or, I glue the stem to the plate—when the acrylic dries, I pull off the stem to create a mold of the stem on the plate surface.

My early landscapes were made from hunks of anything around the house. An ocean, for example, was made of an old pair of blue jeans, since it was the broadest bit of fabric that I, as a non-sewer, had around. I overlapped two pieces of the denim, and wondered why the ink spurted out from the seam when it was printed: the materials were too thick.

Now is the time for you to begin to round up your materials. Be selective—don't make the job too difficult for yourself. To help you, I have photographed some suggested types of collage materials, the necessary acrylic glues, paper, ink products, and a small etching press.

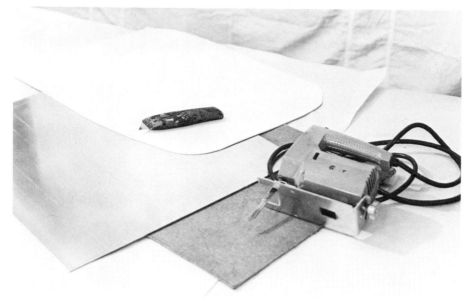

Here you see materials to use as plates—Masonite on the bottom, zinc in the middle, and mat board on top. Untempered Masonite, ⅛" thick, can be cut using either a saber saw or by scoring with a mat knife and breaking the Masonite. The zinc etching plate can be purchased at an art supply store in precut sizes, or you can cut the metal with a jigsaw. Mat board can be easily cut into interesting shapes with a mat knife and can be used for a collagraph plate if it's sealed with thin coats of acrylic modeling paste and a final coat of lacquer, shellac, or acrylic polymer medium.

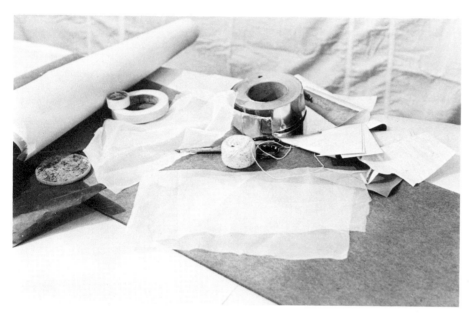

Here are some basic articles which you should round up: tracing paper, silk or rayon organza, scissors, masking tape, shiny tape, emery cloth, rough sandpaper, strings, and bits of paper.

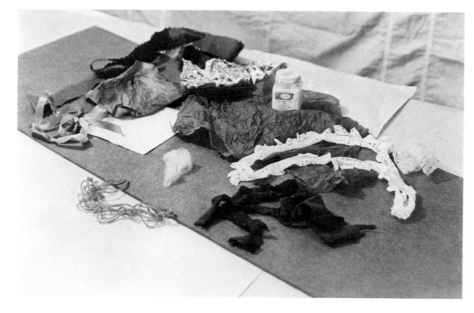

I have gathered some textured odds and ends here for collage building: tissue paper, construction paper, tin foil, fabrics, thin leather and suede scraps, laces, a crocheted bit of lace (too thick to use unless placed beside something else thick), cotton, and some model airplane lacquer.

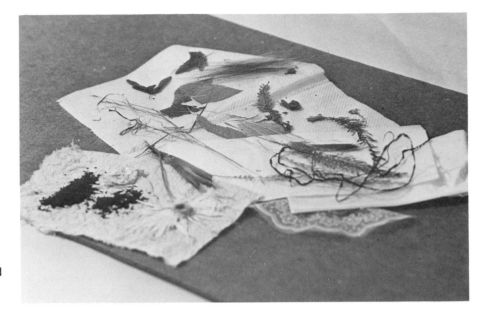

Here are some of my favorite natural things to use: coffee, tea, and crushed eggshells; semi-dried and dried flowers, weeds, and leaves; dried seaweed and thin scrapings of bark; cats' fur and thin feathers; thin papers, rice paper, and kleenex.

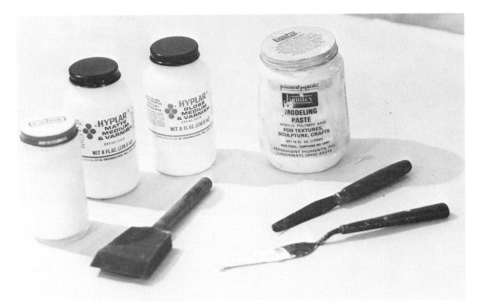

Here are the acrylic products you will be using (from left to right): thinned-down polymer medium, which you will use on your Masonite in two or three coats before you add the organza or other textured materials, matte polymer medium, and gloss polymer medium. Be careful to close these containers immediately after use because the acrylic liquids harden fast. Also shown here are a can of modeling paste, two palette knives, and a sponge-brush for applying the polymer medium to the plate. Always remember to wash out your tools fast after using them because, again, the acrylics will become hard quickly. Not pictured is gel polymer medium, another acrylic product which is very useful.

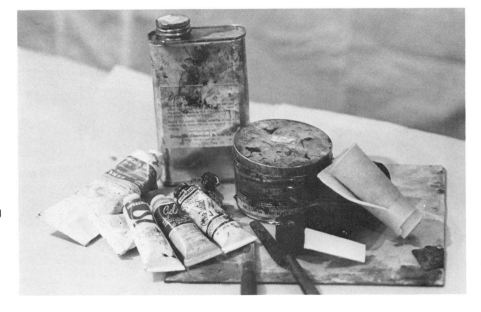

When you are ready to ink your plate, these are the items you will want to have on hand. On the left is a large tube of etching ink. In front of it are some oil paints and palette knives for mixing up paints and inks. The large can is burnt plate oil which is used for mixing the inks and oil paints. The burnt plate oil, distributed by Graphic Chemical, comes in two consistencies— # 00 and # 3. I recommend using the thinner one, # 00. The large tin is black etching ink, an economical container to buy etching ink in: you will usually use this ink for proofing. Ink daubers made of tightly rolled felt strips bound with tape lie on the right, with a square of mat board.

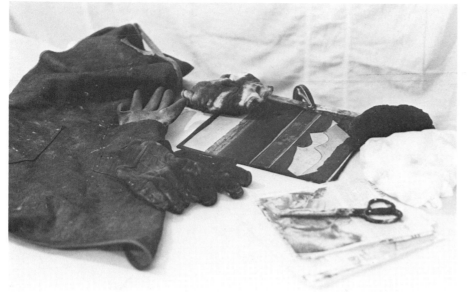

A half-inked plate, an apron, two pairs of gloves, both cotton and rubber, lie to the left of the ball of cheesecloth and cut squares of newspaper with a pair of scissors. The paper is used to wipe the ink from the surface of the collagraph plate while leaving a residue of ink in the crevices. The plate here is pushed up against a piece of lattice—you can also use a wooden ruler—which is fastened to the table with a C-clamp. Be sure to buy a C-clamp because this arrangement will free both of your hands for paper wiping. You will stand behind the wooden lattice, and when you wipe toward yourself, the plate will not fall off the table. This process will be explained in greater detail in Chapter 5.

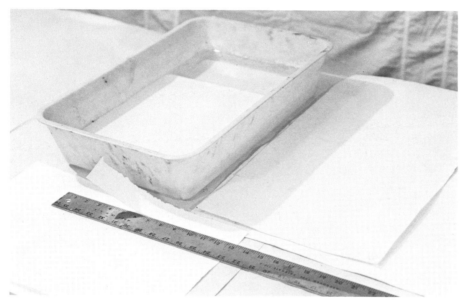

Here is a plastic tray which will hold water for soaking paper—a kitty-litter box or photographic tray would suffice. Buy an assortment of papers to start with, such as half-a-dozen sheets of domestic proof paper, Arches, BFK Rives and German etching. You will *tear* the etching paper to size, not cut it, using a steel ruler. German etching paper need only be soaked for one minute, Arches and BFK Rives for one to three or more hours. The paper that is sold as proofing paper in many art stores is a domestic rice paper which does not need to be soaked. Charcoal paper and thick, colored rice papers can be soaked for varying amounts of times and used in printing.

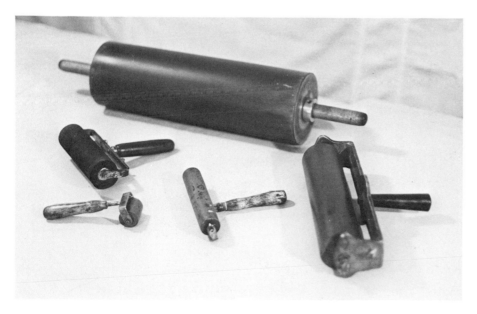

You should start to look for gelatin, composition, and rubber rollers and brayers, like the assortment shown in this picture. These can be very expensive, and I wouldn't buy any except very small ones for a while. My largest is 16" long and 5" in diameter; my smallest is a simple but extremely useful 1" rubber brayer. The hardness and softness of the roller affects the printing of the plate very much: soft rollers sink further down into the plate; hard rollers will touch only the top surfaces of the plate. My favorite hard roller came off an old electric Maytag washing machine.

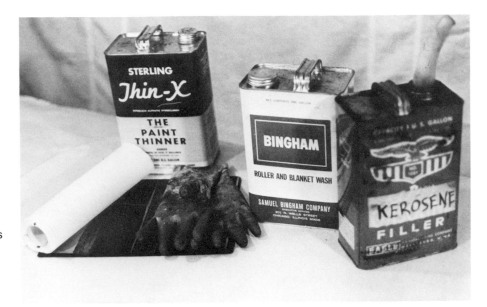

This photograph shows a sampling of the solvents, such as kerosene and paint thinner, and cleaning materials such as blanket wash and paper towels, that you will need. You should make it a general rule to clean all rollers and brayers with kerosene. In addition, be sure to have glass or paper palettes for mixing inks, and large sheets of glass for rolling your colors with the brayers or rollers.

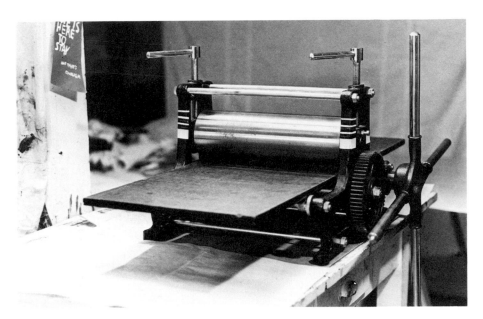

Here is my press with its steel rollers above and below the flat bed. When this Japanese press came, it had a 13″ x 24″ steel bed. It warped. I am delighted, now, with my new ½″ thick Mylar bed, which is 10″ longer. Notice the gears that operate the press and the shiny pivots which lower the top roller to tighten the pressure, or raise it to loosen the pressure. If you decide to buy a small press, get one that is so heavy that you can hardly lift it. Then your press will not slide around when you roll a plate through with lots of pressure.

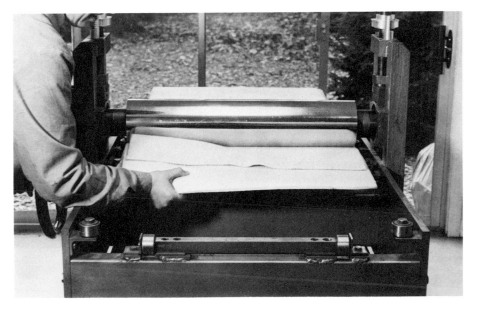

The press Jan Ehrenworth is using in this photograph is much larger than my press—it has a bed that is 24″ wide. Large presses, which are extremely expensive to buy, are necessary to print large plates with; and since you can get more pressure with a large press than you can with a small press, the results of printing plates with complicated color roll-ups are usually more satisfactory. (More information on presses can be found in *Supplies and Suppliers* at the end of this book.)

3.
Platemaking Materials and Their Effects

This chapter should get you started in making collagraph prints. I have assembled a gallery of small plates made from basic materials such as Masonite, organza, and the acrylic glues. The photographs are arranged in pairs, with the picture of each collagraph print placed next to the picture of the collagraph plate the print is made from, so that you can see how different materials print.

Anne MacRae MacLeod and I made these small demonstration plates and prints in order to illustrate certain basic effects that I want you to become familiar with. This will be your collagraph vocabulary. The plates are very plain in appearance so that you can focus attention on the texture of the material glued on the surface. These plates show the diversity of materials which can be used, and you can begin to understand which textures will produce the effects you want.

All plates pictured in this chapter were made on ⅛″ thick, untempered Masonite. The plates were inked with a basic black etching ink slightly thinned with #00 burnt plate oil. This sticky ink was wiped with wads of cheesecloth, until the ink remained only in the edges and in the pores of the textured surfaces.

After studying this sampling of materials and their effects in collagraph prints, make a sketch. Think about what will be light and what will be dark in your print. Then refer back to this gallery. The different materials create varying textures and tones—which would you choose? Perhaps you will prefer the use of sandpaper instead of organza for a dark shape, or shiny tape instead of Mylar for a light form.

Since the following photographs show you pairs of collagraph plates and collagraph prints, compare the materials used on the plate with the textures created in the print.

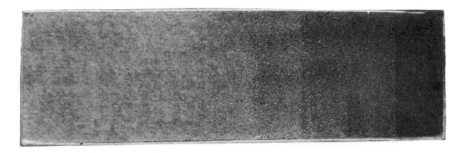

This plate of untempered Masonite is covered with organza and polymer medium. Originally, the organza was glued onto the Masonite with only a *thin* coat of polymer medium. The organza-covered plate then was blocked out by adding nine strips of masking tape to the surface. The strips were removed one at a time, and each time the *whole* uncovered section of plate was coated with the polymer medium. In the end, the first rectangular strip received a total of nine coats of polymer medium, the second strip was coated eight times, and so on until the last rectangular area to be coated only received one coat of polymer medium in addition to the original base coat that held the organza to the plate.

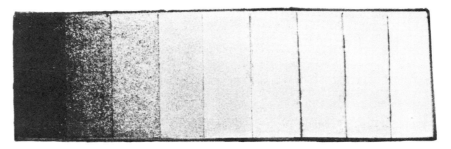

This is a print of the collagraph print just described. The effect of the different amounts of polymer medium on the rectangular strips is readily seen: the less polymer medium on the organza, the more the fabric holds the ink, and vice versa. The last strip to the left—the darkest strip—has been coated with only one coat of the polymer medium.

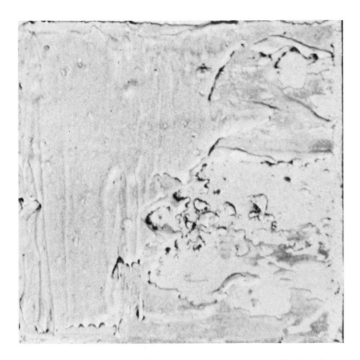

This plate was made with the polymer gesso applied to the plate with a palette knife: see how fluid the medium appears when it dries.

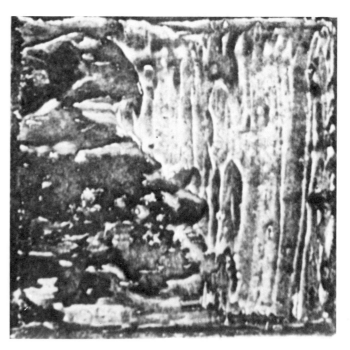

Here is the print of that plate. I found that every edge and surface variation continued to hold ink after wiping, while the top surfaces wiped clean and brilliant.

This sample plate was made with modeling paste so that you can see how similar the modeling paste is to the gesso. Both acrylics can be spread thickly with a palette knife. However, because there is marble dust in modeling paste, the image created with the modeling paste will print in a dark or medium tone. The surfaces will not wipe completely ink-free, as they do when polymer gesso is used.

Here you can see how the marble dust in modeling paste creates an ink-holding surface. Even though the plate was wiped, ink remained on the surface, and the print picked up this gray tone.

In this plate, marble dust has been sprinkled on polymer medium on an uncoated, untempered Masonite surface. The elongated shape is torn paper. The plate was coated with thinned polymer medium to make sure all materials were glued on thoroughly and to unify the total appearance.

When it is printed, the marble dust holds the etching ink and creates a dark tone. The coated, untempered Masonite also holds some ink on its rough surface, which prints as a gray tone; the torn paper holds very little ink and prints as a light tone.

On this plate the tin foil is glued with the polymer medium to the plate and then coated with thinned polymer medium. The foil creates a light background that you might enjoy using.

There are always slight surface variations when you use tin foil—the foil shifts position and folds slightly as it is wiped and printed. That is why this print does not look like an exact reversal of the plate. Remember that generally no two *prints* will be exactly alike either.

A fine sandpaper bonded to the Masonite with gel, a thicker, tackier glue than polymer medium, makes up this plate. The sandpaper's surface has been coated at least twice with thinned polymer medium so that the cheesecloth used in wiping the ink off the plate will not rip.

The fine sandpaper prints in a medium tone. I have found this sandpaper useful for details.

In this photograph you see a plate made of a rough grade of sandpaper, which is stiffer than fine sandpaper and is harder to glue to the plate surface. Rough sandpaper also tends to hurt your hands or tear your gloves and your cheesecloth during the wiping process unless the plate is thoroughly coated with polymer medium at least five times.

The print of rough sandpaper here shows much surface interest—the high spots print lightly, and the crevices hold ink.

The plate in this photograph is covered with a thick coat of polymer medium which was allowed to dry. The plate surface was then cut into with a sharp knife. The untempered Masonite is then bared in the cut-out areas where the polymer had hardened and was pulled off.

In the print, the polymer-coated area of the plate holds little ink. The edges of the cut-out Masonite shapes print in a dark and uneven tone.

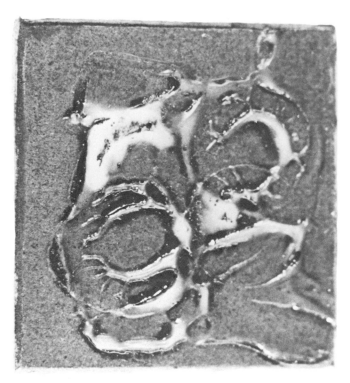

Polymer medium is put on untempered Masonite in a free style in this plate.

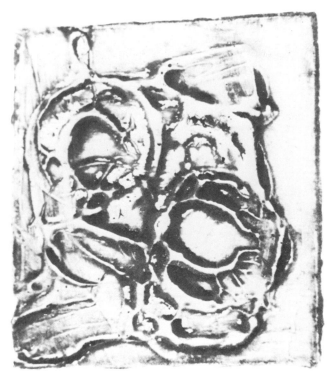

Because the plate was not covered with any material, the Masonite wipes fairly clean and gives a medium tone in the print. The top surfaces of the polymer wipe clean, and the ink settles in the crevices of the polymer. In some places where the polymer is built up in higher relief, the ink in the places where the polymer medium meets the Masonite is harder to wipe away.

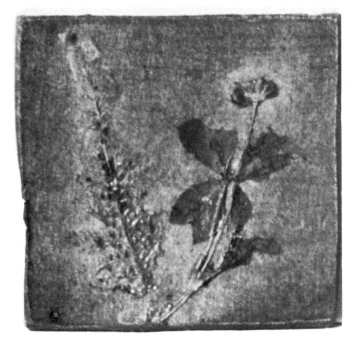

This untempered Masonite plate is covered with organza and coated twice with thinned polymer. A clover and fern shoot were glued on top with diluted polymer medium, and the excess medium was daubed off with a wet sponge. You can see how well *thin* plant materials work in collagraphs.

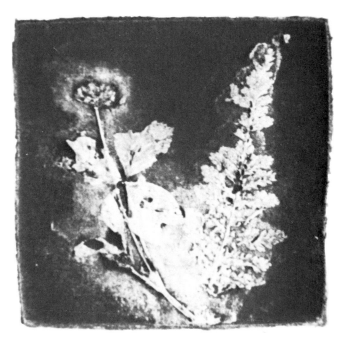

The print of this collagraph plate shows the veined, shiny surfaces of the plants. They show up well on the dark background of the organza-covered plate.

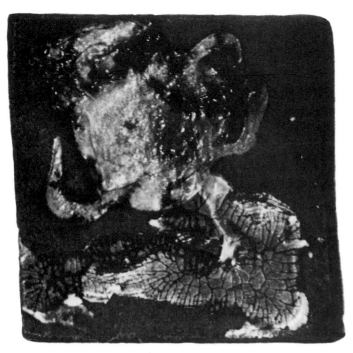

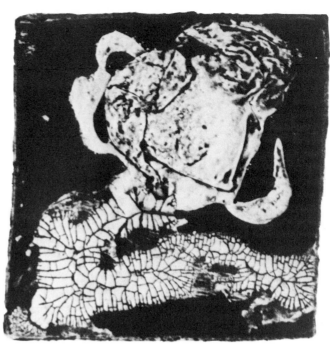

The twisted form on the top half of this experimental plate was produced by slowly broiling Elmer's glue on the plate in the oven. After the plate cooled, thin polymer medium was poured across the bottom and the whole plate was refrigerated overnight, producing an interesting, cracked effect.

In the print of this plate, the dark organza background highlights the lighter, distorted mass of the Elmer's glue and the surface of the cracked area of polymer medium.

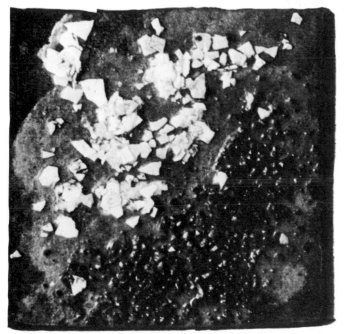

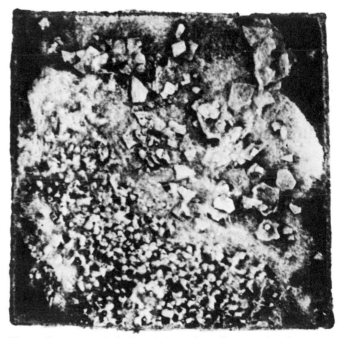

The plate here is made of food material. The larger pieces you see are egg shells, and the finer bits are uncooked coffee grounds, all of which were covered with several coats of polymer medium.

The coffee grounds in the plate make a fine-grained pattern; the egg shells make a geometric design of swirling shapes. Both materials are more effective after being smoothed thoroughly with sandpaper and recoated with polymer.

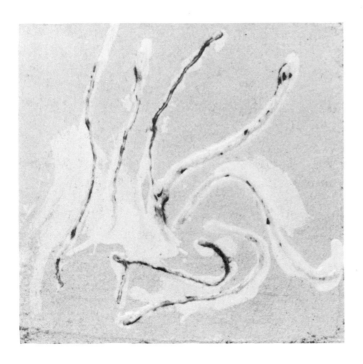

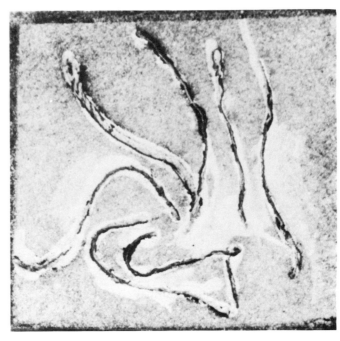

In this plate, string dipped in polymer dries on the polymer-coated plate.

In this print you see how the string absorbs the ink and prints as a dark line. You can also see how the middle string near the top of the plate held too much ink and smeared. When you use string or wool on your plates, be sure to wipe the ink off the edges of the string. I recommend using a Q-tip to remove such excess ink.

Here you see a plate with small, thin sticks glued onto polymer-covered Masonite.

Since this plate was thoroughly coated with the polymer, the background of the print is completely white, without ink. The sticks are not very thin, and therefore they hold a lot of ink on their edges. Remember, natural materials should be almost hair-thin to print easily.

Many different kinds of tape such as plumbing tape, Mystic tape, and paper-covered Scotch tape, were cut and arranged on this gesso-covered plate. If you decide to use tape on your plate, avoid electrical tape, which is sticky on both sides, and tapes that have little adhesive in their backing.

In the print of this plate, notice that the gesso-coated background holds the ink more than the tapes do. Of course, how much ink will be removed or left on the plate surface also depends on how hard you wipe the plate.

Shiny-surfaced Mylar was cut into shapes and glued onto a background covered with organza in this plate. The Mylar was cut into with a sharp knife; the lines created will hold ink and thus provide details in the image.

In this print the Mylar forms hold almost no ink except in the incised lines. Notice where the polymer medium was applied unevenly when the organza was glued to the plate. Pools of the polymer dried along the sides, creating smooth areas which printed in a light tone.

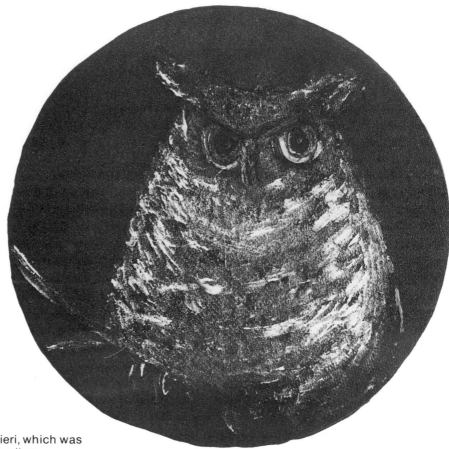

Here you see a plate, *Spooky*, by Eda Cascieri, which was built up with modeling paste and polymer medium.

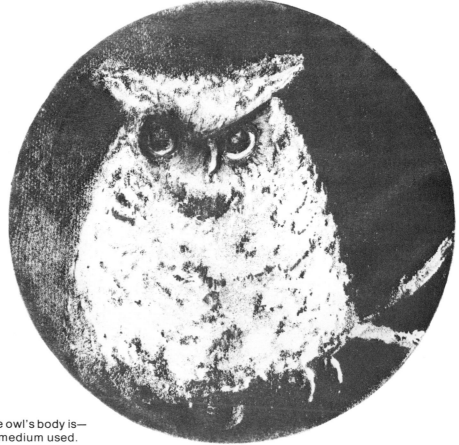

In the print of *Spooky*, notice how light the owl's body is— this is due to the large amount of polymer medium used.

4.
Building Your
Collagraph Plate

You will learn how to build a collagraph plate from the beginning in this chapter. I feel that it is extremely helpful for you to known the basic steps of cutting out and preparing your Masonite for plate-building.

I will demonstrate cutting out the Masonite with a mat knife, and beveling the edges of the plate. Some people simply go to a local hardware store or lumber yard to order pieces of ⅛" Masonite cut to the sizes they want. I prefer to buy a large length of the Masonite and to cut pieces as I need them. I often use a saber saw to cut with, rather than a mat knife.

When the Masonite is ready, I give a preliminary coat of thinned polymer medium to my plate before gluing on materials. The first material I add to *The Towers*, the plate described in this chapter, is organza, because I want a dark tone in the background behind the image of the church towers.

The pores of the organza fabric hold ink according to the amount of polymer medium brushed on. If the organza is coated with, for example, ten coats of polymer medium, the fabric will not be able to hold ink in the minute pores. But since I want the ink to settle in the pores of the organza in *The Towers* so the organza will print in a dark tone after the plate with its shiny tapes is carefully wiped, I brush on only two thin coats of acrylic polymer medium.

When you first start I recommend that you begin making your plate using the organza as a background, even if you want a white background in your print. To get a light background, just coat the organza with many layers of the polymer medium so that it will fill the small pores of the fabric and will therefore not hold much printing ink. When you learn to control the organza and polymer medium to get both light and dark effects in printing, you will have mastered a basic technique of the collagraph.

The following photographs will show you how to prepare your Masonite and organza, and how to build a simple but solid collagraph plate. Refer to Chapter 21 to see how I print this plate.

1. Here you see my husband cutting my plate by lightly scoring the Masonite with a mat knife using a ruler as a cutting edge. You might use a T-square to make sure your cutting line is perpendicular to the edge of the Masonite.

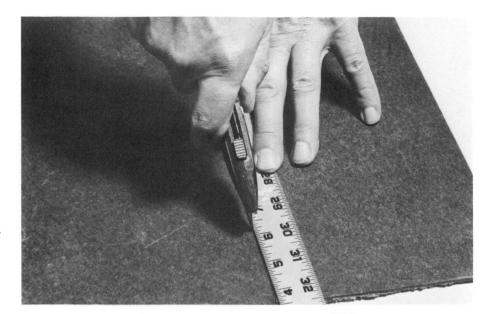

2. Here he is going over the scored line harder, with the mat knife. He does this several times, and then breaks the piece of Masonite in two on the side of a table. A word about cutting Masonite with a mat knife: you might find it easier to use a saber saw. One Christmas my husband, remembering my struggles with a mat knife, went out and bought me "something you really want, in red." I had visions of a nightgown or sweater—but the "something in red" turned out to be a saber saw! It might not have been just what I wanted at the time, but I'm certainly grateful for it every time I go to cut a piece of Masonite. Every printmaker should have one to make the cutting easier and cleaner.

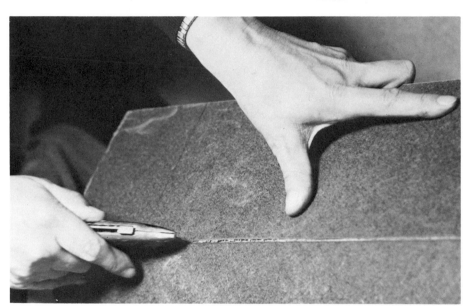

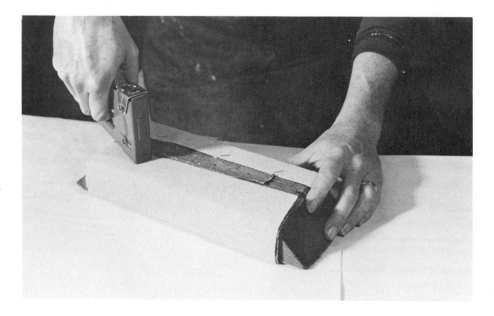

3. My husband is making a sandpaper block—a block of wood with a medium grade of sandpaper stapled on—to go over the rough edges of the Masonite.

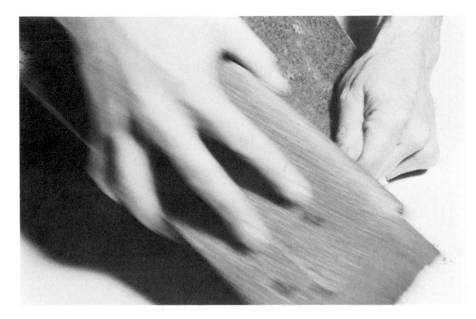

4. In this photograph you see me sanding the edges of the Masonite to get rid of any ragged edges which might later print sloppily and to bevel the sides to a 45° angle. This incline on the side of your plate helps your plate go under the press rollers smoothly—without a bevel the side of the plate sometimes jerks when it goes under the press roller. This jarring of your plate can result in distortions on your print.

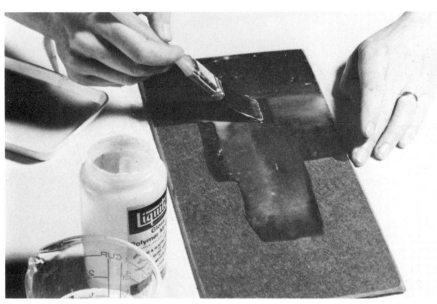

5. Here you see me coating my plate with thin acrylic polymer medium—half water, half polymer medium, as you see in the measuring cup. I do this twice. The polymer acts as a binding agent and anything added to the plate will stick firmly to the surface. When you do this, brush lightly back and forth, and up and down. Let the polymer dry for about 15 minutes between coats.

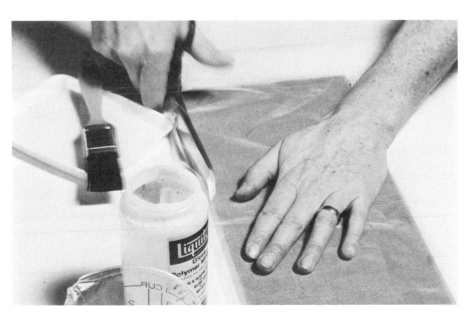

6. Cut your organza a little bigger than your plate, as I am doing in this photograph. I will trim the organza later, after it is glued to the Masonite.

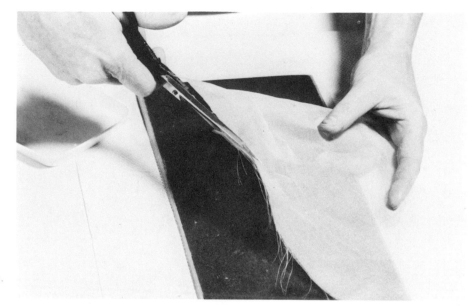

7. Notice the thready quality of the organza as I cut. These long threads can be cut off and used on the plate to create texture. (I didn't use them in this particular plate.)

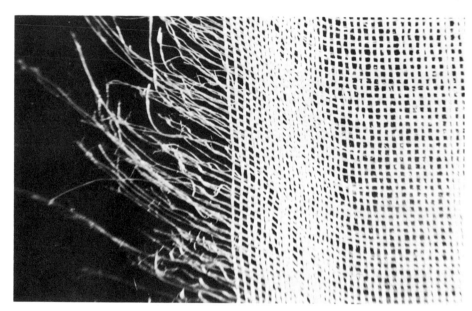

8. Here you see an enlargement of a piece of the organza and the organza threads. Please note that if you can't find silk organza, rayon organza will work. However, rayon organza has some "fill"—little threads—within the weave, and these must be taken into account as you fill in the material with polymer medium. Because of the "fill," rayon organza is not as predictable in its effects.

9. In this photograph, I glue the organza to the Masonite plate with polymer medium. I usually wet my organza first with water so that the fabric will stay in place as I brush on the polymer medium, which will be hard to brush on at first. When you do this, take it easy, and go back and forth several times. Watch for air bubbles—press them out with your brush or fingers. Move the organza back in place if it slips. After the organza is dry, I will use the sanding block again to cut away any excess organza and organza threads from the edge. This step is not pictured, and neither is the following step, which is simply brushing on a second coat of polymer medium.

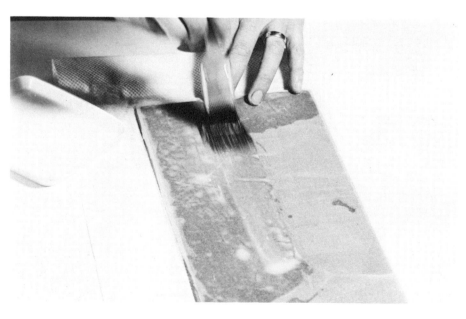

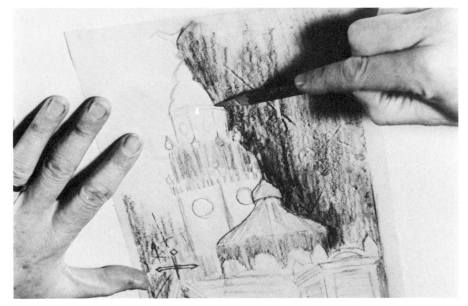

10. At this point I trace my design onto the plate. Remember that you need to reverse your tracing paper to trace your image or your design will print backwards. When you do this, try placing carbon paper under the tracing paper with the carbon side facing the organza. Draw over the lines of the reversed image to transfer the design onto the organza.

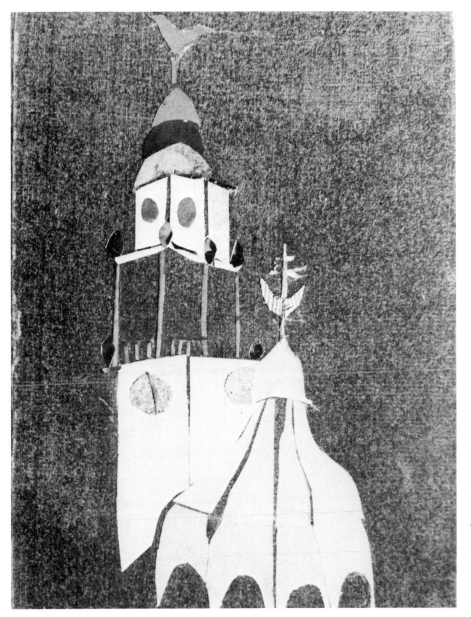

11. Here you see the partly built plate. I have used Mylar and a shiny Scotch tape to form the top of the tower on the dry surface of the organza. When you build your plate, if you use any tape, be careful to put the *uninked* plate through the press to be extra sure that the tape will stick firmly to the plate surface. Sometimes solvents used to clean your plate will dissolve the tape adhesive. If this happens, either replace the tape or glue it back on with polymer medium.

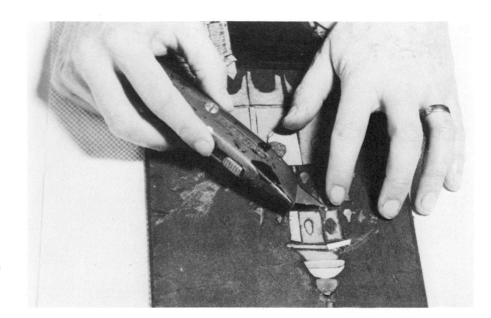

12. Here I apply Mylar shapes with a mat knife to simulate the knobs on the small tower railing. The tower is on a New England church that I can see from my house.

13. In this photograph you see a detail of the plate showing the smooth paper used for the white, wooden church tower. Notice how the smoothness contrasts with the rough texture of the organza background. Also notice the sandpaper clock—I used sandpaper because it would create a dark spot against the light tone of the tower when the plate was printed.

14. Here is another magnified detail of *The Towers*. I used smooth grey tape to create the wind signal on top of the library tower. The tape will wipe clean and show up against the ink-holding organza background.

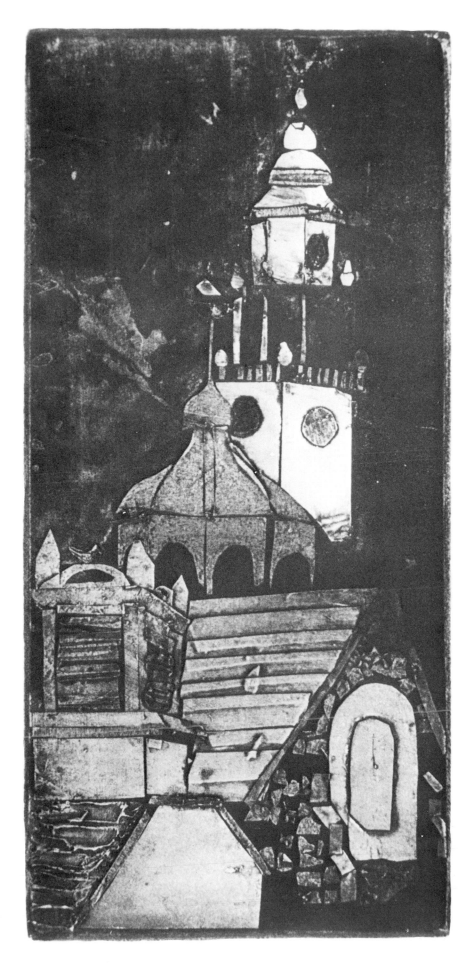

The Towers by Mary Ann Wenniger. Here you see the final print. I used a blue-black intaglio ink and rolled on a rainbow roll (more than one color on one roller—the colors blend into each other) of—in order of their application, from bottom to top of print—phthalo blue, burnt sienna, and raw sienna. All colors were transparent so that they didn't block out any lines or textures. See Chapter 9 for more details on a rainbow roll.

5.
Inking and Printing a
Plate in Black and White

Before I show you more about how to build up your collagraph plate, I want you to know what will be involved in inking and printing it. Then you'll be able to see that a collagraph print is actually the result of the play of surface textures and edges of the materials used to create the collage-like collagraph plate. When your plate is inked, wiped, and printed on paper with the help of an etching press, your print should show a variety of tones from dark to light.

The basic principle of inking is to cover the plate *thoroughly* with a layer of oil-based ink—black or a color—and then remove enough ink from the surface so that different parts of the design carry different amounts of ink. Textured parts will obviously hold more ink than smooth parts, so that smooth areas will print lighter and textured areas will print darker. Keep in mind that, after wiping, edges and crevices will hold ink and will print as lines and masses.

Your first collagraph print will be an *intaglio* print—the simplest type. An intaglio print is made from an impression produced on paper by the pressure of an etching press which forces the thin residue of the thick, viscous etching ink which is in the crevices of the plate's surface onto the paper.

To produce the embossed texture of an intaglio print, place damp etching paper on the face of the inked plate which lies on a sheet of newsprint on the flat bed of the etching press. Now, place three blankets on top of the paper. These blankets are protected from excess ink by a sheet of newsprint which lies on top of your printing paper. By turning the press's wheel, the bed is drawn between the two steel rollers of the press. The pressure created firmly impresses the ink on the various levels of the plate onto the printing paper.

Donald Stoltenberg of Brewster, Massachusetts—a pioneer in the development of the collagraph process—demonstrates how to apply one color of etching ink to your plate and wipe off the plate's surfaces in the following step-by-step demonstration.

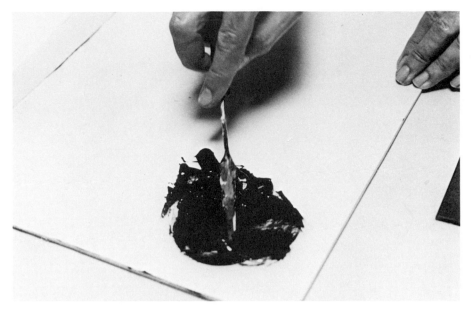

1. You start by "warming"—which really means softening—the etching ink. Mr. Stoltenberg does this by working a glob of ink back and forth against his glass slab with a palette knife. When you do this, add enough light plate oil (#00) so that the ink drips in a steady line from the raised knife to the slab. This makes it easier for the etching ink to sink into the textures of the plate.

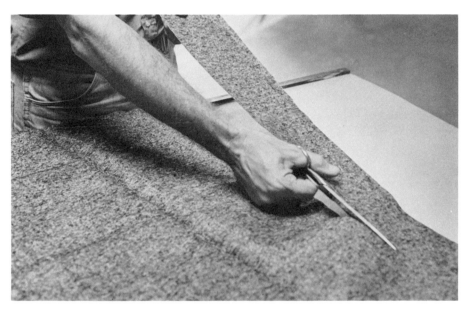

2. To apply the ink to his collagraph plate, Stoltenberg creates an inking dauber from a piece of tightly woven felt. Here he cuts off a strip of felt. A good-quality piece of felt works best, although some printmakers have used cardboard to scrape, rather than daub, ink onto the plate's surface.

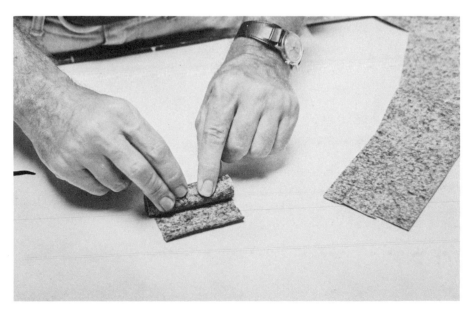

3. Stoltenberg rolls the strip of felt into a tight cylinder. The tighter the roll, the easier it will be to apply ink to the uneven surfaces of the collagraph plate.

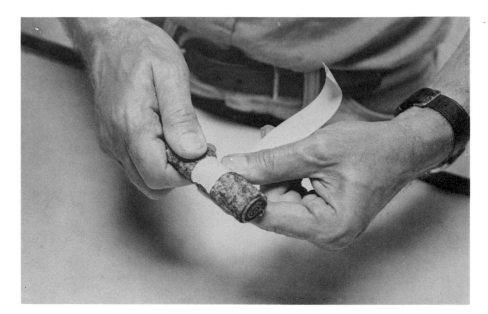

4. Stoltenberg secures the roll of felt with masking tape, which he places around its center. In this way the ends of the dauber are left free to apply the ink. After several applications, the ink will stiffen the ends of the dauber. When this happens, you can cut off the stiffened ends with a mat knife to expose fresh felt.

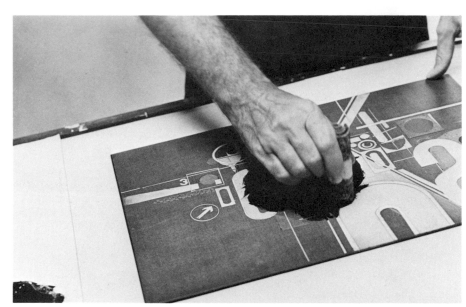

5. Here Stoltenberg applies ink to the collagraph plate's surface with the felt dauber. He covers the entire plate with ink, applying it with a circular motion, working the ink into the crevices and edges of the built-up textures.

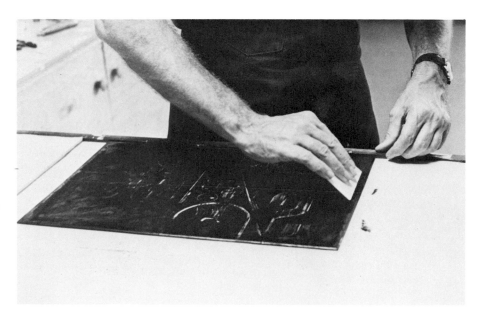

6. After inking with the felt dauber, Stoltenberg scrapes a piece of mat board—you could use heavy cardboard—over the whole plate. This removes some ink from the smoother portions and works more ink into the rougher parts. Ink also accumulates along the edges of the various shapes in the design.

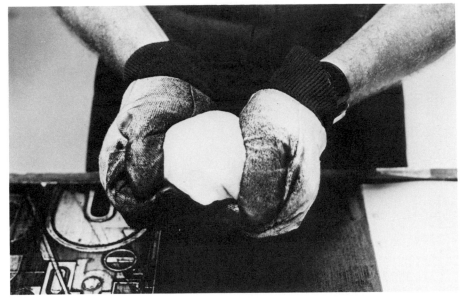

7. To wipe the plate, Stoltenberg rolls cheesecloth into a ball the size of a small grapefruit with a flat bottom. Notice that he is now wearing gloves to keep his hands clean. This absorbent cheesecloth will lift some more ink from the plate's flat areas. By redistributing the ink, eventually every surface variation on the plate will carry the right amount necessary to print the image. By careful wiping, you control the density of the ink on each area of the design.

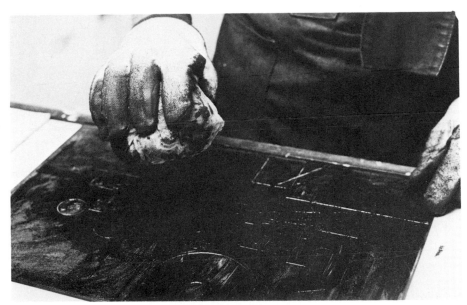

8. Wipe in from the corners of the plate toward the middle. The goal is to leave some ink—but not globs of ink—on the edges of each built-up surface of the plate. You also want your print to have some tone on the flat areas, so that the image is defined as a white image with dark edges against a dark background, or vice versa.

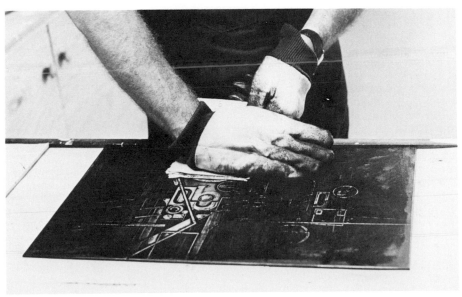

9. The "paper wipe" comes next. Stoltenberg clamps a piece of wood or a ruler to the table with a C-clamp to use as an edge, so that the plate will not fall off the table when wiped. He moves a pad of torn squares of newspaper across the surface of the plate. The pad contains many pieces of paper; the bottom piece is discarded as soon as it picks up ink. (Some artists just use one piece of paper at a time rather than a pad.) The paper takes up ink from the flat areas. These flat, lightly inked areas will produce the lightest tones (sometimes pure white) in the print. Stoltenberg uses both hands, one hand pressing flat on the paper and the other hand pulling the paper toward himself across the plate.

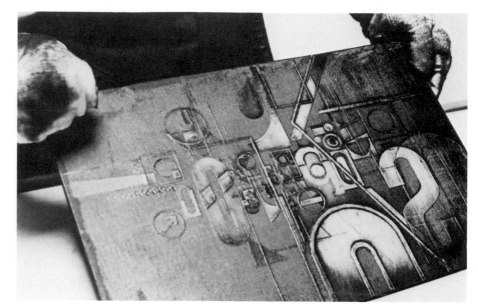

10. The plate you see here has been wiped alternately with cheesecloth and then paper at least *three times* in order to pick up some of the ink on both the edges of the shapes and the flat surfaces. These flat surfaces will then produce a softer tone in the print. Stoltenberg turns the plate as he wipes. Edges are also wiped with the cheesecloth so that no accumulated ink will spurt out and smear as he prints.

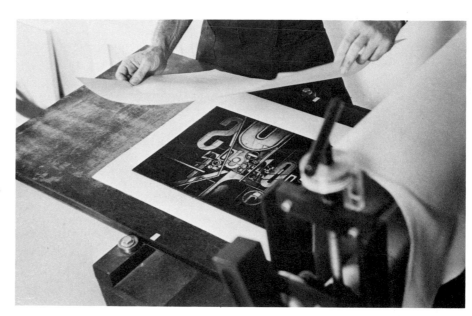

11. Stoltenberg holds dampened paper by the opposite edges, and slowly drops the paper over the inked plate. It's a good idea to keep old playing cards or index cards nearby. With them you can hold the paper without your inky fingers touching the print. One sign of a good printmaker is a perfectly clean, fingerprint-free print.

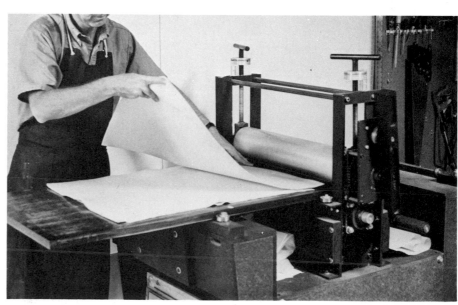

12. Here Stoltenberg places an etching blanket over the paper and plate. Three different types of etching blankets will eventually cover the plate and paper (see Chapter 6). Each blanket *must* cover the entire plate or the print will be uneven and the press may suffer.

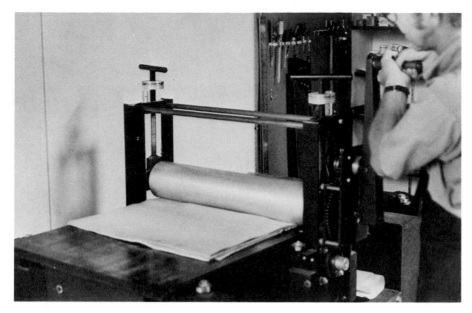

13. When rolling the print through the press, it's essential to maintain an even speed. If you stop for some reason, a mark may appear on your print. Stoltenberg generally runs collagraphs back and forth through the press twice.

14. Notice that this first proof emerges with somewhat blurry edges because the plate needs more ink. Stoltenberg will ink it again in a darker tone with thicker ink in order to pull a richer proof. After printing, he will clean the plate with turpentine or a similar solvent. And if he decided now that the plate needed any changes in the design, he would wash it with soap and lukewarm water to remove the oily ink residue. This cleaning process will make it possible for the polymer medium or gel to stick to the plate's surface.

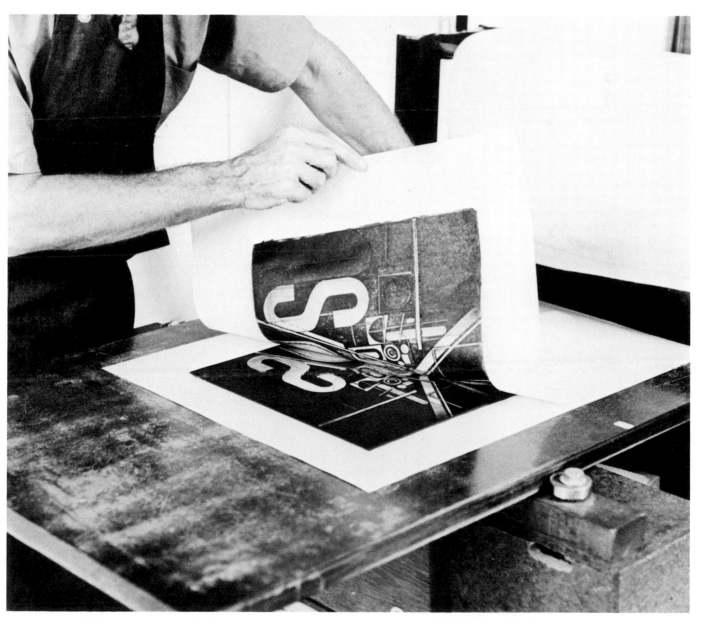

6.
Using an Etching Press

You can obtain the best results in printing a collagraph by using an etching press. In the past I have printed other ways: I have used a big roller to lift the image off the collagraph plate onto the roller, and then I rolled the roller over a smooth piece of paper. This method of printing is called *offset* printing. I have also used a type of woodcut press where you screw a block of wood down over the paper and plate, but that way of printing was arduous. The etching press creates a smooth, even pressure which is exerted on the plate gradually through the soft felt blankets as the plate is drawn through the rollers. In this process, the paper seems to soak up the ink most thoroughly and evenly, and the result is a rich picture.

A press consists of a bed of solid steel or another suitable material such as Mylar. This bed is drawn between two rollers which are connected to screw mechanisms on both sides of the top roller. These screw mechanisms adjust the pressure *equally* and determine how close the top roller will turn over the plate which lies on the bed. The gears on the press are arranged to facilitate the turning of the wheel. On my small Holbein press the gear nearest the wheel, which is a small gear, turns the roller beneath the press bed. This roller moves the bed along. At the same time this small gear pushes the larger gear which is the one that turns the top steel roller. The rotation of the rollers draws the bed with the felt blankets and plate between the two cylinders: all parts move in unison. When you use a large press, you may have to give the bed a push—manually or with electric power—to start the process.

An etching press is really analagous to an old-fashioned, Maytag wringer. One of my students made a good little press from a rubber wringer turned by hand that she picked up in a New Hampshire junk yard. And a friend of mine found a very old hand wringer with wooden rollers that she uses instead of her large contemporary press when she wants to get uneven tones in the background of her prints.

When you begin to print your collagraphs, you will probably be using a class press or another printmaker's press, so I will begin illustrating this chapter with some suggestions for transporting your equipment. Then we will take a look at my Japanese press.

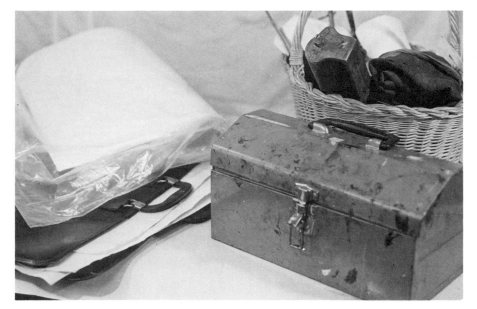

1. You see my equipment ready to go when I am using a friend's large press: large white blotters in my portfolio; damp paper—soaked the night before in the bathtub—wrapped in plastic; my 8'' gelatin roller and an apron in the basket; my box with oil paints and larger tubes of etching inks.

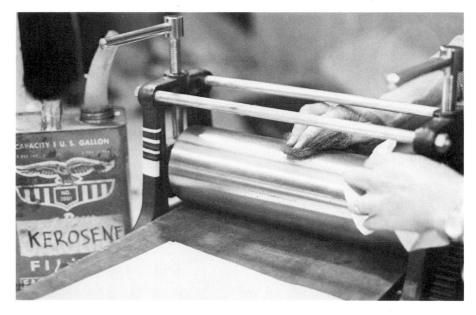

2. I am cleaning off some rust from the top roller of my Japanese press with fine steel wool and kerosene. The rust had accumulated because blankets which were damp from wet printing paper had been left on the roller.

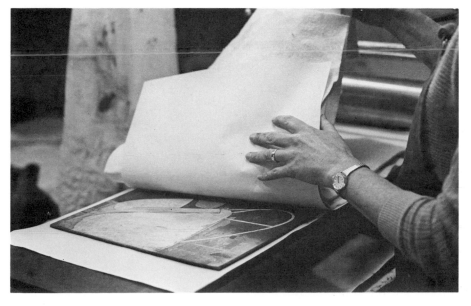

3. Here I am placing my blankets and a piece of newsprint on top of an uninked plate which I will run through the press in order to adjust the pressure. The blankets should be large enough to *completely* cover your plate. Put a piece of newsprint under and over any plate, whether it is inked or not. Do *not* use newspaper instead of newsprint; I did that once and the printed words came off on the blanket.

4. In this photograph, I am laying on the third blanket. Always put your blankets on one at a time: first, the lightly woven, felt blanket—called the *sizing blanket*—which will absorb the paper's sizing and which will "grab" the plate; then the thick *cushion blanket*, which does the main job of pressing into the ups and downs of the plate; and finally the *pusher blanket*, a tightly woven, woolen blanket, which actually builds up tension when it comes in contact with the top roller of the press and consequently helps draw the bed through the press as the roller turns.

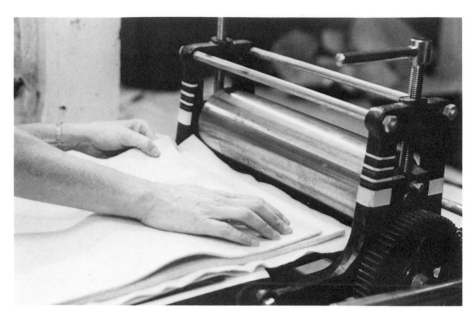

5. I am smoothing the blankets here. They will go through the press more easily if you flatten them, and also if you stagger them as you arrange them in front of the press roller. It's difficult to see, but in this demonstration, I placed the sizing blanket at least ¼" away from the thick cushion blanket.

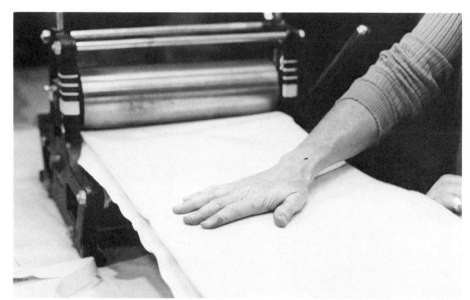

6. When you use a small press like mine, you start moving the uninked plate through the press by pulling the wheel hand over hand, toward yourself.

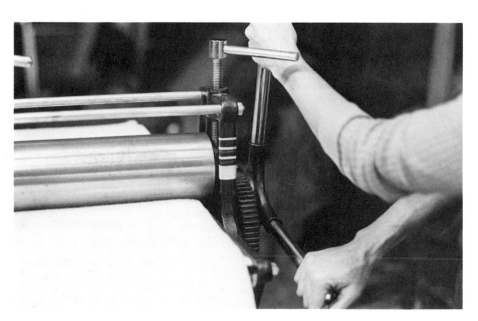

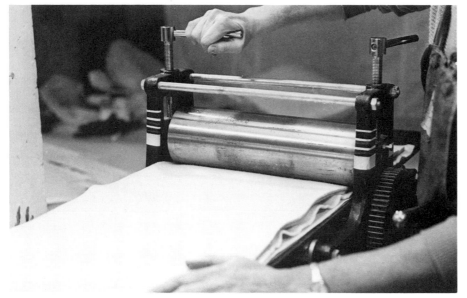

7. You must stop the uninked plate midway through the press as I have done here, and, by turning the lever that changes the height of the top roller, adjust the pressure until you can feel some tension gripping your plate. On a larger press less tension will be evident when you turn the wheel, and you will have to check the back of the top piece of newsprint to see if the embossment is evident when you finish rolling the plate through the press.

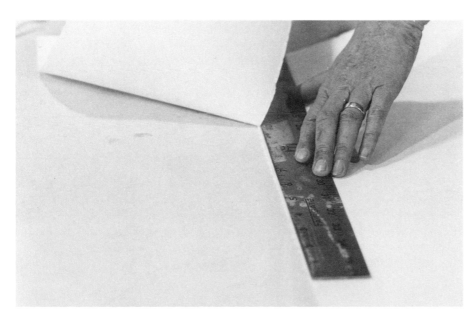

8. Here I am using a *clean* ruler as an edge to tear my etching paper. When you tear your paper, measure your uninked plate and tear your etching paper to a size of *at least ½″* bigger than your plate on every side.

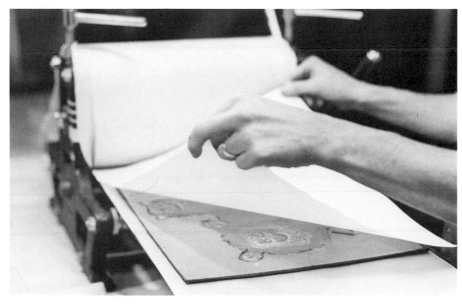

9. I am holding my damp paper by opposite corners and dropping it carefully onto the plate. The paper has been blotted carefully between two blotters until no water showed on the surface.

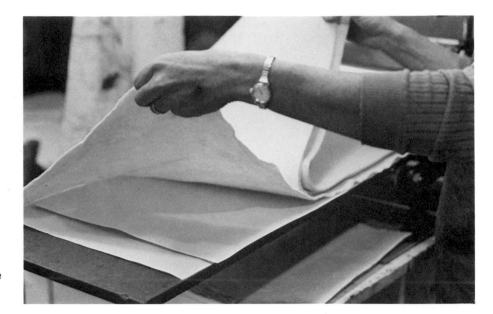

10. In this photograph I am placing the thin sizing blanket that absorbs paper sizing over my printing paper.

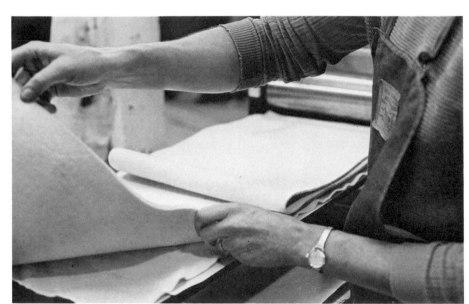

11. Here I am checking to see if my cushion blanket is in its place between the sizing and the pusher blankets.

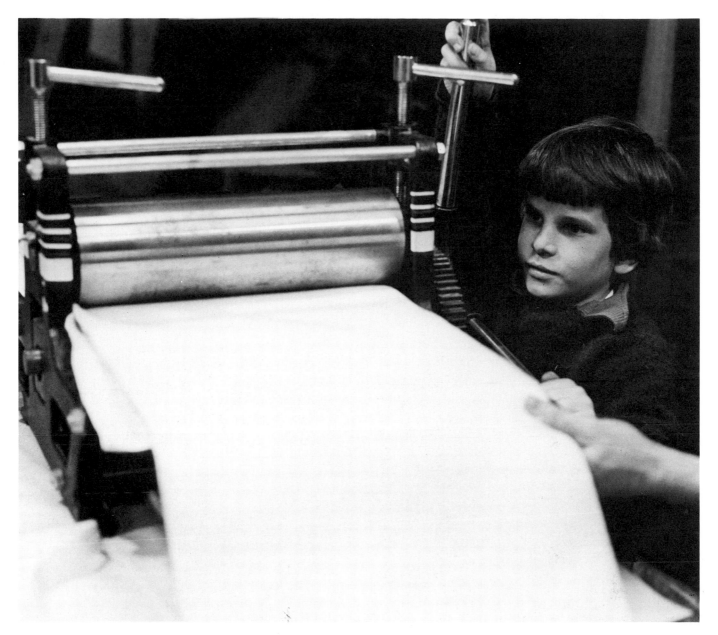

12. I continue to smooth the blankets as the print goes through the press. If any of the blankets are bumpy the result may be an uneven print.

7.
Blended Wipe Technique

One of the most exciting aspects of the collagraph medium of print-making is the technique that has come to be known as the *blended wipe*. This means that various colored inks are worked into different parts of the intaglio of your plate and then wiped. As you wipe, different colors which lie next to each other will blend together.

The technique is a subtle one: your colors are softly blended, and yet kept sufficiently distinct so that they do not turn muddy in tone. The textures on your plate can be enhanced by rich colors which, in turn, accentuate the crispness of form, which is defined by the intaglio when the paper is pushed into the ups and downs of your plate by the pressure created by the etching press.

In wiping your plate, you should clean the ink almost entirely off top surfaces, leaving a white tone which lends a luminosity to your final print. This luminosity works well with the rich colors left in your textured areas and on the edges of your collage shapes.

As you experiment with the blended wipe, give the technique time. Suspend any judgments. The blended wipe is an art that depends on subtleties such as the weight of your hand as you press your cheesecloth into the intaglio and move it across the plate, lifting and blending the ink. You will have to do this many times with each new plate until you know just what your image needs to make it read the way you want it to read. You should also experiment with how much two separate colors should be wiped into each other, and how much each color should be kept distinct. For example, you can predict that blue and yellow areas inked in two adjacent parts on your plate will produce a blended area of green just where the two colors come together. But the blue and the yellow areas can also retain their original colors with careful wiping. You'll need to learn how to keep colors distinct by drawing your hand *away* from other colors when blending.

Also, don't hesitate to try several different color combinations before you select one that will be the final way in which you will print your plate.

Once you have found a method for blending and wiping the inks for a plate, take careful notes. Even write down explanations of how

you turned the plate to pull one color ink away from another color, and make a color guide diagram to guide you when you make your edition. So often I have skipped this step, thinking I would remember because the appropriate inking method was so clear in my mind at the time I discovered it. Unfortunately, when I began the edition later on, I had forgotten.

Anne MacRae MacLeod, a master of the blended wipe, will demonstrate this process step-by-step in the following photographs. She will show you how to arrange your colors on your plate and carefully blend them, while removing ink so that the plate ends up ready for printing. When you try this technique, adapt MacLeod's ideas to suit your own purposes.

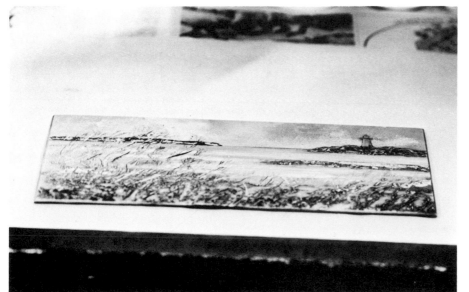

1. Here is the collagraph plate that MacLeod will demonstrate the blended wipe with. This plate, *Sentinel of the Sea*, could have been inked in just one color, but MacLeod decided to increase the illusion of distance by making the foreground a dark and cool burnt sienna, the middleground a warm orange, and the background a cool green-blue. These colors combine well.

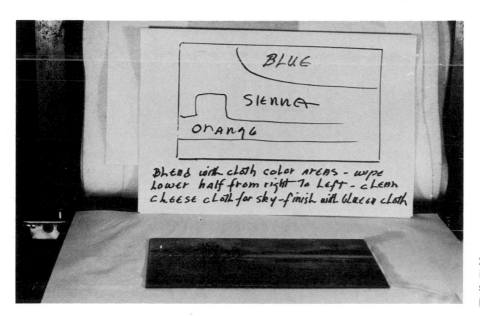

2. In this picture you see MacLeod's inking diagram. She has kept the guide simple—colors are to be put on the plate in large masses.

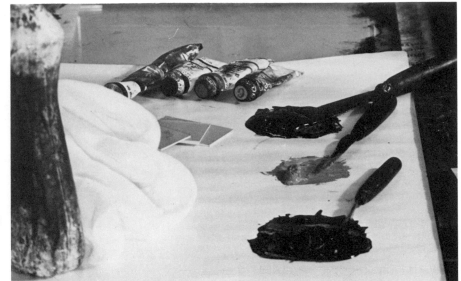

3. Here are the materials MacLeod will use to ink and wipe her collagraph plate: etching ink, oil paints, palette knives, pieces of mat board, cheesecloth, and cloth. The inks are, specifically: burnt sienna etching ink for the foreground; cadmium red light oil paint for the middleground; and a mixture of phthalo blue and phthalo green oil paints for the background. MacLeod adds burnt plate oil to the etching ink to give it a thinner consistency.

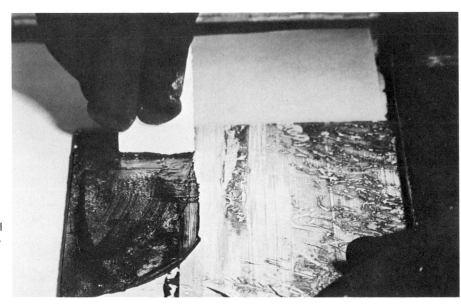

4. MacLeod spreads the green-blue oil paint with a piece of mat board over top area of the plate—this includes the sky, the lighthouse, and part of the water. Mat board is the easiest material with which to ink this plate, as the intaglio is not deep. Also, using mat board is more economical than using the felt dauber described in Chapter 5, as the dauber would absorb some oil paint.

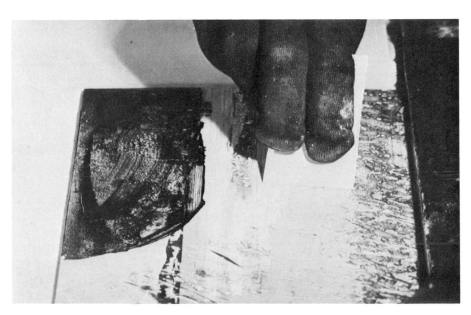

5. MacLeod has taken a fresh piece of mat board and uses it to spread the red-orange oil paint in the central area of the plate.

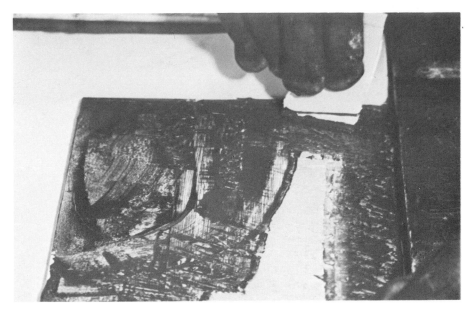

6. Burnt sienna etching ink is applied to the top left area and the bottom horizontal strip of the plate with another clean piece of mat board. Note that there is about ¼" of overlapping color wherever two colors meet.

7. Here MacLeod pulls burnt sienna etching ink lightly over part of the surface of the red-orange middle area of her plate with a piece of newspaper. Since her plate is braced up against a ruler that is nailed to her inking area, she can use both hands. The palm of her right hand is flat and rests heavily on top of the square of newspaper. She pulls the paper toward herself, with her left hand, across the orange surface. She is careful not to blend too much, but only to cover the orange *lightly* with the burnt sienna. MacLeod can achieve control now by turning her plate and pulling the ink in another direction with a fresh square of newspaper. This is a good example of how an artist adapts a technique to suit herself. MacLeod uses one piece of paper at a time in the paper wipe instead of the pad I described in Chapter 5. Both methods work equally well.

8. MacLeod wipes the right-hand sky area with a ball of cheesecloth. She carefully moves her arm from left to right on the plate as she lifts the ink off. She keeps turning the cheesecloth so a fresh area will come in contact with the plate. This helps her wipe off more and more of the blue ink with each stroke.

9. In this picture another wad of cheesecloth is being used to wipe the lower strip of burnt sienna. MacLeod wipes from right to left in this area. She wants to remove the top ink only, not the ink that is deep in the intaglio.

10. Here MacLeod dabs some cheesecloth in dark blue ink which lies on the newsprint beside her plate. She is about to give a little more definition to the lower forms by making shadows and highlights as she wipes the plate lightly with this dark color.

11. She pulls her cheesecloth lightly over the bottom half of the plate. A little of the blue sticks to the edges of the forms in the burnt sienna and orange areas. Not pictured is another clean cheesecloth wipe followed by a light newspaper wipe in this same area. This repeated process will blend the colors and prevent the dabbed blue ink from being thick and spotty.

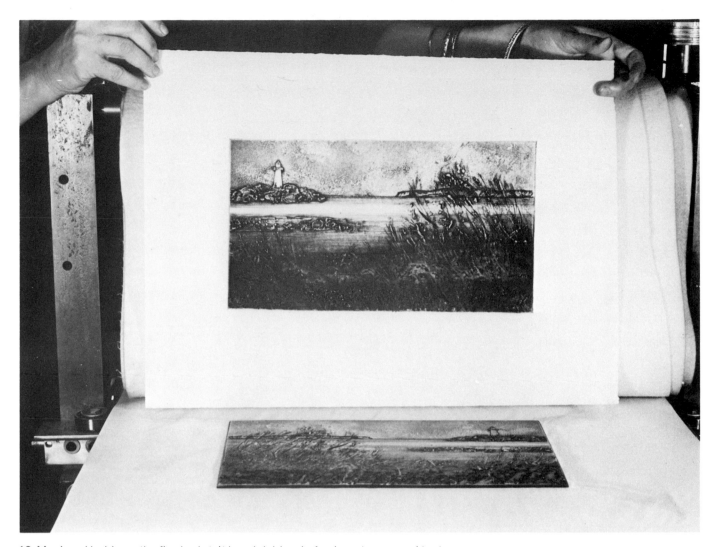

12. MacLeod holds up the final print. It is a rich blend of colors, tones, and textures.

8.
Using Stencils
for Inking

Another way to incorporate color into your prints is to use a stencil. Stencils are a good way to treat isolated spots of color. And, the stencil can provide tonal emphasis without hard edges that can result from intaglio inking and without muddiness that can result from the blended wipe.

Stencils can be made simply and easily from many materials such as stencil paper, contact paper, thin cardboard, or very thin plastic. Charles Wadsworth, a Boston artist and teacher, cuts his stencils out of sheets of typing paper which he coats with several layers of Blair Fixative. The fixative prevents ink from penetrating his stencil.

In this chapter you will see Wadsworth print his collagraph entitled *The Rose and the Hand*. This collagraph plate is one of many which he created to illustrate a book of Christopher Fry's poems. The plate is a beveled piece of Marlite, a plastic-covered Masonite used for bathroom walls. The Marlite provides a pale ground on which darker figures—the hand, the rose, and the ground—play.

Wadsworth used stencils not only in printing this plate, but also in building it. In order to make the stencil for building the collagraph plate, a drawing of the entire plate was done on typing paper, and parts of the basic drawing—the hand and some of the flower forms—were cut out. Wadsworth blew polymer medium with a fixative blower through the holes in the stencil onto the Marlite, so that no brushstrokes would be evident on the plate as the forms were created. Then, while the polymer was still wet, a fine grade of carborundum powder was dusted over the image to provide an ink-holding surface. (This process not photographed for this chapter.)

During the inking process, Wadsworth used a stencil to ink isolated color spots in this plate: the bud forms were inked by rolling shades of pale rose oil paint over cutout areas of the stencil when the stencil was placed in position on the plate. Notice that the background shades of green and yellow were not muddied by the rose paint, as they might have been if the rose had been blended during the wiping process rather than stenciled in during the inking.

In the following pictures, Charles Wadsworth will illustrate the use of stencils in color printing.

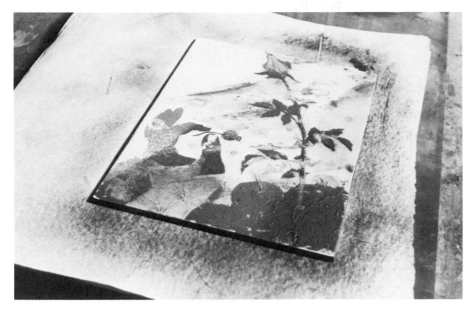

1. Here is Wadsworth's collagraph plate. You can see how well the Marlite surface works with delicate details. Notice the grainy quality of the ground-up carborundum powder.

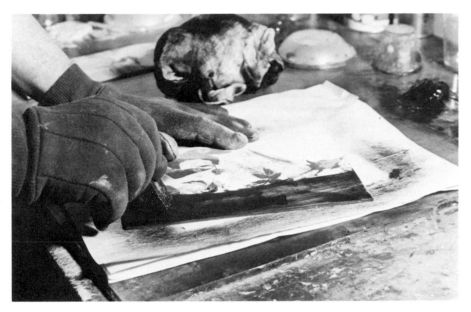

2. In this picture, using a dauber, Wadsworth begins to ink one section of the intaglio part of his plate with Mars black etching ink. Before he began, Wadsworth divided the plate into three parts, each of which will receive a different color. This is similar to the manner in which MacLeod planned the inking of her plate in the preceding chapter.

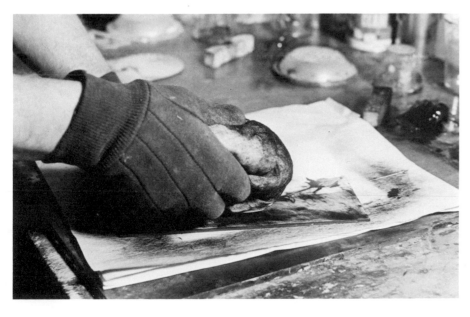

3. Wadsworth wipes the area of the intaglio just inked in black with a soft ball of cheesecloth. Notice that his method of inking and wiping differs from that of MacLeod, who inks the entire plate before she wipes the surface with paper and cheesecloth.

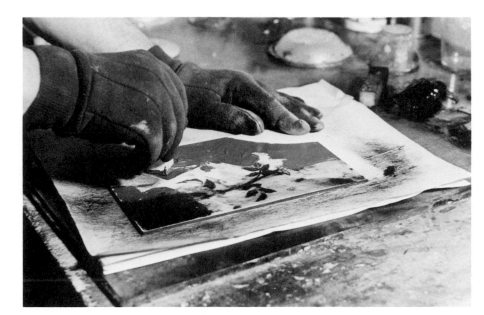

4. Here Wadsworth coats the middle area of his plate with a mixture of raw sienna and chrome oxide on another dauber. The next step, where he wipes this area with a fresh ball of cheesecloth, is not shown.

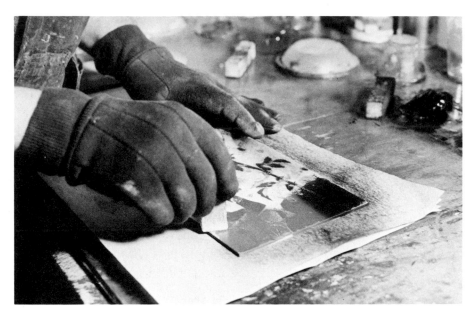

5. Here you see Wadsworth inking the left-hand corner of the plate with a mixture of cadmium yellow light oil paint, a touch of Mars black etching ink, and an opaque white oil paint, Weber's Permalba white.

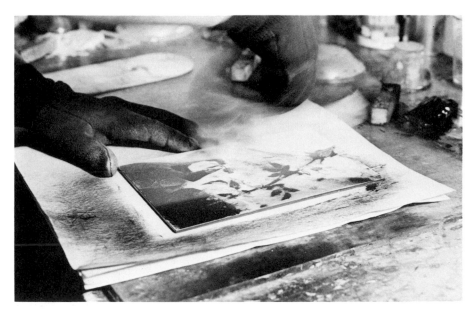

6. In this photo you see Wadsworth wiping the left-hand corner of the plate with a new ball of cheesecloth. In a light, feather-like motion, he gently lifts off the excess ink and blends the edges of the color areas.

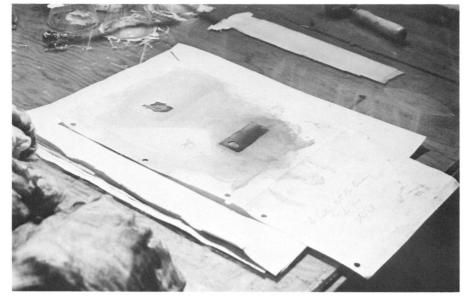

7. The stencil is placed in position over the plate. Wadsworth used his Japanese cutter to cut these shapes out of a tracing of the design made on typing paper. The paper surface of the stencil was sealed with plastic coatings of Blair fixative on both sides. This way no matter how often the stencil is used, the ink will not soak into the paper. In case you're wondering what those upside-down plastic glasses are doing in the background, this is how Wadsworth keeps his inks fresh. The plastic covering prevents the ink from forming skin—a hard layer—on top.

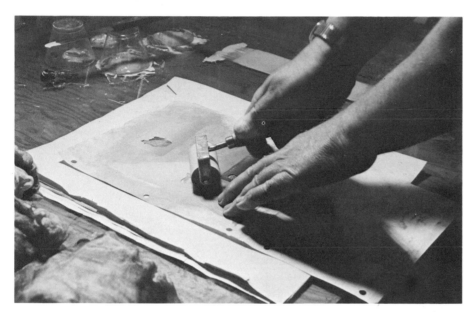

8. Wadsworth rolls a rose tone over the cut-out area of the rose bud with a small, soft rubber roller. Notice the strip of ink to the right of the plate—this is on the glass slab where he rolled out the color to get an even coat of ink on the roller.

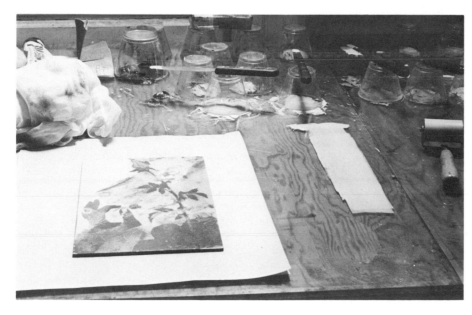

9. Plate for *The Rose and the Hand*, fully inked, is ready for printing.

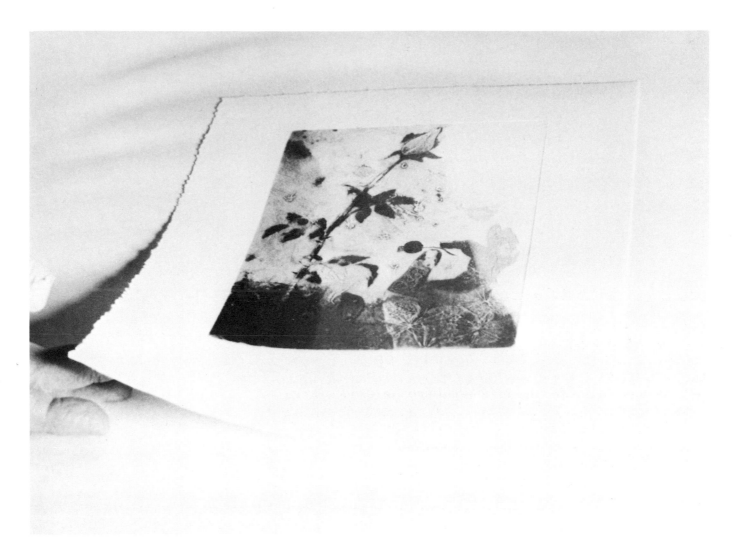

10. Here is the finished print of *The Rose and the Hand*. It is an example of the subtle beauty and delicacy available with stencils.

9.
Using Rollers

Another way to add color to your collagraph plate is to use an inked roller. The roller will deposit ink on the broad surfaces and on the built-up line areas of your plate. The ink on your roller can blend with the one or more inks in your intaglio, and the result will be a great variety of tones. Or, the rolled-on ink can contrast with the color of the intaglio and heighten a desired effect.

I chose to do the latter in *Father and Son*, one of the plates described in this chapter: I wanted to emphasize the silly expressions of the lions, and I decided to play with single color roll-ups until I got the effect I wanted.

I shaped the lion figures of the plate out of silk organza on untempered Masonite covered with gesso. I created the details of the faces, whiskers, and ears with modeling paste, pushing the paste with my fingers and with a pointed palette knife to form raised lines which gave the animals facial expressions.

I inked the intaglio part of the plate with cerulean blue oil paint, since I wanted a soft blue. I added burnt plate oil—you can use stand oil or boiled linseed oil instead—to my oil paint and warmed the ink with my palette knife. After the plate was inked, I wiped it lightly with cheesecloth and paper, and then rolled on a color with my gelatin roller. I tried many colors, both etching inks and oil paints, and finally found that I liked the effect of using a roll of zinc white oil paint with some cerulean blue oil paint added to it. I made this mixture more transparent—without changing the color—by adding oil paint gel to the oil paint mixture before I coated the roller with paint and rolled the color onto the plate.

Please notice that I rolled the blue-tinted, white oil paint from the surface of my roller over the *entire* plate. The rolled color covered the highest surfaces of the modeling paste faces, surfaces which had been clean after the intaglio wipe. The light blue was absorbed into and softened the darker blue of the lions' bodies. The color of the roll also muted the background and therefore accented the lion figures, making the details of the faces stand out and, literally, glow. The highlights and contrasts were obvious in the print.

Generally, after each print is pulled, the intaglio on the plate must

be inked again before I do another color roll-up. Here, however, it is not necessary to clean my plate between each print as I used a dark intaglio and a light roll. If I had used a light intaglio and a dark roll, though, I would have had to clean my plate between each print.

After you pull your print, if the intaglio ink seems fairly strong, you could put your plate immediately through the press again and pull another print. This is a technique called *rétirage*, and it is used often with the viscosity method (see Chapter 11). You could also do the surface roll again without redoing the intaglio, and then pull another proof.

In another demonstration in this chapter, Anne MacRae MacLeod will show you how to do a *double roll-up* and a *blended*, or *rainbow, roll-up.* These are exciting ways to get several colors in one printing, and MacLeod uses both methods in one plate.

First, let me describe the plate. It was made on ⅛" thick untempered Masonite which MacLeod sealed with a thin coat of polymer medium. She then glued on a background of silk organza with thin coats of sponged-on polymer medium. She let the first coat dry before applying a second coat. The forms on the plate were of full strength polymer medium which MacLeod swirled and pushed as it dried. She later added more polymer medium in some places and glued on small star-like forms of shiny paper.

The procedure used with the blended and double rolls involves first inking the intaglio of the plate. In this case, MacLeod uses several colors in the intaglio and wipes them using the blended wipe technique discusse in Chapter 7. She uses a phthalo blue Graphic Chemical etching ink, a transparent ink, in the bottom half of her plate, and a phthalo red-rose Graphic Chemical etching ink on the top half. The intaglio ink is blended and wiped with cheesecloth, and the higher surfaces of the plate are paper wiped until the plate is free of any excess ink.

At this point she prepares the first roll. As you see in the accompanying picture story, oil paint or etching ink can be rolled with a large roller on your glass slab. Two or more colors can be combined on the one roller to get a rainbow effect. MacLeod uses two reds and an orange which blend into each other. As you roll these colors on your glass, the ink is picked up on the surface of your roller. Then, with great care, you roll the colors with your roller over the surface of your plate.

Since MacLeod wants to add more color with the second roll, she must prepare the plate by wiping some of the ink from the first roller off the plate surface. She does this with the *flip wipe* technique, as described in step 15 of *Two Rollers.* After the top surfaces of the collagraph plate are cleaned by this procedure, another color is rolled onto the glass with the roller and then onto the surface of the plate.

In thinking about colors for a double roll-up, I recommend proceeding from darker tones to light as you work from the intaglio to the second roll. MacLeod, however, often works from light colors to dark. Keep your colors transparent: add plate oil and/or transparent white etching ink, or oil painting gel to your inks.

Whenever you use a roller, *do not leave it resting on any surface at any time.* Rollers are soft and sensitive. They should rest on some

sort of holder so that the body of the roller will not be dented by, for instance, slowly rolling off the table while you are on the other side of the room. Always return the roller to its holder, even if you put it down for a minute and intend to use it again right away.

Rollers should be cleaned after use with paper towels or a soft rag and a solvent such as kerosene. All rollers don't demand the same cleaner, but some rollers, such as gelatin rollers, should be cleaned *only* with kerosene as it is the gentlest solvent. Since it is sometimes hard to tell which rollers are gelatin, and which are composition or rubber, I clean them all with kerosene.

After cleaning your roller, put it back on its holder until you are ready for another printing session. There is no need to clean your roller between each print unless you change colors, or unless the ink on the roller is picking up ink from your intaglio. In the latter case, you must clean your rollers in between prints or else the rolled and intaglio inks will combine and your rolled color will change.

One Roller

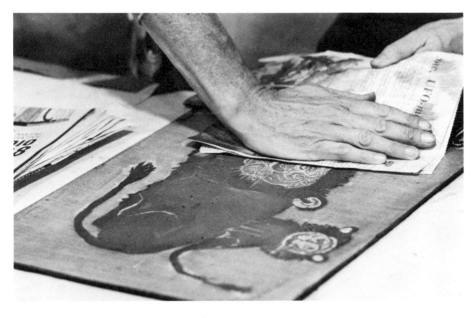

1. Here I am wiping the plate with paper after the intaglio was inked and wiped with cheesecloth. I put this photograph in so you can see what the plate looks like.

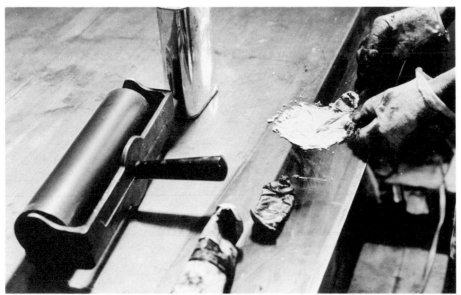

2. Mix your inks or paints for the roll-up, as I am doing here, with a drop of plate oil. Please note that I also added oil paint gel to the mixture of white and cerulean blue oil paints to make the paint slightly transparent.

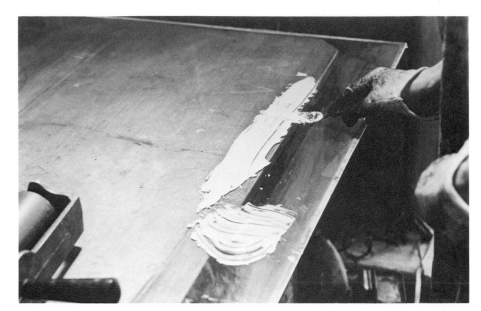

3. In this photograph I am beginning the roll-up by spreading my paint across the glass slab with my palette knife. When you do this, remember that the paint or ink should be spread approximately the length of your roller in a thin line.

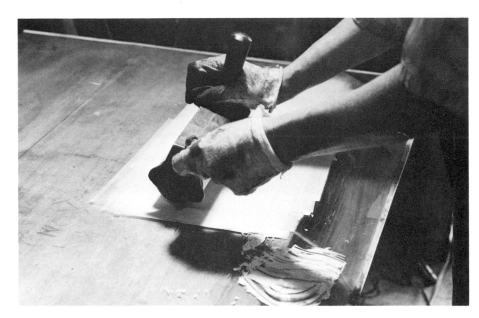

4. Here I am rolling the roller back and forth over the paint, and I turn the roller so that all sides are covered. When the roller seems to be evenly coated with paint, I will search to see if there are any seams or lines, marking the point where one coat of the paint begins. If there are any such seams, I will press them back into the paint on the glass slab, and I will keep turning the roller until the coat of oil paint has no lines or other marks.

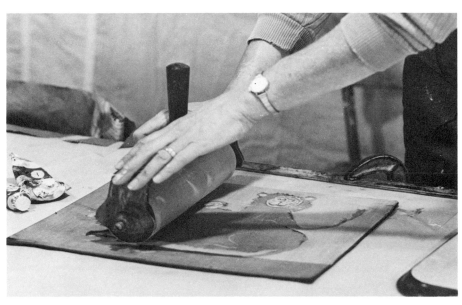

5. Here you see me rolling the inked roller over the surface of my plate. As you can see, the roller is too small for the plate, and I will have to repeat Step 4 in order to cover the plate with ink. This is not a good idea, especially for a beginner. Try to get a roller that is bigger than your plate so that you don't have to worry about getting lines from the edges of the roller in your print. But, in any case, repeat Step 4 if you think the layer of rolled ink is too thin or if you have missed spots.

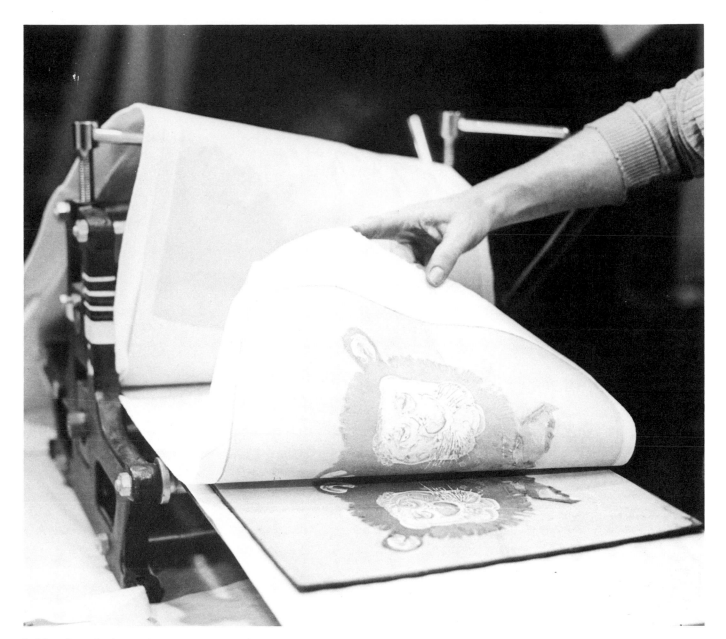

6. After the print is put through the press, I usually pull up the edge of the print—as I'm doing here—to see if the paper has absorbed all the color. If it hasn't, I tighten my press and run the plate through two more times. Notice the dark facial details in the print of this plate, entitled *Father and Son*; the details are accentuated by the blue-white roll-up.

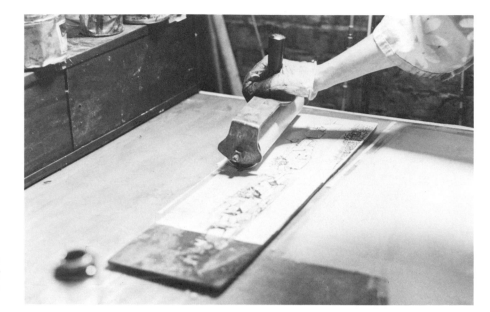

7. Here is another plate of mine, *Blue Morning*, which I am coating with ink with my roller. See how the deep intaglio seems to be covered by the roll. Remember, though, that the lowest parts of the plate will be the top surfaces of the final print. The dark tones in the crevices will not be obscured by the roll-up, but will print in their full intensity.

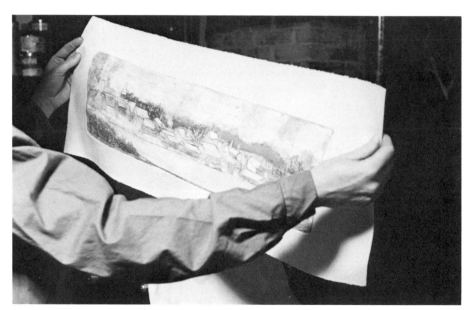

8. Here you see the print of *Blue Morning*. The dark intaglio shows up strongly, and the roll-up unifies the picture. The gray-blue roll touches water, sky and roofs, while the edges of the tapes used to make the building forms hold the intaglio ink and give shape to the design.

Two Rollers

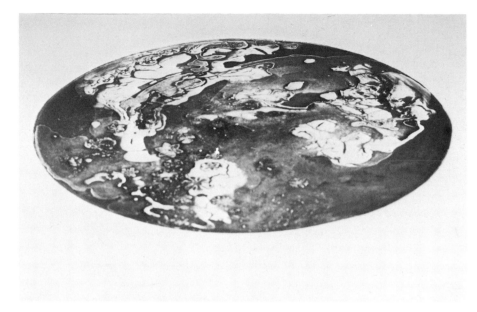

1. Here is Anne MacRae MacLeod's plate after the intaglio ink has been blended and wiped with both newspaper and cheesecloth. The plate could be printed at this stage, but MacLeod, who is essentially a colorist, enjoys interweaving colors in her images.

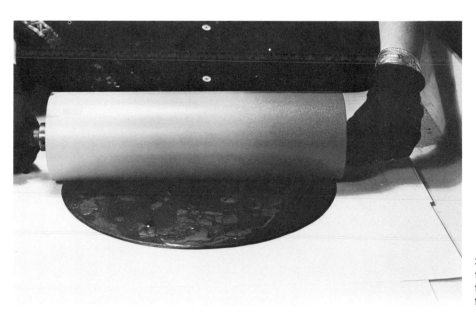

2. MacLeod is rolling the ink for the first color roll-up with a 16" gelatin roller on a Marlite board, which works as well as a glass slab. MacLeod spreads three oil paints—Grumbacher red, cadmium red light and cadmium orange—mixed with plate oil in a row, making a thick, single line across the Marlite for the length of the roller. MacLeod rolls the roller back and forth across the slab, moving the roller slightly to one side or the other to blend the colors into each other and produce new tones on the slab in what is called a *blended*, or *rainbow*, *roll-up*. Remember that whatever is on the slab goes onto the roller and then onto the plate.

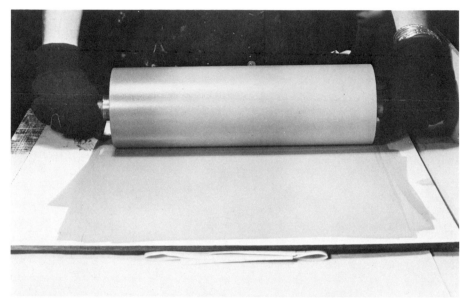

3. Here MacLeod rolls the roller over the plate. She will repeat Step 1 as often as is necessary until the plate surface is covered with an even film of ink.

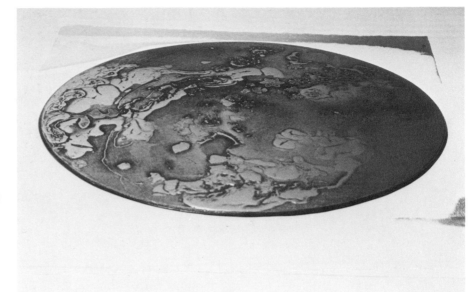

4. In this photograph you see Anne MacRae MacLeod's plate with its surface covered by the ink from the first roll. The roller was fairly soft: it covered not only the top surfaces, but also much of the lower ones. The oranges and reds of the rainbow roll blend with the reds and blues of the intaglio. The roller skipped over the ink around the edges of the polymer forms. These areas will read darker in the final print.

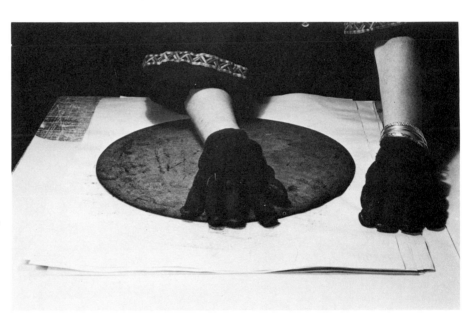

5. Now MacLeod takes her plate by the edges, puts it face down on a flat pile of newsprint. This is called the *flip wipe*— MacLeod applies even pressure by hand and gently moves the plate around and around on the newsprint. Only top levels of the plate will be wiped clean by this motion because they are the only surfaces in contact with the newsprint. When you get to this step, if a lot of ink seems to be coming off on the newsprint, it is best to repeat the process with fresh sheets of flat newsprint until your newsprint stays fairly clean when you push your plate around.

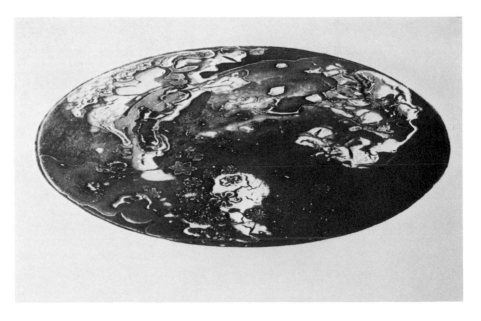

6. This is a photograph of a print from MacLeod's plate at this point. You can see how much the flip wipe technique does remove top surface ink. Of course, if you were inking the plate for a double roll-up, you would not pull a print right now—the plate, with its cleaned surfaces, would be ready to receive the next roll-up. Note that it is in these cleaned top areas that the second roll, blue, will show in the final print.

7. Here MacLeod rolls the ink onto the roller for the second roll-up. In general, the second roll should be a light, fairly transparent color, selected to blend with earlier inkings. MacLeod chose a cerulean blue oil paint because it works well with the deep reds and oranges.

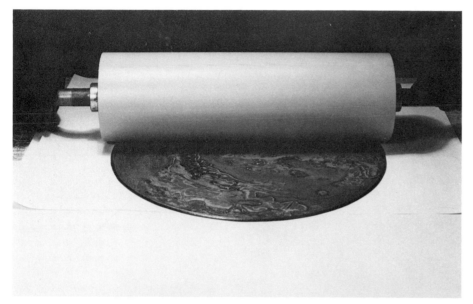

8. MacLeod rolls the blue ink from the roller onto the plate very lightly, with almost no manual pressure. The blue blends with and slightly mutes the reds and oranges when they meet on middle-area surfaces. Where the soft blue is pure—on the surfaces that had been wiped clean—the blue works harmoniously with the stronger oranges and reds.

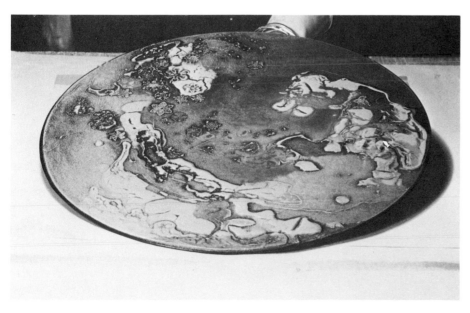

9. Here is the plate, ready for printing. The second color has been completely rolled across the plate.

10. After she runs the plate through the press once, MacLeod lifts her print half-way to check if all the colors have printed intensely and evenly, and to see whether her intaglio is as deep as she wants it to be. If something is not quite right, she can drop the paper back onto the plate, tighten the pressure and run the plate through the press again. Be sure, when you do this, to pick the paper up only half-way, so that the paper doesn't move and cause a blurred image.

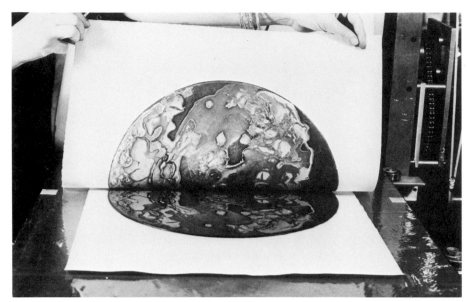

11. The print of *Moon of Jupiter* in this photo shows the advantages of a double roll-up technique and of multiple color printing. The light, medium, and dark areas combine in a soft way— all parts are held together by the color of the second roll.

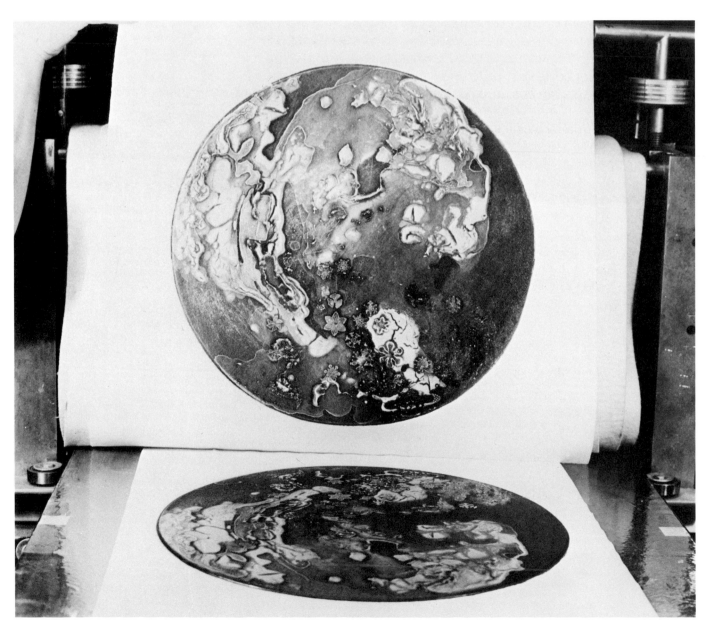

10.
Color Printing
with a Flip Board

Another way to work with color will be demonstrated in this chapter by Dale Pierson Hill of Georgia who has developed her own method of color printing. She uses an abstract arrangement of colors in which each color corresponds to one of the shapes on her plate. She actually paints the colors, oil paints, onto each part of her plate with a brush.

The textural quality of Hill's prints are intensified by the second step of her printing process. After printing her plate once and getting an image in flat colors with indentations from the textures, Dale inks the same plate again with a darker intaglio inking. The plate, wiped and again ready for printing, is run through the press once more, printing the darker intaglio with its greater textural detail over the first, flatter, color image. This method produces a print with the precise color sections softened and enriched by the dark intaglio over-printing. In the print, her images are rich with the textures found on her plates. (See Chapter 17, in which this artist builds this plate with textured fabrics, leaves, and other relatively high-relief materials.)

You will notice that Dale Hill has evolved a registration method, similar to the registration used in lithography, that works well for printing the same plate two or more times. She incises two marks on the back of her plate. When she prints the first colors by laying her plate on top of the damp paper, she makes small pencil marks on her paper which correspond to the marks on the back of her plate. When the plate is put through the press the second time for the intaglio printing step, she lines up the marks on the back of the plate with the marks on the paper.

To facilitate her method, Dale Hill uses a flip board which she makes out of chip board lacquered on both sides. In the following demonstration, see how Hill uses this flip board in the registration process.

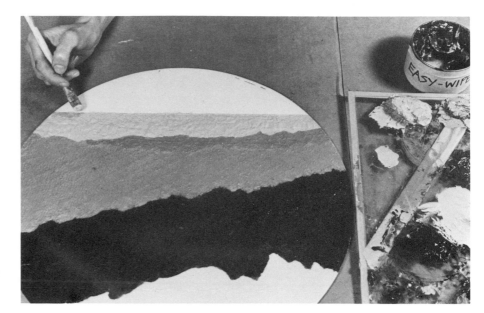

1. The artist brushes oil paint onto the fifth area of the plate with a firm, short bristled, oil paint brush. Hill uses Graphic Chemical Easy Wipe Compound, an extender which you see in the can. When you mix Easy Wipe with oil paint (⅓ Easy Wipe, ⅔ oil paint), the paint stays loose and can be brushed onto the plate easily.

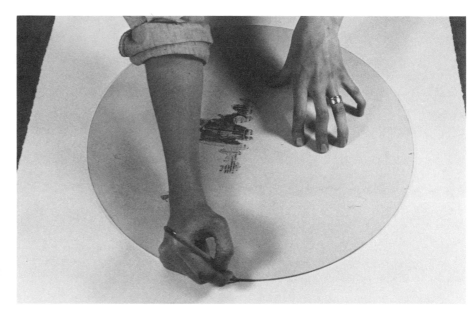

2. After the plate is inked, Hill turns it over and places it face down on the damp printing paper, which is in this case Murillo paper. She marks the paper with two light pencil marks which correspond to two incised registration marks on the back of her plate. These incised marks cannot be seen here, but they can be made with a mat knife or an X-acto knife, in the form of a dot.

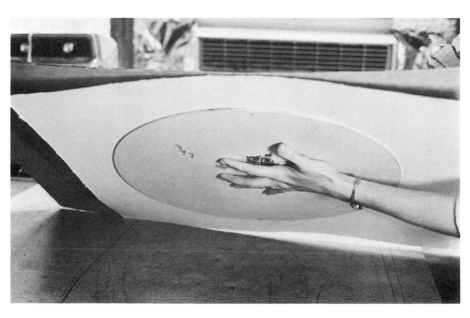

3. In this photograph you see Hill flip the plate and the paper over with the aid of the flip board—made of gesso-coated cardboard or Masonite—onto the bed of the etching press. The printing paper is now on top of the plate. When the plate and paper are in position on the press bed, Hill will remove the flip board and run the plate through the press. Be sure to clean the flip board on both sides before each printing so that no extra ink will smudge your printing paper.

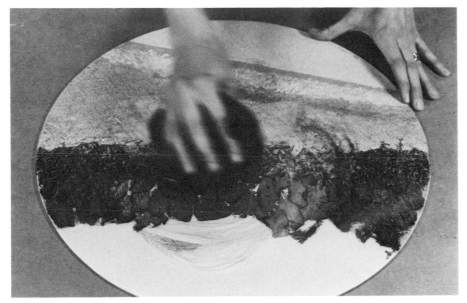

4. After the plate has been printed, Hill cleans the whole plate with mineral spirits or turpentine. She has put the paper with the printed image in plastic to keep it damp until the paper is needed again for the second printing.

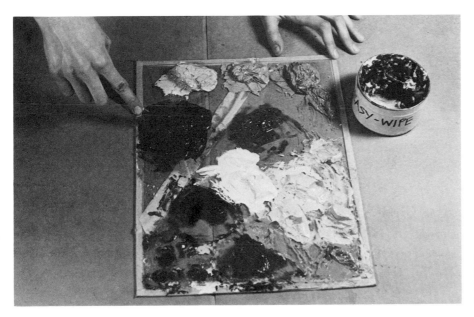

5. Hill prepares the etching ink by mixing the brown and black ink with extender—you could also use burnt plate oil.

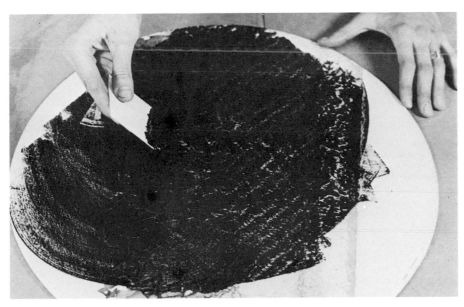

6. In this photograph you see Hill spreading the dark intaglio ink over the entire plate with a square of cardboard. (You could also use a rolled felt dauber.)

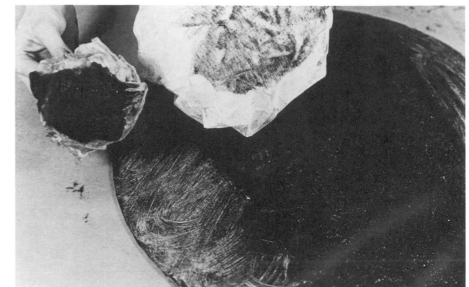

7. After scraping the excess ink off with a cardboard scraping square, Hill rubs the plate with tarlatan using a lot of pressure. In this photograph you can see two tarlatans used—a dirty one which Hill used to make sure that the ink was in all the crevices, and a clean one which Hill used to remove all extra surface ink.

8. Instead of the paper wipe, Hill uses the hand wipe to take ink off the top surfaces. She dabs the edge of her hand in whiting or talcum powder and gradually wipes the entire surface of the plate. Each time the edge of her hand gets covered with etching ink, she puts her hand into more talcum powder and then continues wiping. When she finishes, the top surfaces of the plate will be clean.

9. Hill goes over the edges of the plate with tarlatan to remove any excess ink.

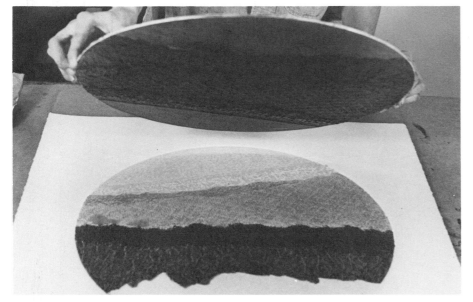

10. Hill places the intaglio inked plate face down on the printed image. She lines up incised marks on the back of the plate with the minute pencil marks on the printing paper. Not pictured is Hill taking the previously printed Murillo paper out of the plastic.

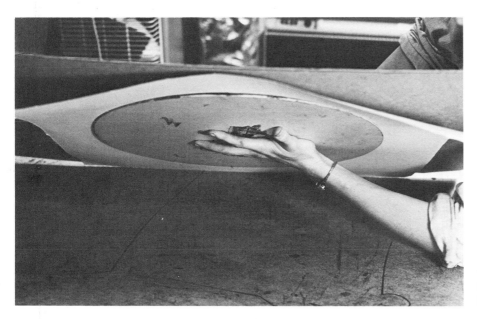

11. Hill uses the flip board again to turn the paper and plate so that the paper lies on top.

12. She positions the plate and paper on the press bed and lifts off the flip board. At this point, she will print the plate again.

11.
Viscosity Printing

The purpose of the viscosity method is to get many different colors on your plate with different rollers by varying the amount of oil in the inks. The less oil in the ink, the more viscous the ink is. Always remember: *an oily ink will repel a dry ink, and a dry ink will absorb and be coated by an oily ink.* This technique was developed in the Paris studio of the etcher Stanley William Hayter. Hayter, Krishna Reddy, and other associates worked with the technique, exploiting its many possiblities.

In this chapter, I will show you how I used the viscosity method of color printing in one of my collagraph plates, *Underwater Fantasy.* The plate was made from botanical specimens—flower blossoms, leaves, and stems—from a collection gathered in the 1890's. Some of the flower blossoms were paper thin, while others had thicker stems and leaves. This variation in thickness, or height, is vital to the success of viscosity printing. Your plate *must* have different surface heights. When you first do this, make the highest surfaces of your plate somewhat close together so that the hard roller will roll over them without touching lower areas.

My intaglio ink in *Underwater Fantasy* was a blue mixed with a little bit of plate oil. After I inked and wiped the plate, I rolled on an oily red etching ink mixed with an *equal* amount of raw linseed oil. The ink was loose enough to drip easily from the palette knife to the glass slab. The hard roller with this ink went lightly over the top surfaces of the plants.

My second roll was done with a light yellow etching ink mixed with *less than half* as much raw linseed oil, just enough oil to loosen the ink enough to roll it on the glass slab. The dry yellow was repelled by the oily surface of the first red roll-up. Because the roller was soft, the yellow film of etching ink sank into the deep areas of the plate where the blue intaglio remained and where the surface had not been touched by the hard roller with its oily red ink. The result is a glowing green which contrasts beautifully with the strong red areas of oily ink that have rejected the dry yellow roll. The yellow roll and blue intaglio combined because the blue was the drier of the two inks and therefore absorbed the yellow.

You can vary this technique by using three rollers of differing hardness and softness and / or by varying which kind of ink—oily or dry—goes on which roller—soft or hard.

Try it this way first—a dry red intaglio and an oily yellow hard roll followed by a dry blue soft roll. The oily yellow will coat the top surfaces of the plate. The dry blue will be repelled by the yellow but, because the roller is soft, the blue will sink into the deep parts of the plate. The blue will be blue where the red intaglio was wiped off in a low area; the blue will print in a purple tone where it combines with the red.

Then start again and try a dry red intaglio with a dry blue hard roll followed by an oily yellow soft roll. The dry blue hard roll will coat the top surface of the plate. Then the oily yellow will hit the top surfaces with dry blue and coat the blue, making green. The oily yellow will also sink into the deep parts of the plate and coat the dry red to make orange Nowhere do you get yellow, but you do get some interesting effects.

Also, after you pull your print and remove the paper, try leaving the plate on the press, put down another clean piece of damp paper and pull a second print. This technique of pulling a second print is called *rétirage*, and produces a print with very muted tones.

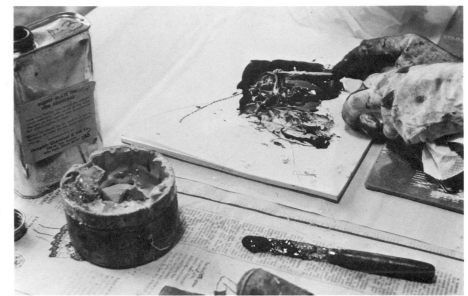

1. Here you see me preparing the ultramarine blue etching ink for the intaglio on a paper palette. I added transparent white—in the can—and some burnt plate oil to the ink before mixing it with my palette knife. Transparent white is added to any etching ink to make that color ink transparent and to increase the amount of ink. Notice that the ink, even with the addition of some plate oil, is rather sticky.

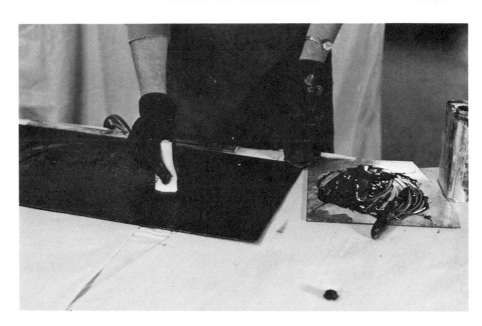

2. This step shows me inking the intaglio of *Underwater Fantasy* with a dauber. You can see the glass slab on which I warm the ink next to the plate.

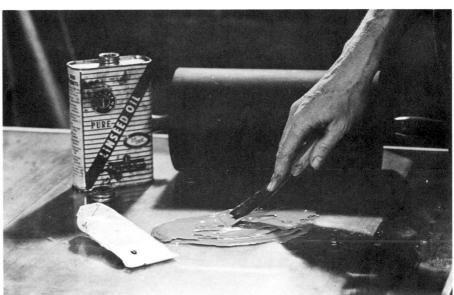

3. In this photograph, I am preparing a *loose* ink for my first roll-up. I have already finished wiping the plate with an old curtain (instead of tarlatan—the curtain was cheaper) and squares of newspaper. The etching ink is bright red, from Graphic Chemicals, and is mixed with an *equal* amount of raw, not boiled, linseed oil.

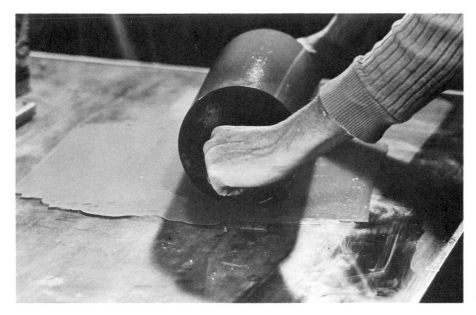

4. Here I am rolling the loose, red ink with a hard rubber roller on a glass slab. The ink is so loose that I have trouble rolling it on the stiff roller.

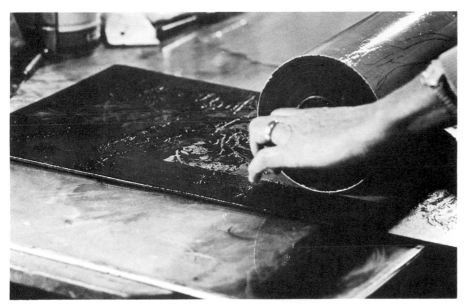

5. I roll the loose red ink over the medium-dry blue intaglio. Notice that the red ink picks up almost no blue from the intaglio on the plate. The dry ink, blue, is coated by the oily ink, red. The red covers the top surfaces: due to the stiffness of the roller, the oily red does not sink much into the recesses of the plate.

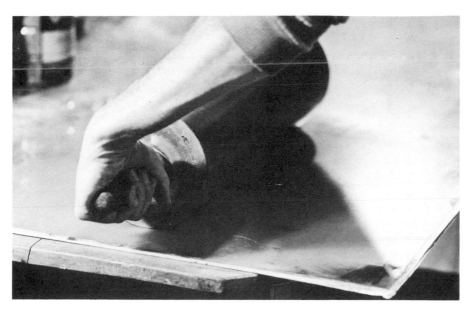

6. Here you see me rolling my dry yellow ink—four parts of ink to one part raw linseed oil—across the glass in preparation for the second roll-up. This roller is much softer than the first one, and will sink into the deep parts of the plate.

7. I am rolling the dry yellow ink over the plate. I roll first from one side of the plate and then from the other. I try to avoid getting a line where the two roll-ups meet by lifting my roller just after reaching the midpoint of the plate. Between each roll of yellow, though, I must clean the red and sometimes the blue ink off the roller. Remember, a dry ink (yellow) absorbs an oilier ink (red and maybe blue) and that is why red and blue stick to the yellow roller. It would be simpler if I had a larger roller: then I would have to clean the roller only between prints.

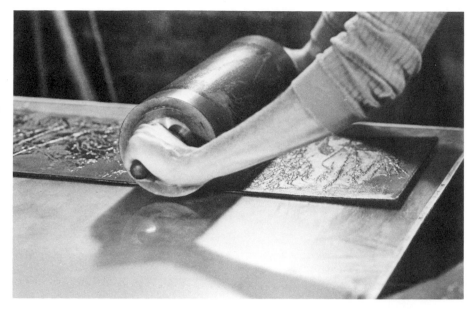

8. You can see that the viscosity method worked here. The yellow on my roller did not coat the oilier red ink, which repelled the drier yellow. You can also see how the yellow absorbed, or picked up, the red ink on the roller.

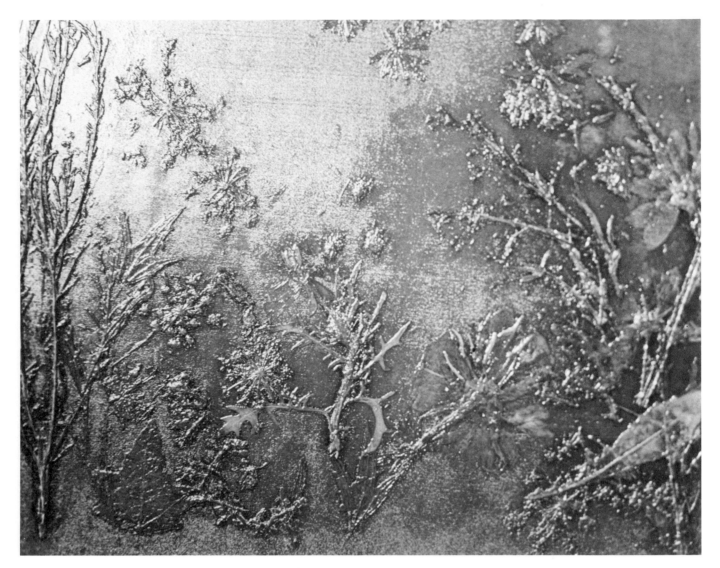

9. Here is a detail of the *Underwater Fantasy* print. The red roll-up brings out the delicacy of the plants and lichen forms on the top surface. Because I used a soft roller, the dry yellow coats some of the lower plant surfaces and also combines with the blue intaglio, making a transparent green in the background. With the edges of the plant forms silhouetted with the remains of the blue intaglio ink, the play of color is terrific.

12.
Color Printing
from Multiple Plates

In this chapter you will learn how to do color printing using several plates to create one picture. By using multiple plates, each inked with a different color, you can preserve the intensity of each color in its full strength or you can create new colors where the plates overlap.

The easiest approach to multiple-plate printing is to use two or three plates that have been cut in exactly the same size and shape. You print one plate and then lift up the blankets and paper while keeping them locked in place under the roller of the etching press. Drape the blankets and the paper over the press roller. Before you remove this first plate, draw a light pencil line around it on your newsprint covering the press bed so that you will clearly see where to put the other plates for printing. Then, take off that plate, and place the second plate to be printed in exactly the same place as the first plate had been within the pencil marks.

You will find that the secret of the whole multiple printing process is to use printing paper that is much longer than the plates. This will allow you to keep your printing paper under the etching press roller during all steps.

In the step-by-step presentation on the following pages, Elsbeth Deser demonstrates how to use three plates to create one print. All three plates were made on tempered Masonite—coated with several layers of polymer medium—with pieces of organza torn and cut into free shapes. The organza was glued to the untempered Masonite with thin coats of acrylic polymer medium. The parts of the plate without organza were also coated with thinned polymer. The intaglio of each plate described in the photographs has been inked completely, and then carefully wiped with paper and cheesecloth.

Deser uses colors that will blend well together when they overlap in the final printing, and you should try to do the same. Also, try printing the plate with lighter color first so that the light ink will be absorbed into the white paper without darker inks dulling its impact, unless you want the more subdued effect which would come from printing a plate with light ink over a plate with dark ink.

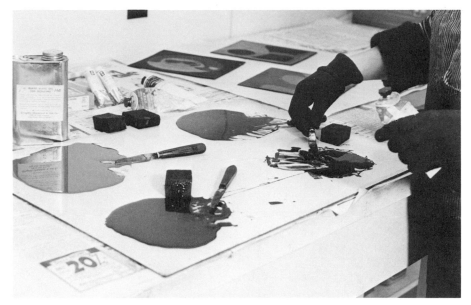

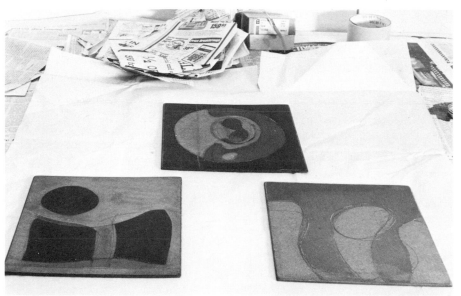

1. Deser prepares her ink for printing with thick plate oil (# 3 grade) in order to get thick, viscous ink which will print densely when held by the organza. She uses both etching inks and oil paints. Notice the black chunks of felt Deser uses as daubers—she buys the thick felt in rectangular strips as scrap and cuts them up.

2. In this photograph you see all three plates inked and wiped and ready for printing. The wiping process is almost the same as in previous chapters. The only difference is that after she applies the thick ink to the plate, she wipes some of it off with squares of newspaper before using cheesecloth *lightly*. She does not press heavily with the cheesecloth—she uses the cheesecloth to integrate tones rather than to remove ink.

3. Deser takes the etching paper out of the water, which is contained in a plastic photographic tray. If you are using a paper that needs a long soaking to get the paper ready for printing, such as Rives BFK, you would start to soak it the night before and keep it damp by wrapping it in plastic. As this paper is German Copper Plate, it needs to be soaked in water for only a minute. Note that the amount of time you soak paper depends on what kind of paper it is: Arches needs at least ½ hour in water; Rives BFK, at least one or two hours; German Etching, one minute.

4. Deser puts the wet paper between two large white blotters and rolls an ordinary rolling pin back and forth over the blotters so that the water on the wet printing paper is evenly absorbed, and so that no shiny spots of water are left on the paper.

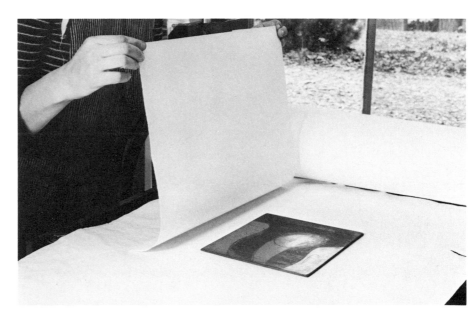

5. The first plate, the key plate, is now placed on the clean sheet of newsprint lying on the press bed, and Deser carefully drops her blotted paper over the plate.

6. Deser covers the wet paper with newsprint before covering everything with blankets. The newsprint absorbs extra water from the paper and prevents any extra ink that may penetrate the etching paper from soiling the blankets.

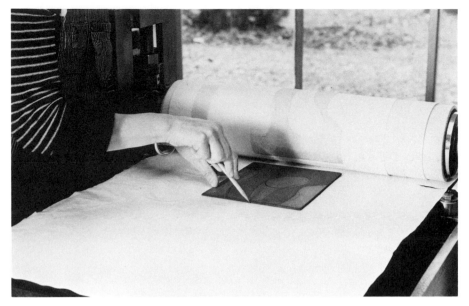

7. After the first plate is run through the press and then back again to the starting position as it is here, Deser lifts the blankets and paper and draws a line around the plate with a pencil. Notice that she keeps the edge of her paper and the blankets firmly caught under the press roller, so that they can be dropped easily on the next plate to be printed.

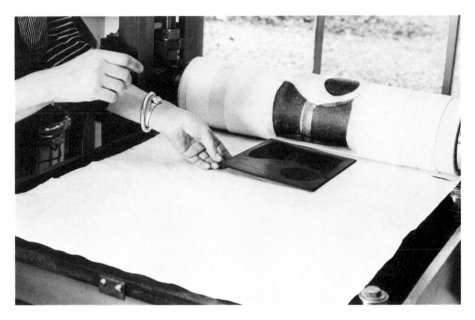

8. In this photograph Deser places the second plate to be printed on the newsprint using the pencil lines made in Step 7 as a placement guide. If she wanted to, Deser could cover this piece of newsprint with a thin layer of acetate which she could clean with solvent in between printing steps.

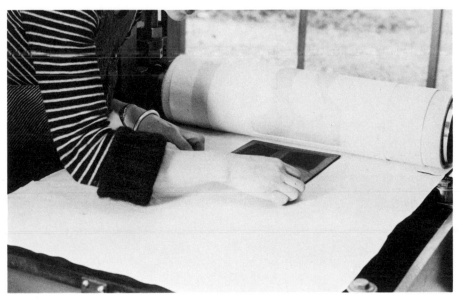

9. Deser picks up her second plate from the newsprint, and is about to print the third plate. Notice that the second image has printed on top of the first image on the paper.

10. Here Deser has printed the third plate and is lifting the paper with clean hands. If her hands had been dirty, she could have used a piece of paper or aluminum foil, or a folded playing card (a meton), to grip the paper and to prevent smudgy fingerprints. Deser will now turn the press so that the paper will be released from beneath the roller. The print will then be dried.

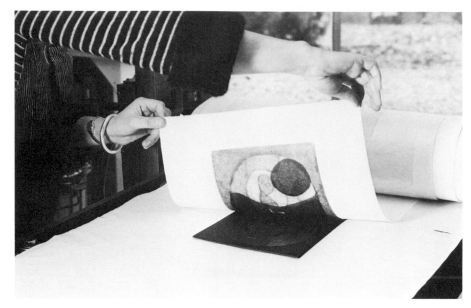

Madonna by Elsbeth Deser. Here you see the final print. Notice the subtle tones of color which exist in the sections of the print in which the plates were over-printed and the clear tones where the plates were separated.

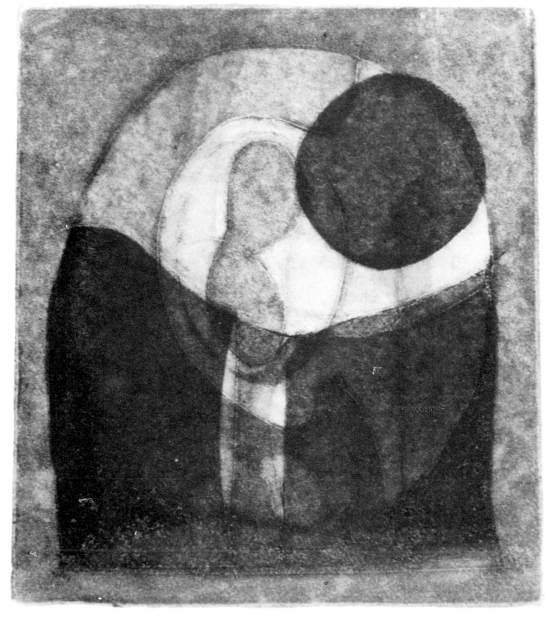

13.
Color Printing
with Multiple Templates

In this chapter Jan Ehrenworth presents her method of printing with multiple plates of different sizes. She uses templates, or frames, in which her plates are positioned before printing. Sometimes each plate is put in the same template, which is another way of printing plates of the same size, like those described in Chapter 12. Here, though, Ehrenworth fits a second template inside the first template in order to position her third plate precisely, inside the second plate.

This sounds complicated but let's examine this process closely. The first template is the remainder of the mat board or Masonite from which the first plate is cut out. When you do this, pay attention to the dimensions of the template and plate—remember that the whole board will have to fit on the bed of your press.

Ehrenworth uses mat board here, and she coats the whole piece with thinned-down acrylic gesso. The surface becomes slightly rough so that it can hold inks which are rolled on. When you do this, give the board at least four thin coats on *both sides*. I learned about this the hard way when I carefully coated a mat board only on one side. As each coat of gesso dried, I watched the board gradually buckle and shrink until it looked like a piece of curled-up lettuce.

Next, coat your mat board, also on both sides, with two or three coats of thinned polymer medium in order to seal the plate so that the plate will not absorb any ink and so the paper will not stick to the gesso during printing. Ehrenworth coats the mat board with two coats of polymer medium, which she uses almost full strength on the second coat. She is careful to let each coat of polymer and gesso dry fully before applying the next coat.

After preparing the mat board, Ehrenworth can cut it easily in a firm crisp line using a mat knife with a fresh blade. She cuts the first plate from the mat board, producing the plate and the template. She cuts a second plate—a cut-out oval—with the same outer dimensions as the first plate so that she can use the same template. Then, she uses this second plate as a template to position the third series of plates.

In the following photographs, you can see how Ehrenworth inks her plates with surfaces rolls and how she positions them on the press bed with templates.

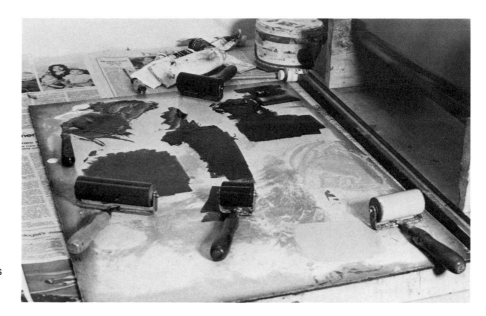

1. Ehrenworth mixes all her inks for all her plates first on a glass slab. The plates are to be inked with surface rolls only. You can see the small rollers and the rolled ink.

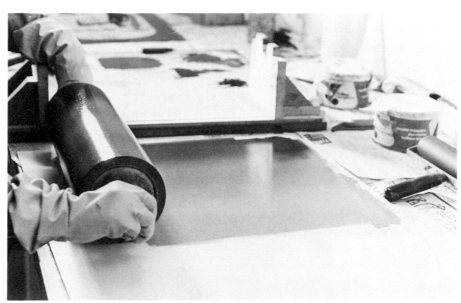

2. Ehrenworth is rolling her inks for the surface roll of her first plate with a blended, or rainbow, roll. For the red to orange roll, she uses Lorilleux inks, French etching inks, which she mixes with medium plate oil— #00 grade— until they are of a soupy consistency. This ink will roll onto the plate densely. Note that Ehrenworth uses a plastic slab to roll out the ink with the roller.

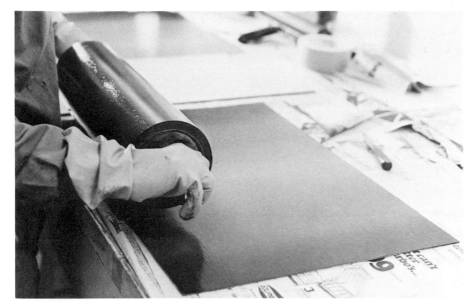

3. In this picture you see Ehrenworth about to roll the red and orange ink on her mat board plate. She can add more color to the plate by returning to the plastic slab, picking up some more on the roller and rolling that roller on the plate again.

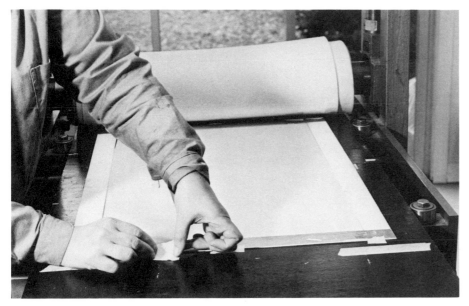

4. Here Ehrenworth is taping one side of the template—the mat board from which her first plate has been cut—to the press bed so that it will not move during the printing process. Several pieces of newsprint are under this template so that each time a plate goes through the press, the residue of ink can be removed by slipping off the top layer of newsprint.

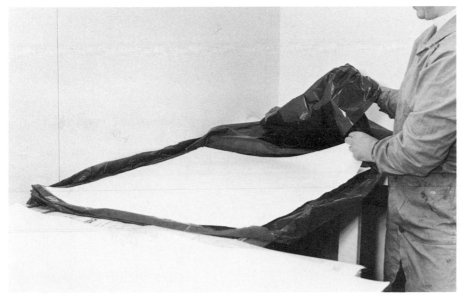

5. Ehrenworth is about to take her German Etching paper out of the plastic, where it has been lying, damp, for about two weeks. Originally, she soaked it in water for about half an hour and then put it, soaking wet but drained, into the sheet of plastic. She keeps the plastic sealed with tape whenever she is not using the paper. If you use this technique of preserving damp paper, you can use the paper from the day after you put it in plastic until mildew forms. Ehrenworth prevented the paper from getting mildewed by adding a drop of alcohol to the water in the tray where the paper was soaked.

6. Ehrenworth pulls up the paper after the first plate has been rolled under the press roller and back again to the starting position. The paper, which is caught under the roller of the press, remains locked in position and is folded back over the blankets, which are dropped on top of the press roller.

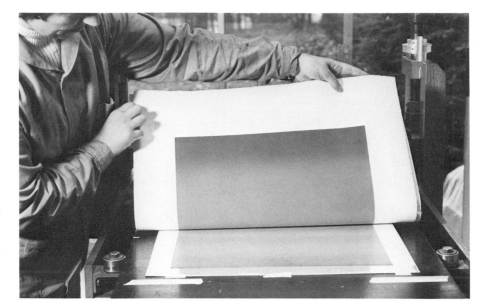

7. Her second plate—with the same outer dimensions as the first plate—rests within the same template still taped to the press bed. This plate has been inked with a strong blue roll-up made up of Lorilleux Tahitian blue etching ink with Graphic Chemicals ultramarine blue etching ink. When you do this, keep in mind that any of these plates could have been made with different levels and textures, and they also could have been intaglio-wiped to get a textured effect.

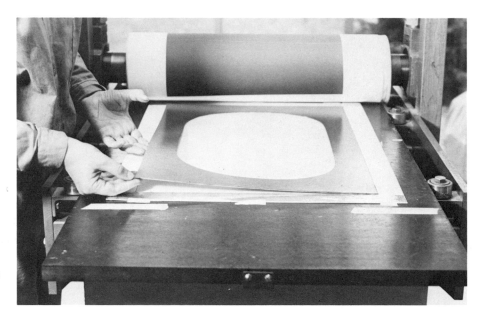

8. Ehrenworth lifts the paper after the second plate is printed. The strong blue on the second plate covers the first color, the lighter oranges and reds. Note that Ehrenworth could have printed a red oval with one plate, and a large blue area fitting around the oval with a second plate. However, there would have been a small white line where the plates joined. You may want this effect, but Ehrenworth didn't. At this point the paper is again held in place by the roller of the press. Not photographed is Ehrenworth cleaning this plate so it can be used as a template for the last plates. Also not pictured is the removal of the top sheet of newsprint lying under the first template on the press bed.

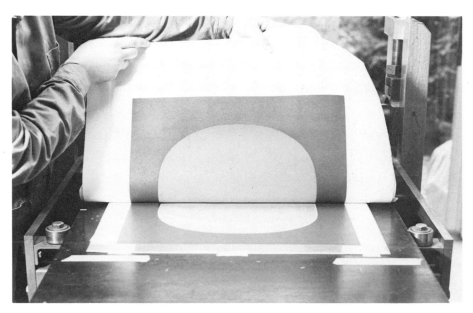

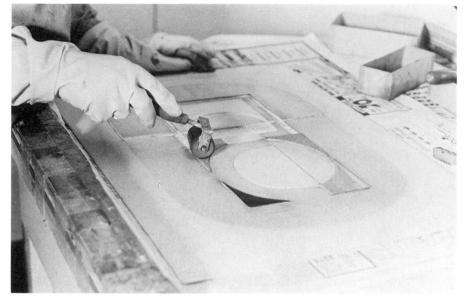

9. Ehrenworth rolls ink on part of the last plates, which are inked with different colors using the small rollers pictured in Step 1. This third plate fits inside the second plate and is made up of many small shapes glued onto the mat board base. The lower circle acts as a template for yet another plate, the small, semicircular plate. The semicircular form is cut out of a plastic floormat: the uninked, corrugated surface rests on the press bed and will emboss the red ink from the first plate in high relief.

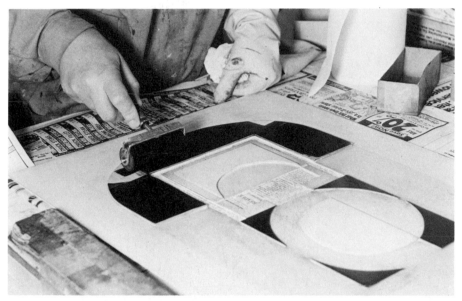

10. In this photograph, one of the last plates is being inked in black. This plate is fastened on top of the third plate with double-sticking masking tape. The plate with black ink will push into the surface of the printing paper and will make a debossed surface.

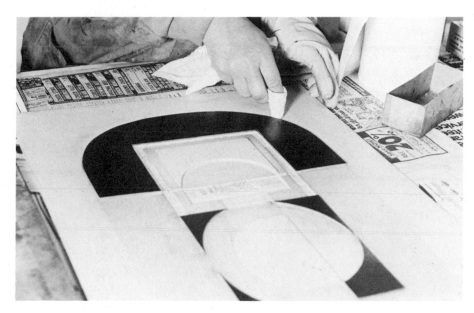

11. Ehrenworth wipes excess ink off the template (the second plate).

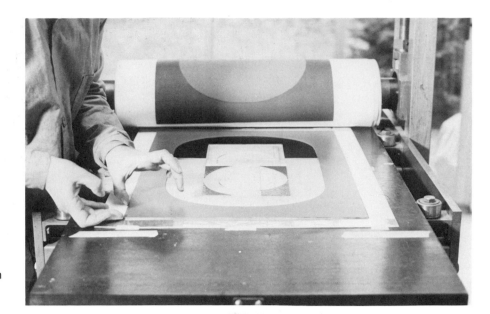

12. In this picture you see Ehrenworth adjusting the plates and templates on the press bed before printing.

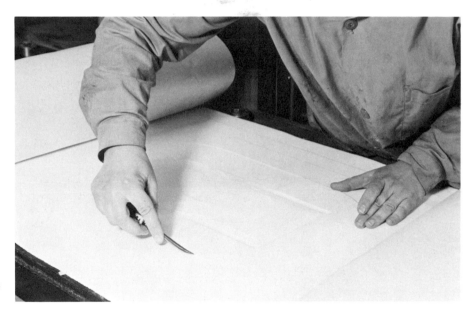

13. After the plates have gone through the press again, Ehrenworth uses a burnisher, an etching tool, to strengthen her embossed areas. She presses down, and guides the burnisher around the edges of her forms on the back of her print before the paper is lifted from the press.

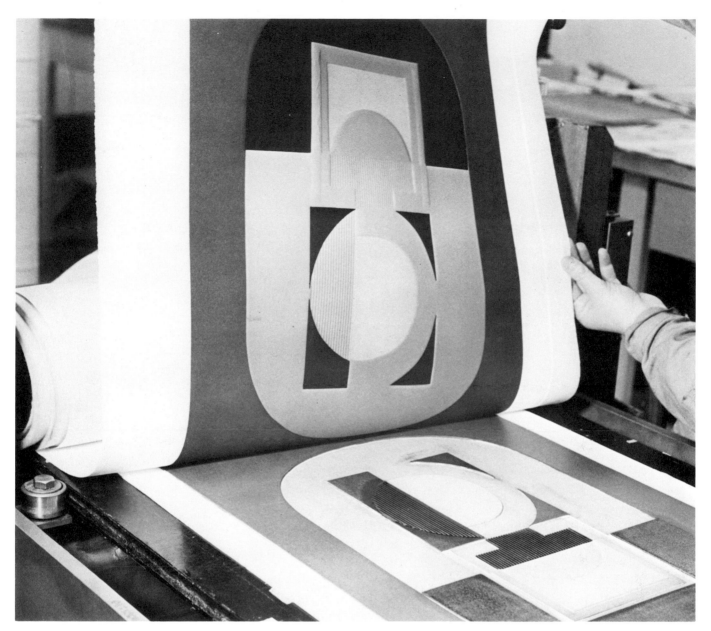

14. Here Ehrenworth lifts the print of *Energy Cell* (© 1973 by Jan Ehrenworth) from the press—it is a good, clean print due to showing carefully planned registration by use of templates.

14.
Color Printing from Leather and Wood Plates Using a Template

In this chapter Cynthia Knapton, assisted by her husband Ken Knapton, demonstrates her way of making a sculptural surface in a collagraph print with wood and leather. Knapton deals with masses rather than with lines. Her early collagraph plates were made with linen sewn together on the plate: the linen created soft, textural images in the prints. When she discovered the printable, sensitive surface of leather and realized that the leather could be sewn together on the plate also and would hold less ink than linen, she began to explore this interesting technique.

When glued to a plate, leather creates a very high relief: therefore a leather shape will print with a white line around its form. To avoid this white-lined look in her prints and to also add a deep, three dimensional quality to her design, Knapton prints the leather with its lines and texture over a colored background printed on the paper with a separate, smooth plate of Plexiglas. The wood, printed with the leather, adds even more texture to the design.

The largest plate of *Distilled Fire*, which is the plate Knapton will demonstrate here, is made out of 1/4" plywood which was cut out of a large piece of wood, burned with an acetylene torch and then shellacked on both sides. Knapton used a wire brush to bring up the grain on the plate. The plywood is thick to prevent warping and chipping during printing.

Knapton glued calfskin to parts of the plywood by brushing Elmer's glue on the wood, laying on the leather and pressing down. The leather was coated later with a thin layer of acrylic polymer gloss medium.

The template for this plate was cut with a saber saw from 1/4" Masonite. Note that any template should be the same thickness as the plate it is printed with. The Masonite was sealed with gloss finish of acrylic polymer medium.

Before any printing is done, a piece of paper which is the size to be used in printing is put down on top of the template, and the corners of the template where the paper lies are marked with masking tape to make a guide for registration. Every time Knapton drops the

paper onto the inked plate, she can drop it in the same spot.

Knapton is making an edition with this plate. She will show you her careful method of mixing and storing her printing inks. So that each print can be made exactly the same, she uses the same ink each time she prints. In the following photographs, Knapton will demonstrate how she concentrates on making a perfect print.

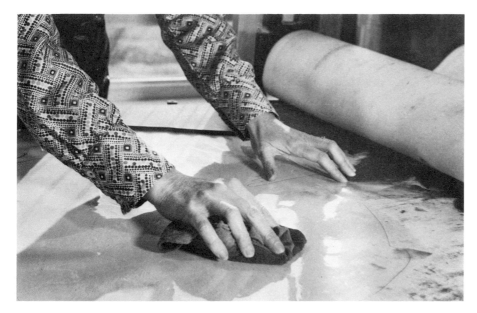

1. In this photograph Knapton cleans the thin, clear plastic with Trichlorethepene, a powerful solvent, which will lie on the press bed during the printing of her plate, *Distilled Fire*. Notice the penciled guidelines drawn on the newsprint underneath the plastic.

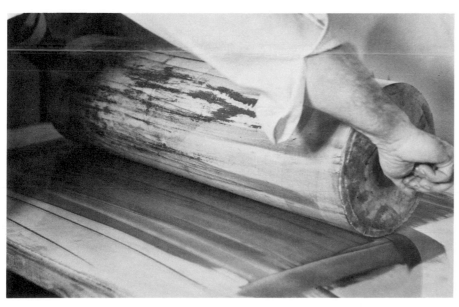

2. Ken Knapton rolls out the background color, orange-red, which will be the first color to be printed. He rolls a veil of this ink, a commercial offset printing ink, on a glass slab with a Durethane plastic roller which he manufactures in Hollis, New Hampshire.

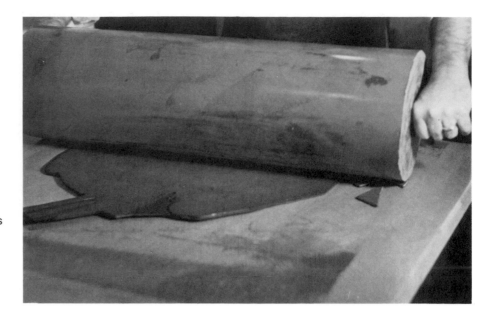

3. Here you see Ken Knapton roll the ink back and forth over the Plexiglas plate and smaller plates until the plates are covered with several layers of ink. The Plexiglas plate will show clearly any flaws in the roll-up. Note that a leather and wood plate with a red intaglio ink will be printed over this Plexiglas shape. (See Step 8.)

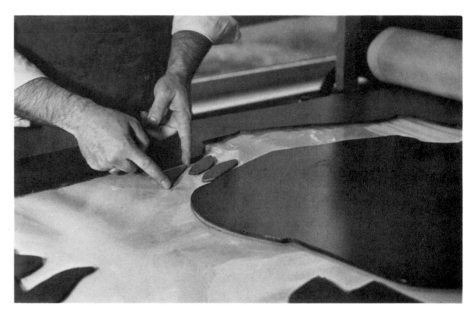

4. All of the rolled-up plates—the Plexiglas plate and the smaller plates—are positioned on the plastic using the penciled guide lines. Notice the uninked template, the larger form, which encloses the plates. Its uneven shape will create an embossment in the printing paper.

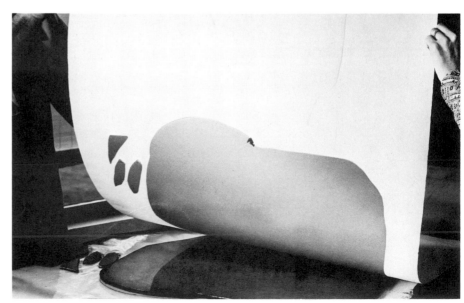

5. The first stage of Knapton's print is pulled and is lifted from the press. Flat orange provides a background on which the intaglio inkings of the leather and wood plates will interplay. Note the embossment created by the template. Not pictured is Knapton taking the damp paper off the press entirely and storing it in plastic to keep it damp until it is needed for further printing.

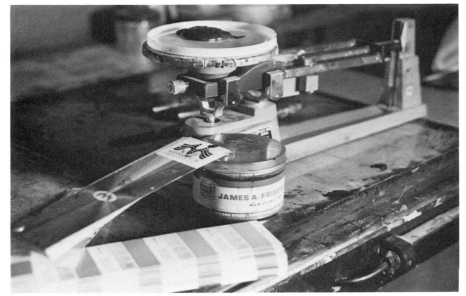

6. Knapton measures the correct amount of inks to be used in mixing the color for the intaglio of the key (main) plate on the metric scale you see in this photograph. She goes through this measuring process for each color ink used in printing this collagraph. Thus she can mix a large amount of any given color for any size edition. The color is determined by trial and error when the first proofs of the print are pulled. After Knapton decides what color an edition will be printed in, ink is mixed for the entire edition and is stored in a labeled can. Sometimes she will refer to a metric color chart, a book of colors such as the one shown in this photograph. The book—*Metric Color System Color Chart* put out by J.A. Frisone Co., Bow Street, Somerville, Massachusetts—consists of paper of different shades of colors, and lists the exact amounts of basic colors needed to make the various hues. Also, Knapton keeps a notebook with a page for each plate which records the color and the amount of ink necessary for each print.

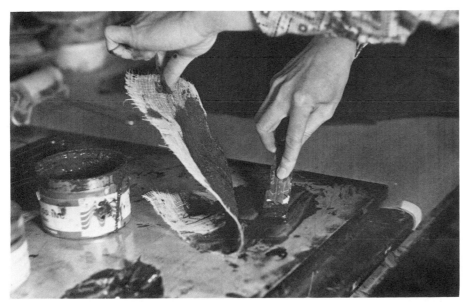

7. Knapton scoops up her prepared ink with a palette knife. She prepared it by forcing the ink through the piece of cheesecloth with the palette knife in order to remove pieces of hardened ink and grit.

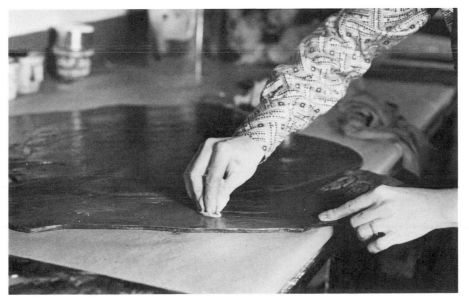

8. Knapton inks and wipes the intaglio of the key plate, the plate made with wood and leather. She uses a sticky ink—rubine red on the wood center and an orange on the leather edge. Small holes in the leather section are inked in flame red with a finger.

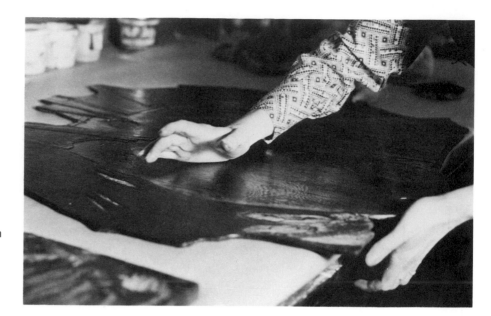

9. In this photograph you see Knapton hand-wipe her plate to distribute an even film of ink over the surface. She has already used tarlatan. In some areas she finishes the wiping process with paper.

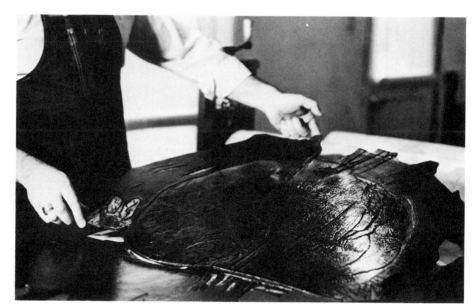

10. Ken Knapton drops the main plate into the template on the press bed. Another plate which will be printed at this time is already on the press.

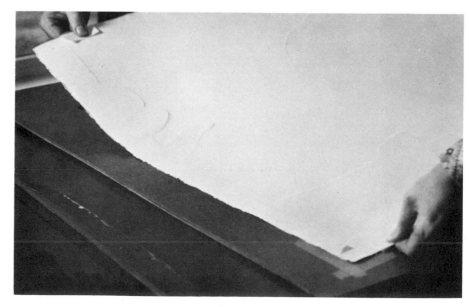

11. Both the Knaptons use the masking tape guide lines on the template to lay the same piece of paper used earlier in this demonstration back on the press. The paper, Arches Cover, is still damp, since it had been wrapped in plastic. Both the Knaptons are needed to drop the paper accurately into place as the paper is so large—30″ x 41½.″

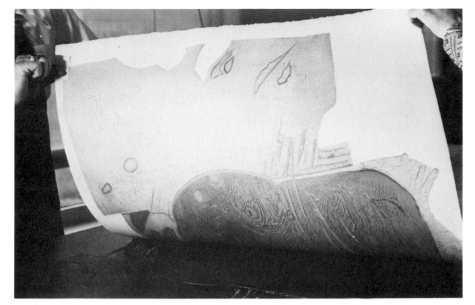

12. The Knaptons lift the paper off the press after the two base plates are printed over the first red roll-up. The deep red in the intaglio of the key plate reveals the grain of the wood: the texture stands out against the orange-red of the first roll. Notice that there are no white lines where the different plates meet even though the leather is in high relief. This is because the first plate, the Plexiglas, printed with the flat orange-red as background, is larger than the plate with leather and wood which prints over that Plexiglas.

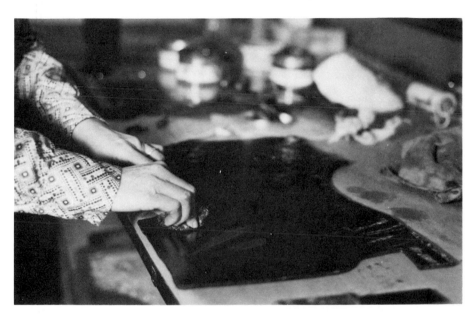

13. In this photograph Knapton inks the intaglio of the leather part of one of the base plates a second time, with an intense black printers ink. She does the same to the other base plate, the main plate. But she carefully avoids putting any black ink on the central, wooden, section of that main plate. If any ink happens to smear on this part of the surface, it is lifted off immediately with a rag slightly moistened with solvent.

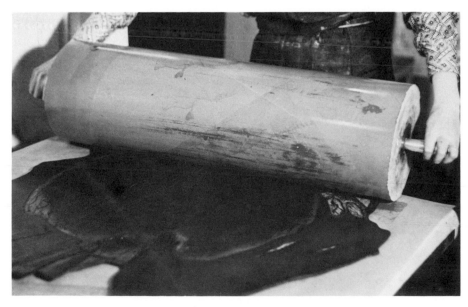

14. Knapton rolls a transparent layer of green-gold over the main plate after the base plates have been wiped. She does the same for the other base plate.

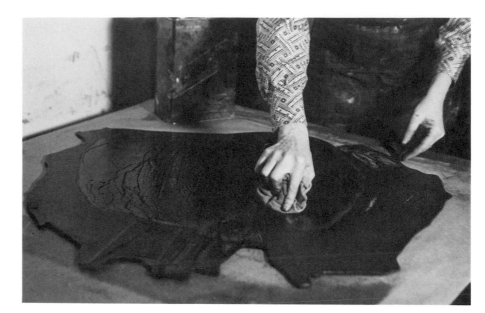

15. The green-gold roll is wiped off the wooden section of the main plate before printing with a rag moistened with solvent. As this wooden part of the plate was not inked and wiped in black, it is easy to clean. At this point, the plates are printed again.

16. The rag used in Step 15 is thrown away immediately into this type of garbage can. The can is metal and has a lid. This is the correct way to keep rags soaked in solvents such as benzine in order to avoid fires.

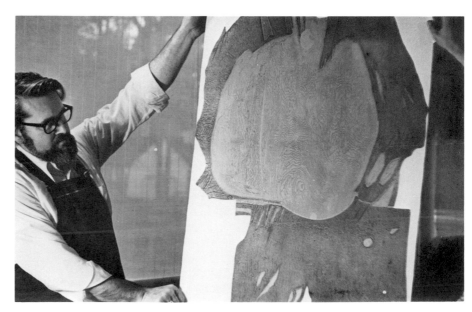

17. Ken Knapton holds up the finished collagraph print of *Distilled Fire*. The combination of orange, black, and green-gold in the leather area creates a rich brown-black. Note the vibrant textures of both the leather and wood. (For the color reproduction of this plate, see page 115.)

15.
Building with Acrylics

This chapter excites me—Will MacLeod photographed his wife, Anne, as she constructed the plate for the collagraph entitled *Shore Sentinel*. Therefore, we have actual documentation of the additive process of using the various acrylic products.

This step-by-step process includes making the plate, two important changes in the design, and the prints that resulted from these changes.

When you build your plates, you will realize the importance of first proofing your plate, making critical decisions regarding the design, and then making appropriate changes in your plate. I recommend a basic attitude of *suspended judgment*. Take for granted that your plate may not necessarily produce a good print right away. If your first proofs are weak, you can always add to or subtract from your plate to make changes.

I usually hang my first proofs where I can see them once in a while, for example, on the refrigerator. (I use magnets to make the paper stay in place.) Hanging my print in such a place seems to slowly help me resolve the design of the plate and determine the color scheme. Solutions usually come to me at unlikely moments.

In this chapter you will notice that MacLeod starts her collagraph from a sketch on tracing paper. However, she notes that she does not always work from a sketch or preconceived idea. When you begin making collagraphs, try working both ways.

In the following photographs you will see how MacLeod uses the different acrylic products—polymer medium, modeling paste, gesso, and Flextex—to shape *Shore Sentinel*.

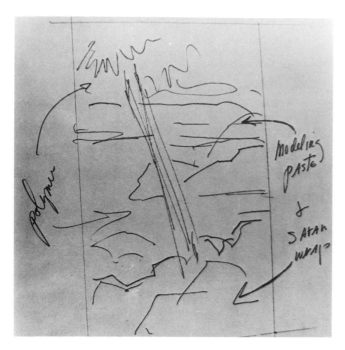

1. Here is MacLeod's *reversed* sketch of *Shore Sentinel*, with areas marked off where different acrylics will be used. MacLeod will transfer the rough design to the plate after Step 3 by tracing the lines over the plate coated with dry gesso and dry polymer medium.

2. MacLeod pours polymer medium over the whole plate to ensure a smooth background surface. Not pictured is the artist painting a layer of gesso onto the plate, which she does first.

3. MacLeod tips her plate with the wet polymer medium and pours the extra liquid into a dish. She then pours this extra polymer medium back into the bottle. At this point, she will take a wet sponge or rag, clean the mouth of the jar and the jar top, and close the jar. Remember, acrylic polymer, gesso, and modeling paste dry up *rapidly* if they are exposed for even a short amount of time to air.

4. MacLeod begins to build her image by scooping up a lot of modeling paste with a plasterer's tool. You can also use a putty knife or a palette knife. She spreads the modeling paste with short, crisp strokes in the areas designated on the sketch—these shapes will form the rocks of the image. Remember that the modeling paste spread by each stroke will become a plane in the final print, and that the edges between planes will hold the most ink. These edges, then, will become the crevices in the rocks in the final print. Notice the diagonal strip of tape which will become the tree trunk—modeling paste will not cover the plate under that strip. The tape will be pulled off later.

5. In this photograph MacLeod continues to work the modeling paste all over the areas designated in the sketch. Notice how the low foreground has been given more texture than the top, background area.

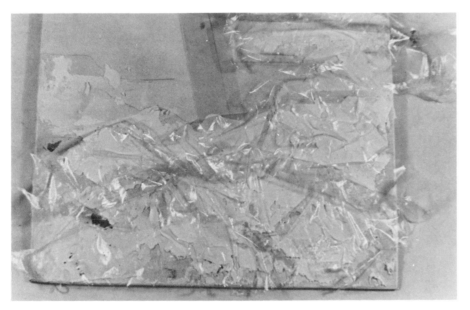

6. MacLeod has pushed Saran Wrap with her fingers lightly into the wet modeling paste to create an interesting texture.

7. After the modeling paste has dried the Saran Wrap can be easily pulled off. The strip of tape has been pulled off and the tree form is evident.

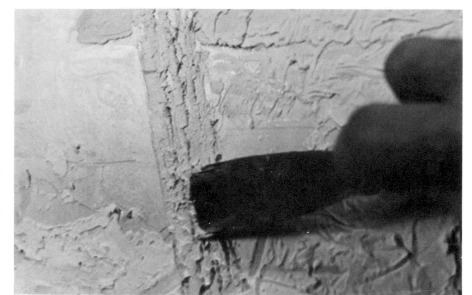

8. MacLeod uses a putty knife to define the tree with Flextex, an acrylic product that feels somewhat like putty mixed with sand. Flextex is composed of an opaque white acrylic mixed with marble dust, and works well to define forms that need a great deal of rough texture. Because of its roughness, Flextex holds ink more intensely than gesso or modeling paste, and therefore Flextex is a good choice for the dark tree trunk.

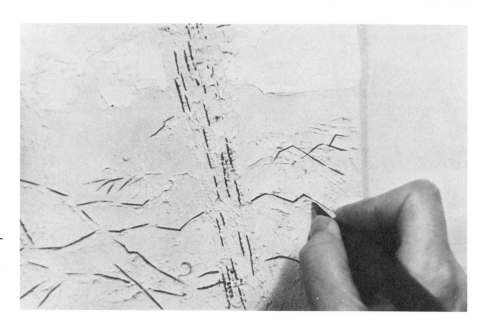

9. Now MacLeod cuts into the plate with a linoleum cutting tool. She cuts into the modeling paste and the Flextex, incising crevices in which the etching ink will stay, thus printing as crisp, dark lines. In this print the incised lines will create dark highlights on the tree trunk, in the branches, and along the shore.

10. Here you see MacLeod smoothing the roughest edges of the polymer medium, Flextex and modeling paste with sandpaper. She uses Garnet sandpaper, which is fine but has a sharp tooth. Here MacLeod tries to preserve the textures while removing the highest points which would rip the cheesecloth during the wiping process and tear the etching paper during printing.

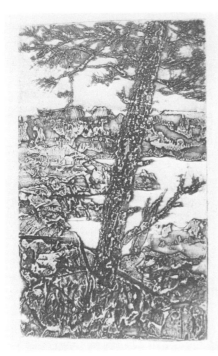

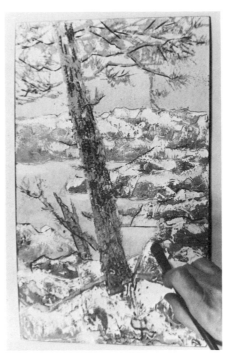

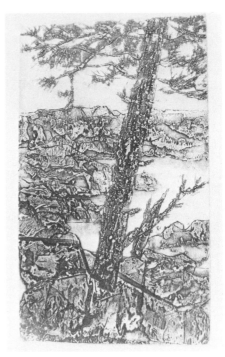

11. Here is the first print, or first proof, of *Shore Sentinel*. Inked in dark brown, the artist felt that this print had too many dark areas. The tree trunk—which was supposed to be the darkest area—did not stand out enough as a dark shape. Also, the foreground rocks lacked definition—their textures were all the same.

12. MacLeod is brushing modeling paste onto some crevices which held too much ink. Before doing this she cleaned the plate with Ronolene (you could also use paint thinner) and washed it with soap and lukewarm water. Ronolene is a very gentle solvent ordinarily used for washing felt etching blankets. Note that the plate must be *thoroughly* dry before adding any acrylic to the surface.

13. Here is the second proof, and this time MacLeod inks the plate with a blue Graphic Chemicals etching ink. The color or change of color in etching inks used in proofing is unimportant. When you proof, use whatever ink is handy. In this print you can see the contrasts that MacLeod wanted. The dark, textured tree trunk now stands out and comes forward with great strength, while the background has been softened.

14. Again, MacLeod decides to change her plate—she incises the edges of the rocks with her V-shaped cutting tool. Some of the lines, particularly those in the foreground, are thicker. They will read as strong, dark lines in her next proof.

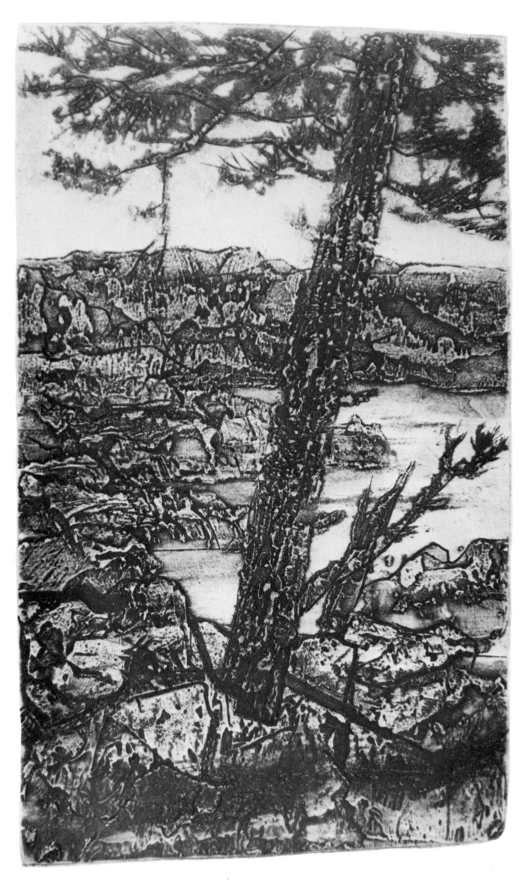

Shore Sentinel by Anne MacRae MacLeod. This last proof reads as the artist intended, with poetry and with a feeling for windswept coastal spaces. Now, as her plate making is finished, MacLeod will begin to experiment with color.

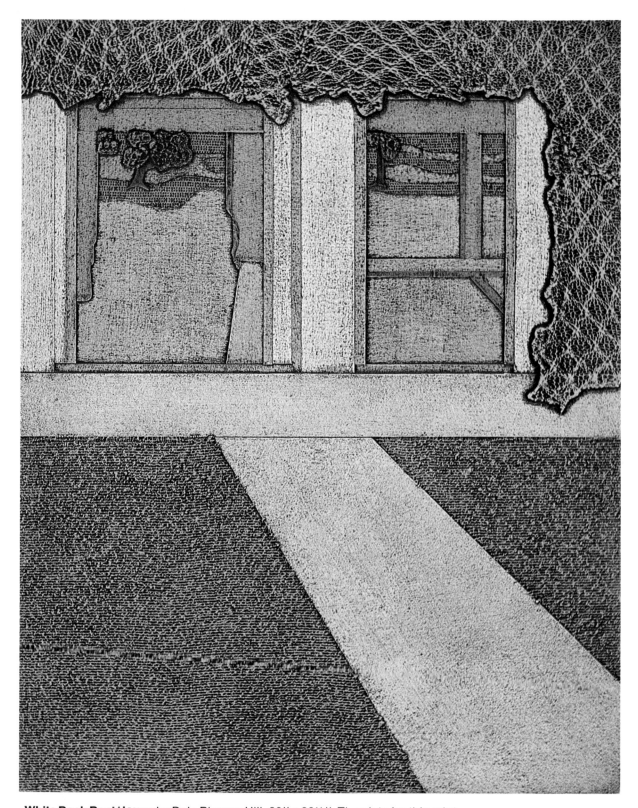

White Rock Boat House by Dale Pierson Hill. 20″ x 22½″. The plate for this print was made with thick, textured fabrics, and the artist prints the plate two times to get her final image. First, she applies oil paint to each area of her plate with a brush, and prints it. Then, after cleaning the plate, she inks the intaglio again in a dark tone and wipes again. The dark intaglio inking is then printed over the first image. The second printing softens the colors from the first printing and intensifies the textures.

Rolling Sails by Donald Stoltenberg. 9¾″ x 14″. This plate was created by the reduction method of collagraph platemaking, which involves covering the organza background on the plate with tape. The artist cuts into the tape, creating shapes in the organza which are filled with varying amounts of polymer medium. The sky area and the light-toned sails are filled with about ten coats of thinned polymer medium, and therefore these intaglio areas wipe fairly clean—they tend to be very light areas in the print. Note the careful blending of the etching inks: some colors remain separate while others melt into each other.

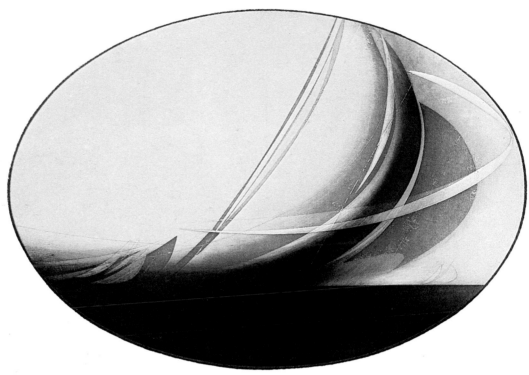

Dreaming Deep by Mary Ann Wenniger. 15″ circle. Disobeying all rules regarding the thinness of materials used to build up the surface of a collagraph plate, I used thick seaweed here. Even though the seaweed had been carefully dried, it expanded again with each application of the polymer medium. Only after a struggle and much use of gel medium to seal loose edges plus extreme pressure to hold the seaweed down and somewhat flat, did this plate become printable. I used green ink for the intaglio. After I wiped the plate, I rolled on two surface colors using a composition roller.

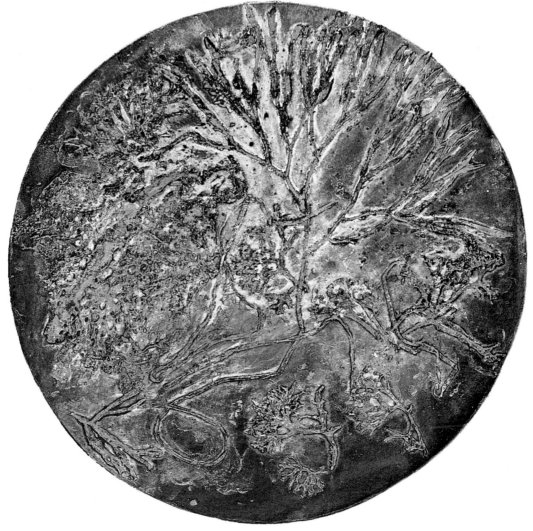

Distilled Fire by Cynthia Knapton. 30″ x 41½″. This powerful collagraph has been printed with one key plate plus other auxiliary plates. All plates, made primarily of leather and wood, were printed over and under each other with orange reds, blacks, and green golds. See Chapter 14 for a detailed description of the making and printing of this plate.

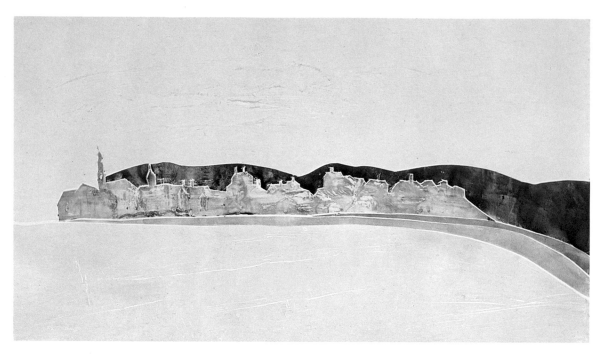

Sweet Morning by Mary Ann Wenniger. 18″ x 31″. This harbor scene was inspired by a method of printing developed in California. I cut up cardboard collagraph plates, inked each piece separately, and then printed them all at once in jigsaw puzzle fashion. The section that depicts my town was built up lightly with gesso—I used a fine brush. This part was inked with a blue etching ink and wiped before printing. The other segments of the plate were rolled with transparent and opaque oil paints.

A Quiet Memory by Ruth Rodman. 23½″ x 17½″. Many of the white areas on this plate were created by the use of Mylar, a foil-coated and gum-backed paper that wipes completely clean. Modeling paste, tapes, papers and organza strips were glued to this Mylar. The intaglio ink is a combination of yellow ochre and raw sienna. Also, a rich mixture of phthalo green and brown etching ink was worked into the bottom area of the plate and then pulled lightly over the golden intaglio during the wiping process before printing.

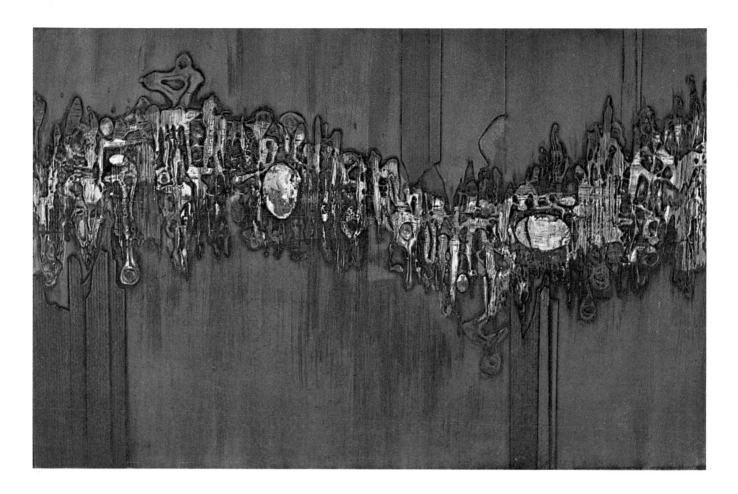

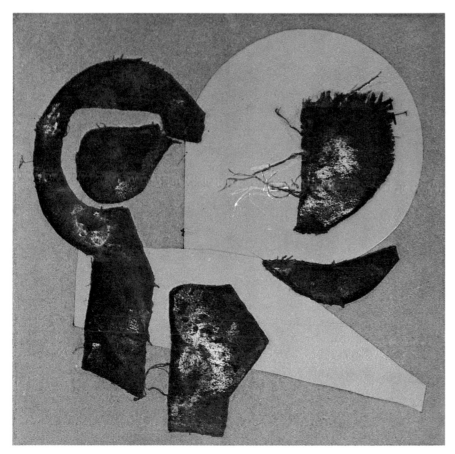

Chromatic Fugue by Dolores Klein. 11½″ x 18″. The middle area of this plate was built up with various acrylic mediums which are later inked in different colors with a palette knife and paper-wiped. The paper in the paper wipe is held over a block of wood so that the paper will touch only the highest surfaces of the built up forms: the inks remain in the crevices of the deeply embossed shapes. The rest of the plate, bands of organza, is then intaglio-inked in blue and red. After the middle area is masked out, various roll ups enrich both horizontal areas.

Composition in Black and Ochre by Mary Ann Pierce. 14″ x 14½″. This image was created with one plate with uncoated Masonite for the background and organza shapes in the foreground. Pierce inked the entire plate with intense black etching ink and then wiped the plate. The background held only a little ink, as it was smooth, while the organza shapes in the foreground, which had received only two coats of the polymer, retained the full intensity black ink. The artist rolled ochre oil paint over the whole plate, and then she printed the image. Note how the black forms absorbed the ochre roll-up.

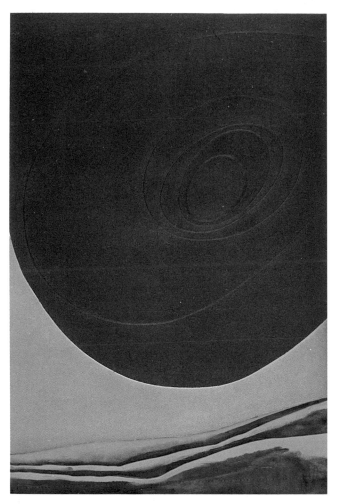

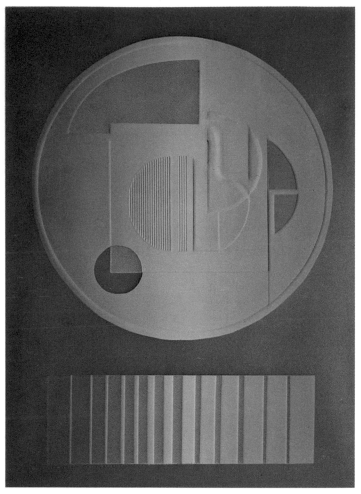

Primal Form by Beatrice Berlin. 18″ x 11½″. This collagraph was printed in two stages. First, the artist rolled ink on three segments of the plate which had been cut out of cardboard. These segments were reassembled like a jigsaw puzzle and printed in a template. The printing paper was then held under the etching press roller while the three segments were replaced by another cardboard plate made of built-up cardboard rings around the edges. When this second plate was printed, the rings created a graduated embossment. If Berlin had simply inked the multi-level plate with red ink, the edges of the cardboard rings would have left white lines on the print.

Spatial Elements by Jan Ehrenworth (© 1972 by Jan Ehrenworth). 20″ x 26″. A surface embossment with color, this print is created from a series of variously shaped plates which are cut from gesso and polymer-coated boards. Some of the plates are multi-level, and this produces the embossment when they are printed. Covered with rolled-on transparent and opaque inks, the plates are printed successively to produce this glowing effect.

Marigold by Elsbeth Deser. 17″ x 24″. Deser cut four different Masonite plates into four shapes. The organza forms on the surfaces are each inked with a different color oil paint or etching ink and printed one over the other in registration on the same piece of paper to produce this striking collagraph.

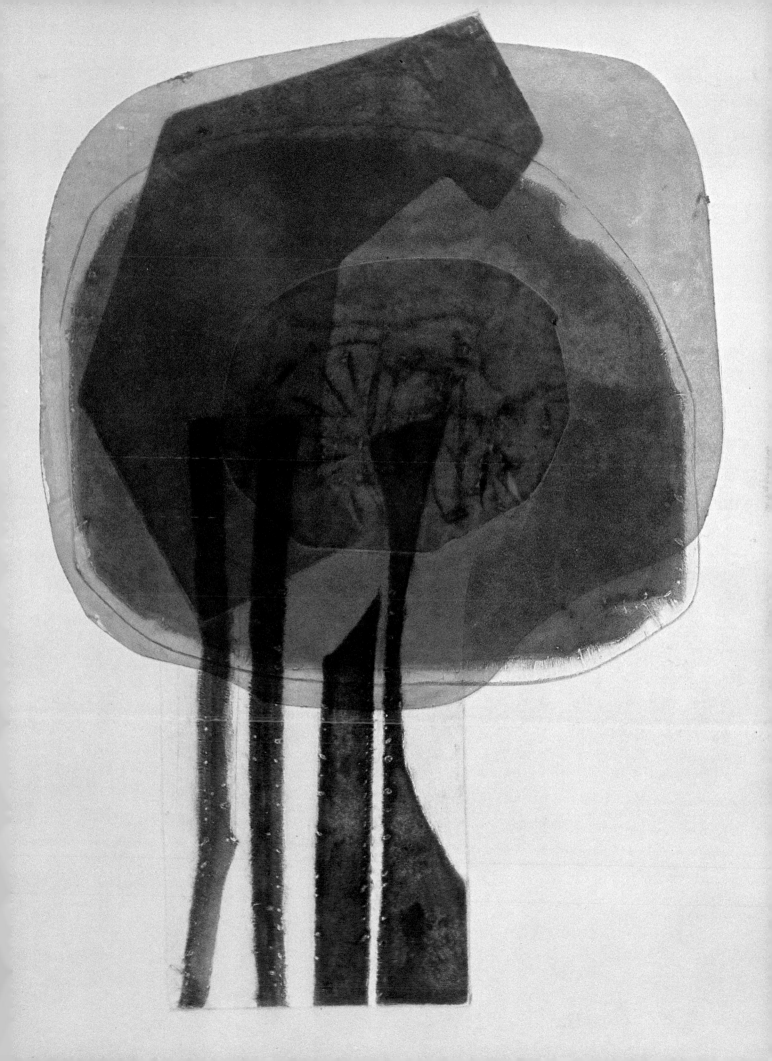

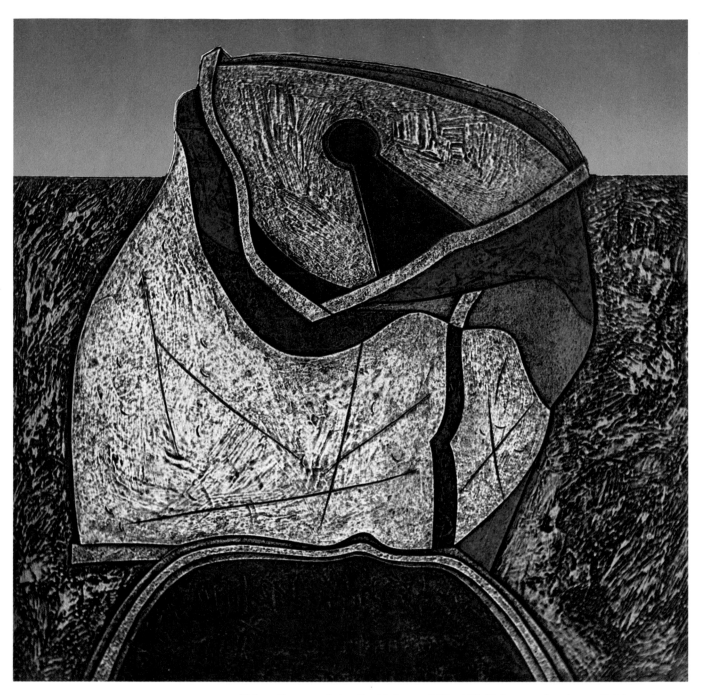

Urban Fragments by Jim McLean. 10″ x 10″. Using an aluminum plate as a base for the central area, McLean used the various acrylic mediums with carborundum and papers to build up the image. After he intaglio-inks and wipes this triangular plate, he rolls color on a carefully shaped lithographic plate which fits around the first plate. Both plates are printed at the same time. The result is an extreme contrast of smooth and rough surfaces.

16.
Building with
Plant Materials

I enjoy using found materials such as dried flowers, vines, seaweed, tree bark, and cobwebs on my collagraph plates. These materials, however, can be difficult to use.

When you try this, keep in mind my basic rule of creating a hair-thin collage. In other words, most of the flowers you will use will have to be put on the plate *petal by petal*. If you overlap—and you should try not to overlap—be sure that each petal is dry. A half-dried petal can dry after it is glued onto the plate only if it is out in the open. If the half-dried petal is covered with another half-dried petal, the petals will never dry, and they will come apart during printing. Also, if you want to use a whole flower and it is thick, like a daffodil or a Chinese lantern, cut the flower in half so it can dry before you glue it to the plate.

I must say that when I have overlapped fleshy petals, they tend to come off after I pull a few prints. This is what happened with the camellia petals on the plate described in this chapter. I dried the petals my usual way—between the pages of a phone book. After three weeks of drying, the petals still seemed fleshy, but I took a gamble and used them. After a few prints, the plate deteriorated, and I added fully dried petals.

In gathering your flowers and leaves, look for textures. Completely avoid fleshy, water-filled plant material such as succulents or cacti. Then decide if you want to arrange your flowers on a dark background like organza or on a light background such as Marlite or Mylar. Either way, there will be a problem of messiness and extra glue. Bear in mind, though, that cleaning up extra glue is more critical when the glue will read as a light smudge on your dark background created by using organza.

If you want a mixture of darks and lights in the background, take a water-filled sponge and go over the areas *not* to be coated with a lot of polymer. Then sponge the polymer over the surface—the medium will be very thin where the water covers the plate. The areas where the water was, then, will print darker as very little polymer will be able to sink into the holes of the organza.

The easiest way to start to work with flower plates with dark backgrounds—as I do in this chapter—is to put two *thin* coats of the polymer medium on a piece of Masonite covered with organza. (Note that the Masonite must be coated twice with polymer medium before the organza is glued on.) When the second coat is partially dry, arrange your thin plant materials on the plate. Then, when the polymer medium dries, put another, *full strength* coat of it over the whole plate with a brush. Use a fine sponge if you want to avoid brushstrokes.

I prefer to glue my plant materials with gel, an acrylic which seems to be tackier than the gloss or matte polymer medium and bonds tighter. I keep the gel I am using on wax paper to avoid getting any excess on my plate. If I am disturbed while working, I drop some water on the gel and cover it with Saran Wrap. The gel stays usable for at least one day.

Sometimes I put wax paper over the plant materials drying on the plate, weight the plate, and put it aside to dry. The wax paper leaves a pattern on the plate. When I want a texture-free background, I use wet sponges to remove all traces of the last coat of wet polymer medium from the background. I dry the areas around the plants with a paper towel, and *then* I cover the plate with wax paper and weight it. The only texture on the background of the plate, then, will be where waxed paper presses into polymer which oozes out from the plants.

One other technique with flowers I want to suggest is to spray the household product PAM on your thicker plants. Then, imprint these plants in a thin coat of modeling paste on your collagraph plate. After the modeling paste sets, remove the plants: you will have a casting of the plant forms. At this point you must sand the plate to remove rough edges and overly deep areas, and coat the surface with thinned-down polymer medium.

In the following demonstration I show you how I made the plate, *Midwinter's Gift*.

1. Here I am drawing a circle on the Masonite with a pencil using the top of a trash container as a guide. I go over the line repeatedly to be sure that it is dark enough and that the line is exact.

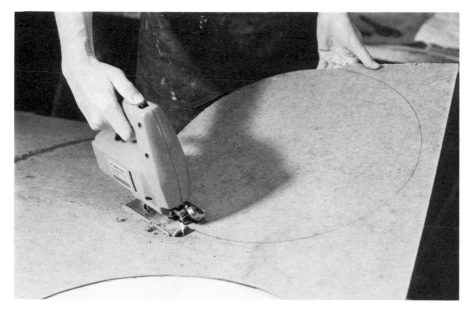

2. I gently guide my saber saw around the circular line. I use a slow speed so that even if I need to shift my plate or my grip, I get an even cut. If you don't have a saw, use a mat knife with a sharp blade, though you may tear some of the backing of the Masonite this way.

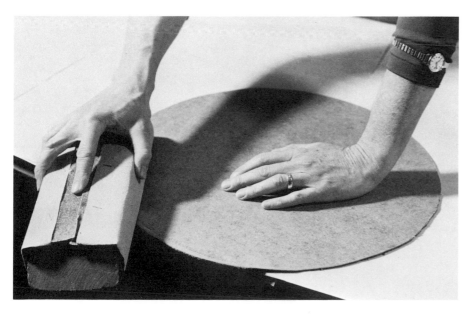

3. I am beveling the plate edges with a block of wood covered with a medium grade of sandpaper before adding the organza. I push the sandpaper across the Masonite at an angle, away from myself. If you wait until the organza is on the plate to do this, the threads of the organza will tend to get ragged from the friction of the sandpaper.

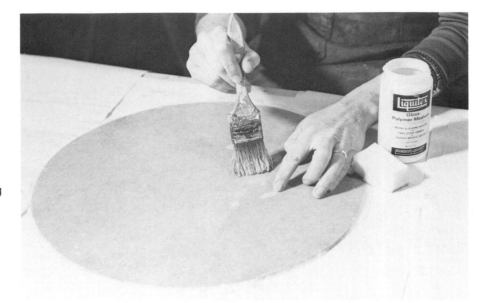

4. In this photograph you see me gluing on the organza which has been cut to size. I have already coated the Masonite with two layers of thinned-down polymer medium. As you glue on the organza, air bubbles may form: squeeze them out with your fingers as you coat the organza with more thinned polymer medium.

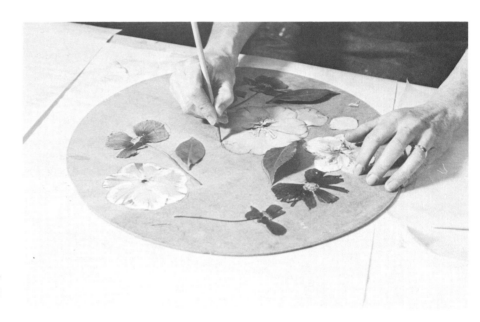

5. After one more coat of the polymer medium has been applied to the organza and after it dries completely, I start to arrange my flowers. I then draw a line around the arrangement, as I am doing in this photograph, so I will know where I had intended to place the plant materials.

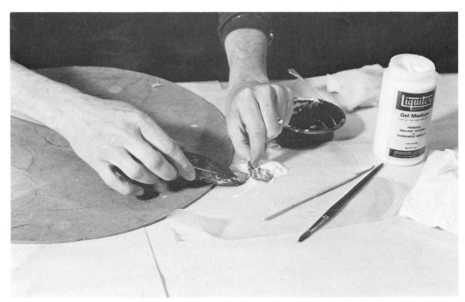

6. Next, I begin gluing on the plants, petal by petal, leaf by leaf, with gel medium. After the leaf is coated both sides, I glue it to my plate. To make sure that the materials adhere, I rub them through wax paper. The waxed paper will not stick to the tacky surface of the glue-covered petal.

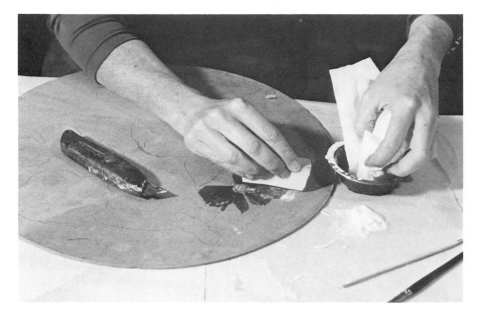

7. Here I rub the glued leaf with a damp sponge to remove extra gel from the edges. The gel would print if I left it on the plate.

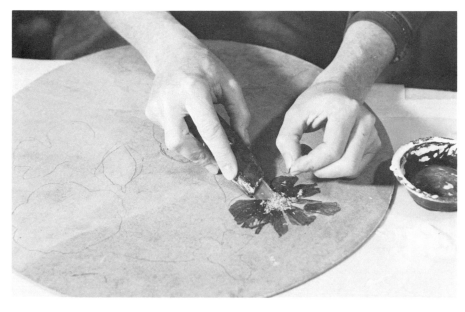

8. As the middle of a flower was too thick to be glued onto the plate whole, I took it apart. In this photograph I am gluing it on, bit by bit. If this center becomes too thick, I will use an electric sander to flatten the area after it has been coated many times with polymer medium and is completely dry.

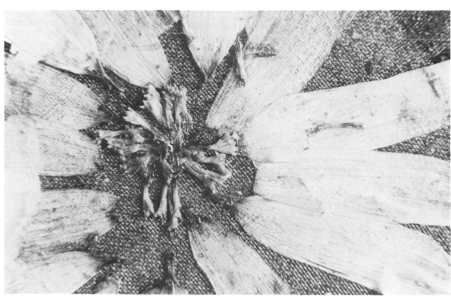

9. Here is a close-up of the center of a plant on another plate. You can see how I take apart the middle and put it back together again so that it reads as a flower in the final print.

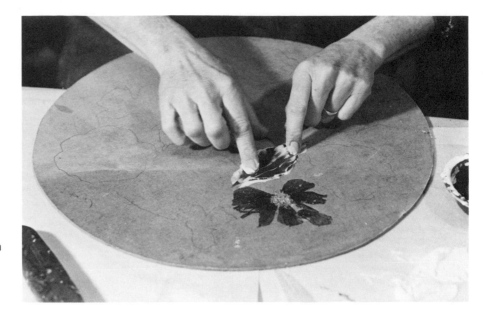

10. Here I am gluing on a particularly stiff camellia leaf. I put lots of the gel on both sides of the leaf; then I hold it down with a weight (the block of wood in the next photograph) while I am gluing the rest of the plant materials.

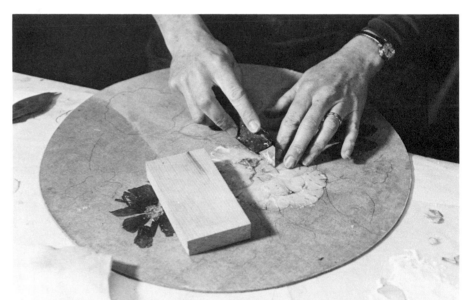

11. In this photograph I am gluing on the separate camellia petals. Although they are only partially dry, I am overlapping the edges. There is a chance that because I am overlapping the petals and the bottoms are still fleshy, the petals will not dry on the plate. (Note that during the printing of this plate several of the petals did come off. It is best to glue petals separately.)

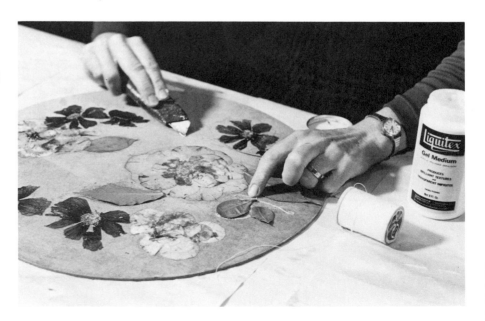

12. As the plate progresses, I add lines by cutting into the plate with a sharp mat knife. Sometimes I add threads and other non-plant materials.
You can see in this photo how the edges of some of the leaves are not staying down. I finally took them off the plate completely: since the gel retained a perfect image of the leaves, they still printed when the plate was inked and wiped. Actually, you can do this with all the plant forms. Coat the plate with full-strength polymer medium, arrange the plant forms *before* the medium dries, cover with waxed paper and weights such as books. When the plate is dry, remove the plants and smooth any extra variations on the plate surface with steel wool and sandpaper. Do not smooth away the plant forms.

13. After the plate seems finished and all excess polymer is removed, I cover it with wax paper and weight the whole thing down with books. After a day or so, I will take a look and decide if the plant materials are sticking to the plate. Then I may put another coat of the gel on the top surface of the plant materials just to be *sure* that they are sealed, unless the petals are so delicate that another coating of gel would obscure their veins.

14. The finished print.

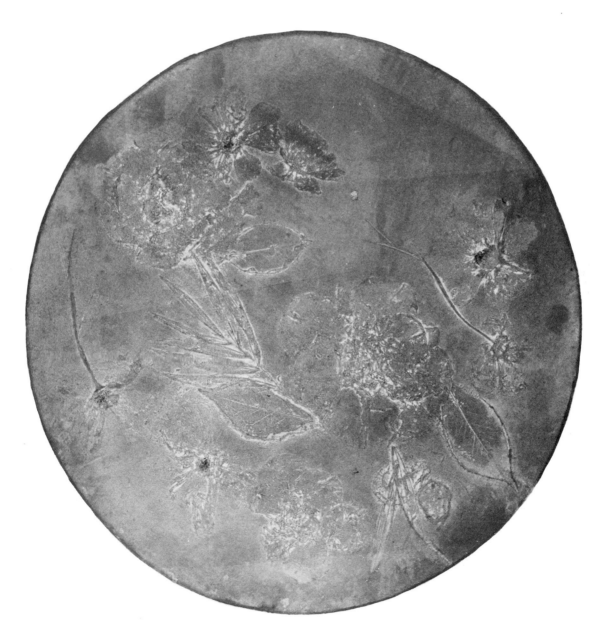

17.
Building with
Thick Materials

You may remember that one of my basic rules for beginning colla-graph printmakers is to use hair-thin material. It is possible, though, to use thicker materials. The easiest way to use thick fabrics, pa-pers, or natural objects successfully is to make sure that the differ-ent materials you use to make your plate are approximately the same thickness or height.

When you feel ready to experiment with different textural mate-rials, you should end up with either a low relief, a medium relief, or a high relief plate. If you have a low relief area such as lace or paper adjoining a high relief area of, for example, corrugated cardboard, you will have to use extreme pressure on the press to pick up the ink in the lower areas when you print. This heavy pressure will cause the ink on the corrugated cardboard to be pushed out of its area in a runny smear. Or if you loosen your press pressure to pick up the ink on the high relief areas properly, you probably will not be able to pick up fully the ink on the lower areas.

In this chapter, Dale Pierson Hill builds one of her typical colla-graph plates. I have always been impressed with her simple, yet ef-fective compositions which are made up of fabrics, laces, and pa-pers. Her approach to building plates consists of keeping materials of similar thicknesses next to each other.

Hill stresses the sealing of the fabrics. She soaks her materials, such as burlap or other roughly woven cottons, in a solution of the matte polymer medium thinned with water before she starts to glue the pieces to her plate. This process was a revelation to me: when I used to use any coarse fabric like cheesecloth on my plate, I first glued the fabric onto the plate and then brushed on many, many coats of polymer medium to seal the material. Hill's soaking step saves time and energy indeed.

This is a process which must be done with some sensitivity, so that each material used keeps its textural qualities. For the roughest materials, Hill recommends that you coat the fabric or carborun-dum or corrugated cardboard or whatever with brushing lacquer. Brushing lacquer provides the thickest, most impermeable cov-

erage. If you use it, be sure you have good ventilation—the fumes are powerful!

Note when you use papers or modeling paste on the same plate with rough fabric—as Hill does on her plate in this chapter—that the finer materials require less sealing. *Don't* coat paper or modeling paste with brushing lacquer. After the plate is made, you can go over everything with a final coat of gloss polymer medium, thinned or full strength, according to the ink-holding capacities you want.

Be sure to notice and work with the transition space, the area between different pieces of fabric, papers, and other materials. Be careful to seal up any gaps which exist with modeling paste or gel or a piece of *thin* material, or create your plate so that there are no gaps, no transition spaces.

In the following demonstration notice how careful Dale Hill is to make sure that no ink-holding gaps exist on her finished plate. She overlaps the edges of the different materials slightly.

1. Hill starts by lacquering both sides of her mat board plate twice, to seal the mat board. Lacquering both sides will prevent buckling and will enable Hill to clean off any ink smears from the back side of the plate. You could use gloss polymer medium, though, instead of the brushing lacquer. Hill cut the circular shape with a circular mat cutter. Please note that you can also build a collagraph plate with materials of varying thicknesses on Masonite.

2. After outlining in pencil the general areas of the design which will gradually be covered with the different materials, Hill begins building the plate by spreading Elmer's glue thickly in the area designated for trees. Note the photograph on which she based her design.

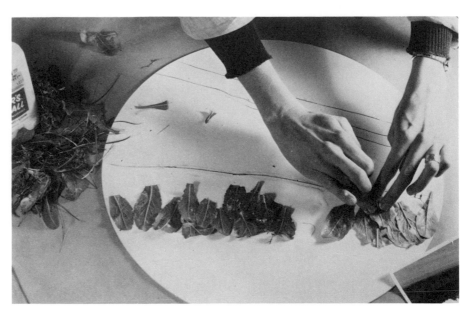

3. The artist lays her leaves down on the wet Elmer's glue. She did not dry the leaves first—they were freshly picked when she used them. Hill does not put the leaves down one by one, but rather she arranges them in a mass by overlapping their edges. Later, she will cover the leaves *completely* with brushing lacquer, and then she will scrape off any sharp, unnecessarily high parts. Finally, she will seal the scraped parts again. Thus, the leaves will not absorb too much ink when Hill prints this plate, but will read as an effective dark mass in her print.

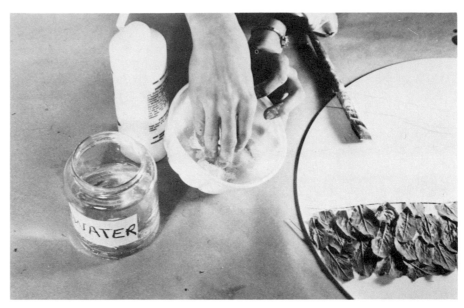

4. After cutting out a hillside shape from a piece of fabric, Hill soaks the fabric in a solution of thinned-down polymer medium in a plastic container. She cuts her various shapes from material exactly by first cutting out the shapes on her drawing on tracing paper. She uses these shapes like sewing patterns and pins the tracing paper shapes to the thick fabrics before cutting the fabrics with scissors.

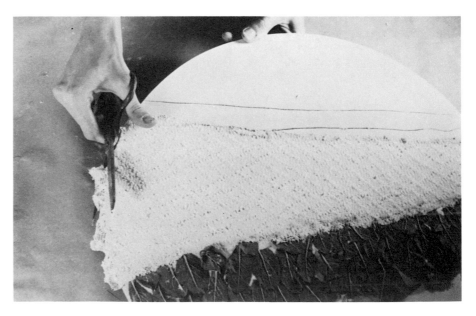

5. In this photograph you see Hill cutting off excess fabric—some fabrics stretch after being soaked in polymer medium—when she glues the fabric to the mat board. Notice how carefully the fabric edge fits against the leaves so that there is no transitional gap between the two materials where ink can gather and smear when the plate is printed.

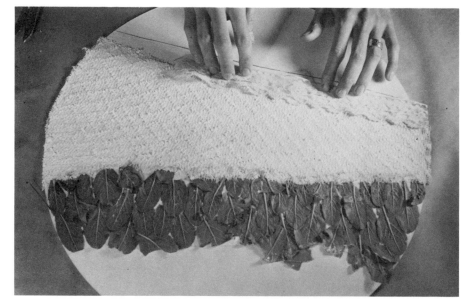

6. Here Hill glues a strip of lace onto the plate. The lace has already been cut and trimmed to the shape of the plate and soaked in a solution of polymer and water. Then it was dipped in full strength polymer medium which permeates the lace, bonds it to the plate, and unites the lace with the fabric above it on the plate. Notice again how the top edge of the lace and the bottom edge of the fabric overlap slightly.

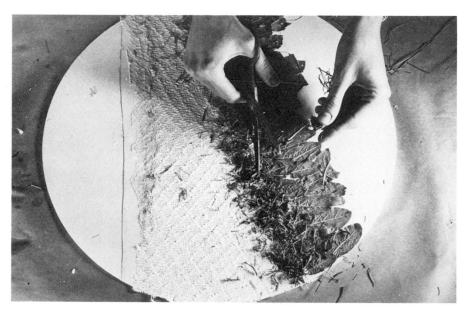

7. Hill cuts shreds of grass onto the plate where a line of full strength polymer medium has been brushed on. Some of the grass sticks, and Hill then applies a *thick* coat of brushing lacquer to this grass-covered area so that the grass will not hold too much ink when the plate is printed.

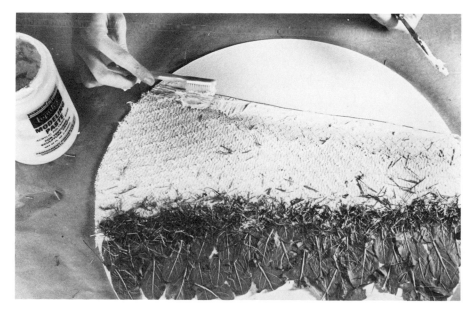

8. Hill uses modeling paste put on the plate with a toothbrush and palette knife to create a grass texture which will print in a medium tone. She uses the modeling paste for this effect rather than real grass because the modeling paste will wipe cleaner than the natural grasses, which are highly ink absorbent even after being submerged in polymer medium or brushing lacquer. The light tone of the modeling paste will bring this area into the foreground.

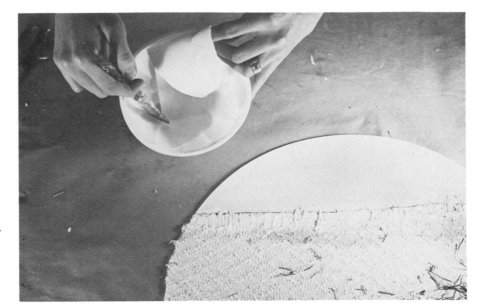

9. Hill soaks a piece of copperplate paper in the polymer medium and water solution in the plastic container: the paper has already been cut into the proper shape. Copperplate paper is a porous printing paper, thicker than construction paper, but with the same surface texture as construction paper.

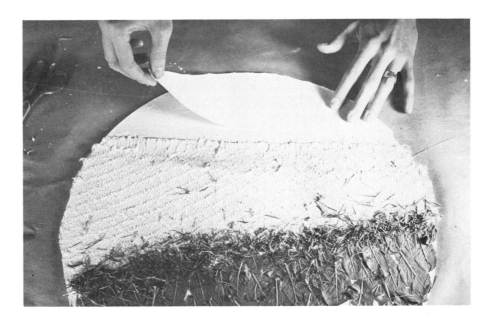

10. Hill lays the damp copperplate paper on the plate. After smoothing out the bubbles and wrinkles, she will brush on a dilute solution of polymer medium and water so that none of her fingerprints will show. The texture of the copperplate paper will still be evident in the print of the plate.

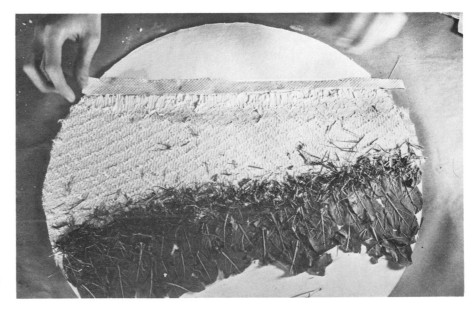

11. In this photograph you see Hill covering the small area of mat board between the copperplate paper and the modeling paste with a narrow strip of paper toweling. The paper toweling was glued on by first brushing full strength polymer medium onto the narrow area, laying on the strip, and covering the area with weights such as books while the plate dried. Later, Hill will brush more polymer medium on top of the paper toweling.

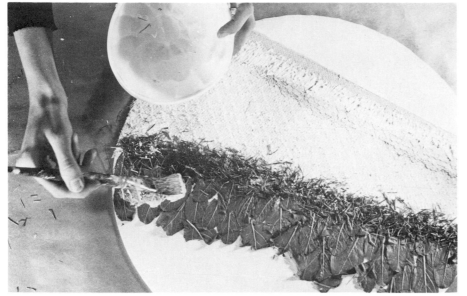

12. Here you see Hill brushing polymer medium onto the leaves. At the end of the plate building process, Hill seals the plate with several coats of the full strength polymer medium until the textures are coated but not obliterated. The sky area, made of plain mat board, will also be lightly sealed with polymer medium. Note that the tops of the leaves are so thin that there is a sliding progression from the fine leaves to the mat board sky surface.

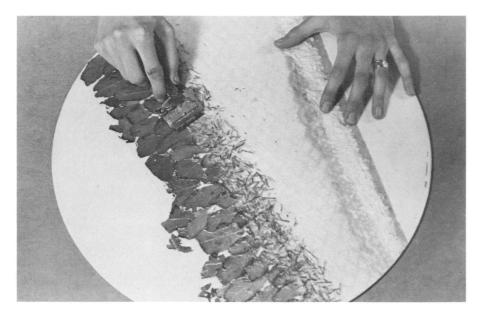

13. Hill trims the rough points of the dried materials on the plate with a razor blade scraper, the type used for scraping glass.

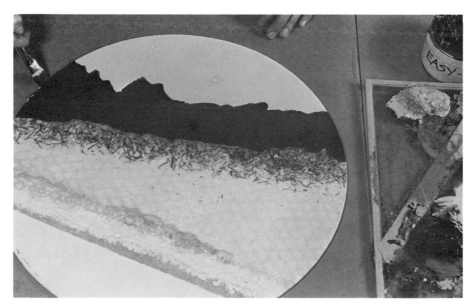

14. The artist now applies brushing lacquer to the leaf area of the plate to create a more even plate surface which will not hurt her hand or rip the cheesecloth during wiping. She will eventually cover the whole plate with thinned polymer medium, which will also prevent the printing paper from tearing or sticking during printing.

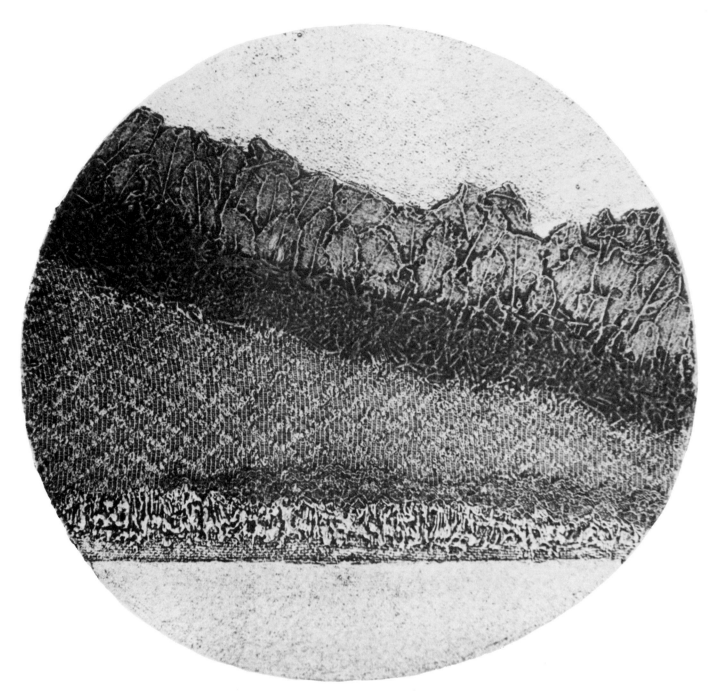

15. Here you see Hill's final print of this collagraph plate.

18.
Building with Silicon Carbide Grit and Textured Paper

In this approach to making collagraph plates, Jim McLean of Atlanta, Georgia—originally a lithographer—assembles a collage of papers and textures. The design weaves back and forth between different textures and forms, sizes and shapes, and lines. Note that there is no overlapping of thicker materials as this would cause his image to print unevenly. I find McLean's use of stencils and roll-up masks very exciting.

McLean begins cutting shapes of papers and cardboard, making straight or beveled edges with a mat knife or a pair of scissors. These shapes are then assembled on his plate where they are glued side by side. The places where the papers or cardboard meet on the plate create lines which hold ink. Be careful how you bevel your cardboard edges. Remember that the deeper the bevel, the more ink it will hold which you will have to remove in order to have a neat print.

A certain pattern will emerge as you study the step-by-step demonstration that follows. First, McLean creates his basic composition with the paper shapes. Then, he adds textured papers to certain areas to provide surface contrast. To increase these contrasts, McLean adds silicon carbide grit to wet areas of the polymer medium. The silicon carbide powder comes in four different grades of fineness, which you could use to make four varying dark tones. Emery powder, a similar substance, makes a richer black, but is much rougher and is harder to wipe. Emery powder will tear your cheesecloth and your hand.

McLean treats other areas in the composition with thick applications of modeling paste to introduce more texture. Then he seals the plate with several coats of gloss polymer medium. This prevents the damp printing paper from sticking to the plate and it also helps you control the amount of ink left on your plate after inking. When you do this, certain areas of your plate can have fewer coats of gloss polymer medium so they will hold more ink.

In the following demonstration, watch Jim McLean make his plate of textures and paper.

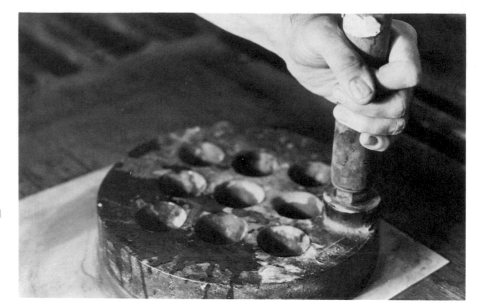

1. McLean grains, or scratches, the surface of a smooth aluminum plate—which will be the base of his collagraph—with a lithography levigator and a mixture of water and silicon carbide grit (# 120). You could use sandpaper to achieve the same effect. The roughness thus created gives the plate enough tooth to hold the collage shapes that will be glued on.

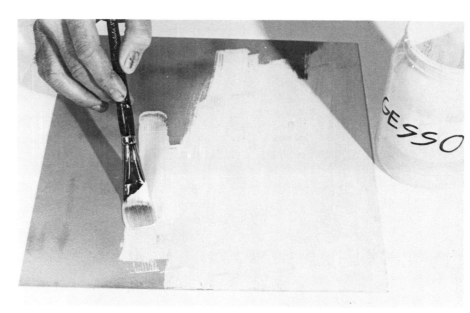

2. In this photograph you see McLean brushing a coat of gesso onto the grained plate in order to provide a clean, light surface on which to trace his drawing.

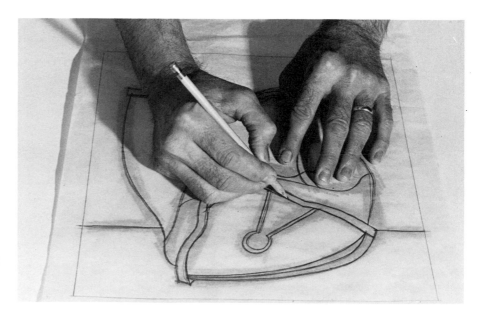

3. McLean places his reversed drawing on the surface of the plate and traces the lines to transfer the image onto the plate.

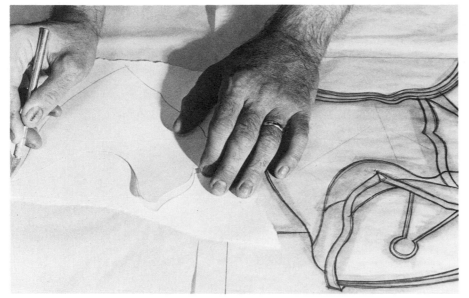

4. McLean uses his drawing as a guide for cutting basic shapes from thick paper—as he is doing here—with an X-acto knife. The paper shown here is German Copper Plate paper, a printing paper which has a soft surface.

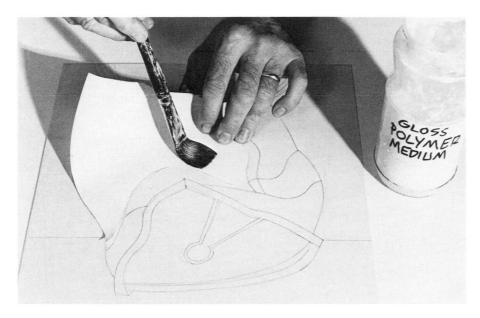

5. Here you see McLean coating the large paper shape with gloss polymer medium. He will then press the shape onto his plate with his fingers to eliminate air bubbles and to make sure the shape is completely glued on. Finally, McLean will varnish the shape with a thin coat of gloss polymer medium. He repeats this process with every paper shape. Note the pencil lines of the design which were transferred onto the plate.

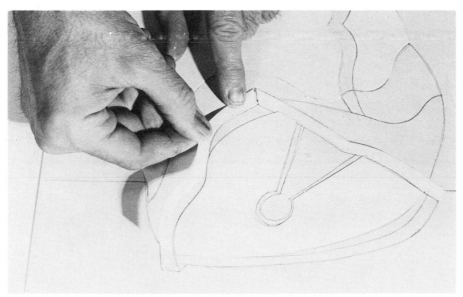

6. McLean places a small shape cut from Bristol board, which is smooth, onto the plate. Notice the slightly beveled edges of the Bristol board. He will follow the process described in Step 5.

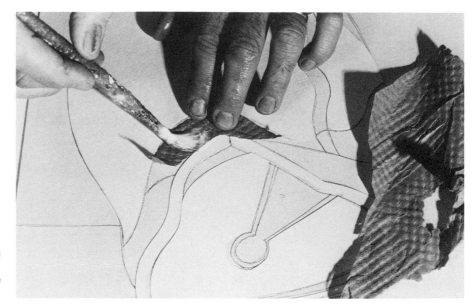

7. After the basic composition is established with thick paper shapes, McLean glues on textured papers to certain areas to provide surface contrast, as he does in this photograph.

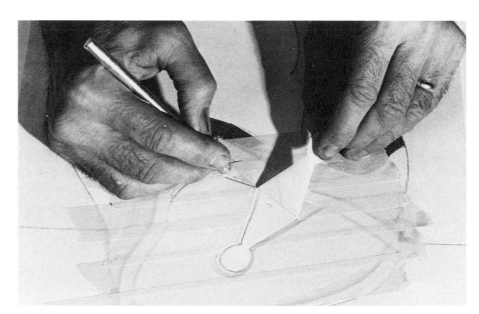

8. McLean cuts a shape out of masking tape which has been placed on the plate. He pulls off the cut-out form to create a stencil.

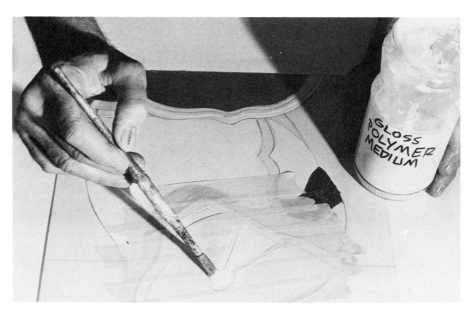

9. In this photograph you see McLean applying a coat of polymer medium to the tape stencil.

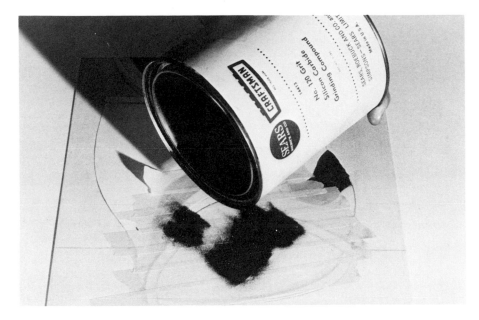

10. McLean pours silicon carbide grit onto the wet areas of the polymer medium in the stencil. Excess grit is shaken from the plate.

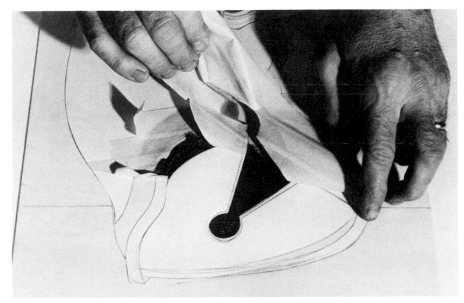

11. After the grit dries, McLean pulls off the tape stencil. You can see the clean-edged textured shape of grit. This is a rough area which will hold much ink and print in a dark tone.

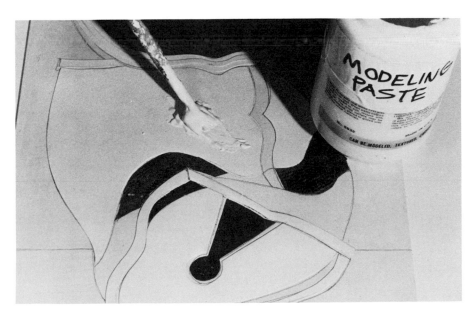

12. Here you see McLean brushing on modeling paste to provide additional texture. Remember that modeling paste contains marble dust and will hold more ink than gesso would hold, so that areas with the paste will print darker than areas with gesso. Not pictured is McLean cutting into the plate with a knife and creating incised, ink-holding lines.

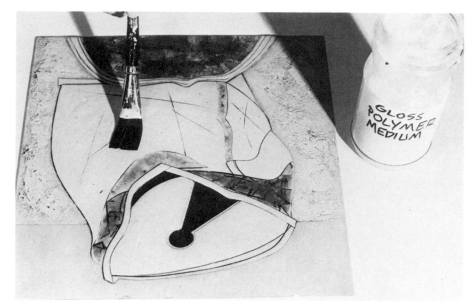

13. McLean brushes gloss polymer medium onto his completed plate to seal all of the plate's surfaces. He does this several times, but is careful not to drown the textures on the plate. Note that some artists who work in this collage-like style seal their roughest textures with brushing lacquer.

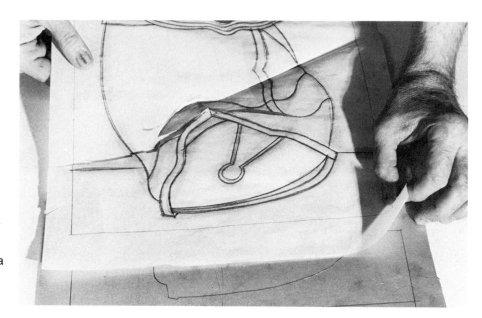

14. McLean uses his drawing to trace a shape to an offset litho plate to make a special relief printing mask. He will use this mask to print a flat color by rolling a color onto the smooth surface. Note that the offset litho plate is made of a thin metal.

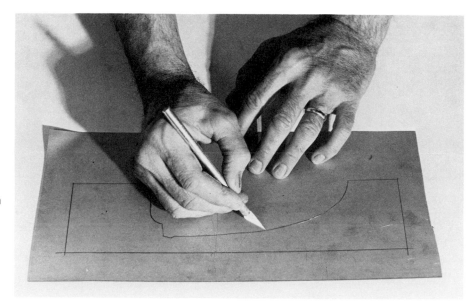

15. McLean cuts the printing mask from the offset litho plates with an X-acto knife. When you do this, you could make a mask by cutting up mat board coated on both sides with many layers of gesso and polymer medium. You do not have to use offset litho plates for this process.

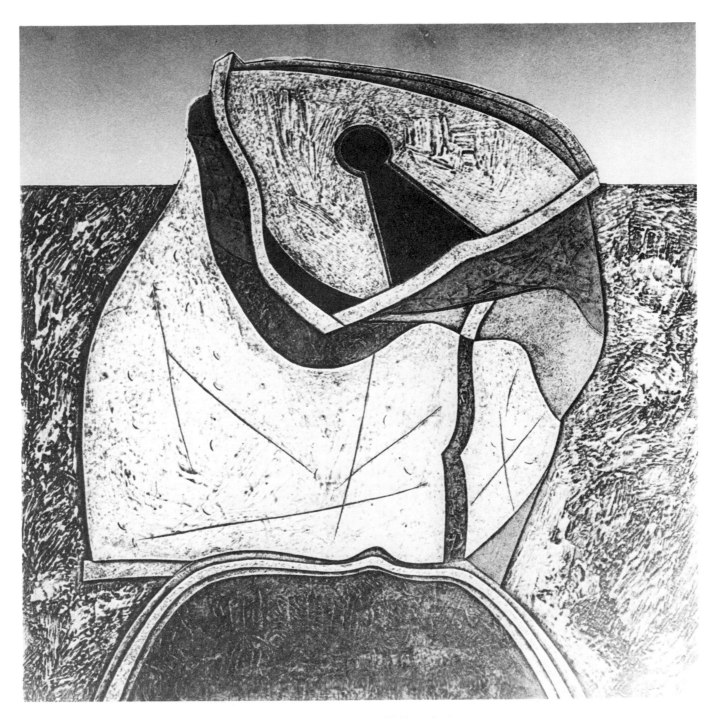

16. Here you see the final print of McLean's plate, *Urban Fragment III*. Note the top area of flat color which was printed with the mask described in Steps 14 and 15. The smoothness of the mask roll-up works well with the even shows off the rough textures of the rest of this print.

19.
Building with Stencils, Tapes, and Acrylics

This chapter is made up of demonstrations by four different print-makers who describe special plate-building techniques. We look first at the innovative techniques of Donald Stoltenberg, whose ideas in both the additive and subtractive uses of the acrylic mediums have set many a collagraph printmaker, including myself, on his or her way.

Stoltenberg was the first artist I know of who used silk organza as an ink-holding material in the background of his plate. As he worked with the organza, he added layers of polymer medium to vary the amount of ink that would be held in the pores. As we have discussed elsewhere, the more polymer medium you brush on the organza, the less ink the material will hold and the lighter that area will print. This is an *additive* technique.

Stoltenberg varies this approach by his very original and extensive use of stencils, such as masking tape stencils, in collagraphs. This is a *subtractive* method and is used, for instance, in *Sail Tondo* (see Chapter 1). In that print many areas appear to have been cut out of something because their edges are so crisp—yet they do not appear to be cut from paper.

Stoltenberg works in this way—he glues organza to his plate, and then, when the surface has dried, he covers it with wide overlapping strips of masking tape. Using a mat knife, he cuts shapes in the tape and removes some sections while he simultaneously covers the plate with coats of thinned polymer medium. By the time Stoltenberg removes all of the tape, the areas first uncovered may be covered with ten coats of polymer. The last of the taped areas to be removed might only hold the original two coats of polymer with which he had glued the organza to the plate. These last areas will print darkest. Sometimes Stoltenberg leaves some bits of the tape on the plate. This adds another texture and strongly defined lines to his print.

I did not include photographs of Stoltenberg building a plate in this way, but felt that a description of his subtractive method should be included in this book.

In Stoltenberg's demonstration, you also see him make a modeling paste casting of a coin. And finally, you will see how he uses a brush to distribute a fine spray of ink-holding particles of modeling paste onto areas of his plates.

Grace White, the second printmaker to show you special techniques in this chapter, will demonstrate further the use of stencils which are made by cutting shapes within wide strips of masking tape. She fills in the cut-out shapes in the tape with from one to ten coats of a half-and-half mixture of polymer medium and water, according to the ink-holding capacities desired.

White also glues papers and tapes of various textures onto her plate to create a wide range of tones. The important quality to be aware of is surface texture—all tapes and papers hold different amounts of ink. In this chapter, White uses smooth, shiny tapes which wipe clean, and plumber's tape which wipes almost clean for her pale shapes.

The third printmaker to give a demonstration here is Ruth Rodman, whose dark shapes play rhythmically on large, light background spaces made of Mylar, an architectural drafting material which is smooth foil with silver or gold on the surface and adhesive on the underside.

In Rodman's prints, the cold white areas created by the Mylar bring out the dark natural tree and root forms that she creates with torn organza strips and various acrylic products. She stipples and dabs the acrylics onto the Mylar and organza in fantastic detail. She recommends Flextex for your darkest areas—Flextex is gritty and contains the most marble dust of all the acrylic products. Aquatec prints the lightest of the acrylics, with Liquitex and Hyplar falling in between.

In case you cannot find Mylar, remember that you can use tin foil glued to the plate with polymer. However, the surface pattern of the tin foil will usually change slightly with each print. This does not happen with Mylar. *Tempered* Masonite (not untempered) coated with several thinned, sponged-on coats of polymer will also work as a light background. However, the coated Masonite seems to hold a film of ink; Mylar produces a dead white area.

The last technique discussed in this chapter is demonstrated by Eda Cascieri, who incises lines and areas into her plates. Here, she cuts flowing lines in her foil-covered plate to create a linear but richly toned image. You will find that Cascieri's favorite knife for this purpose, the NT cutter, Japanese pattern #405718, cuts through foil or Mylar easily. The Masonite areas revealed print in a dark tone, while the foil prints in a light tone.

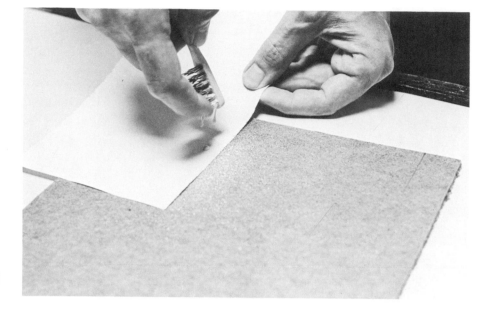

1. Stoltenberg stipples thinned modeling paste on the surface of a plate by running his finger along a toothbrush that was dipped in the paste. Notice that he has blocked part of the plate off with a piece of paper.

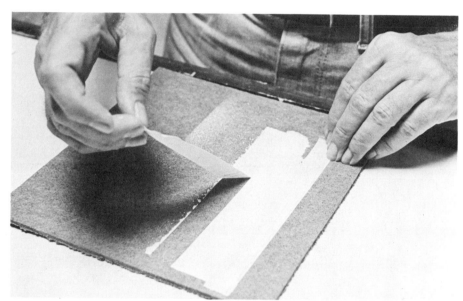

2. In this photograph you see Stoltenberg lifting one of several strips of masking tape which have been coated with modeling paste. Notice the crispness of the line of modeling paste left on the plate.

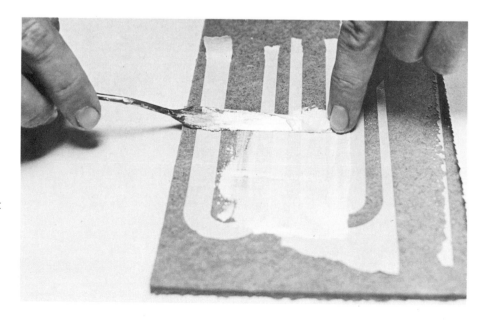

3. After cutting shapes into an area that had been covered with masking tape and lifting off the excess tape, Stoltenberg scrapes a thin skin of modeling paste over all of the tape, including the open areas. He creates the precise forms seen in his collagraphs by peeling off the tape when the paste is dry.

4. This is the sort of architectonic form that remains when Stoltenberg removes the tape.

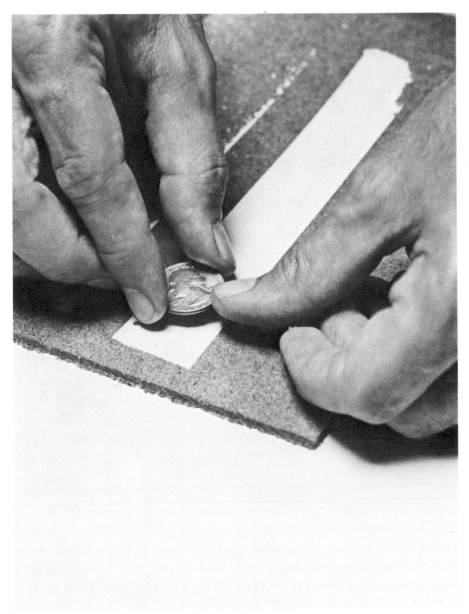

5. Here Stoltenberg places a coin coated with colorless wax shoe polish on a piece of typing paper that is lying on the plate's surface. The paper has been thinly coated with very wet modeling paste. When the modeling paste is dry, he will lift off the coin. This process produces a negative image of the coin on the modeling paste—the coin itself would be too thick to use on a collagraph. Another way to use this casting technique would be to coat any hollow shape such as a piece of jewelry with colorless shoe polish and then fill the form with a layer of the modeling paste. The cast can be easily removed when the paste is dry, and the form can be added to your plate.

6. In the plate you see here, Stoltenberg has used many coin castings—you can see the image formed delicately on the paper's surface. Note that he either incorporates the typing paper background into the design or simply cuts out the mold of the coin.

1. Grace White's half-made collagraph plate uses masking tape stencils in another way. These stenciled forms are to be gradually filled with thin coats of polymer medium. White makes the cut-out figures on masking tape by tracing the outlines of the paper figures you see lying on paper in front of the plate onto the tape. She then cuts the shapes out with an X-acto knife. The paper figures in the foreground, of both rough and smooth papers, are glued onto the plate at some later point.

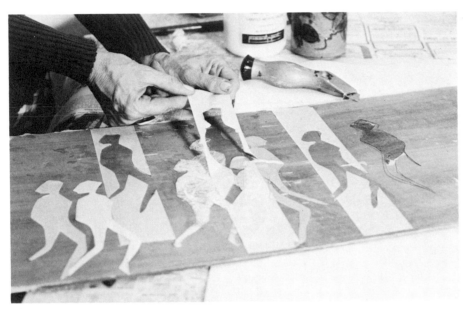

2. White glues on a strip of tape with a cut-out figure over other figures already glued to the surface of the plate. This negative shape will be used as a stencil. The tape outline will be pulled off later after a number of coats of polymer medium have been brushed on and have dried.

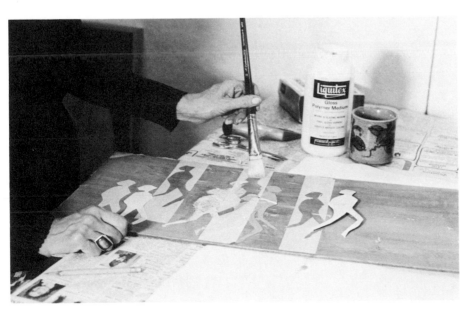

3. Here White coats the form within the tape and edges of the tape itself with a coat of thinned polymer medium. This process will be repeated on each of the stencils from one to ten times, depending on the effect desired. Shadowy forms will result from few coats of polymer medium, while brilliant, sharp figures will result from many coats. Note that each coat of polymer medium is allowed to dry for at least half an hour before the next coat is added.

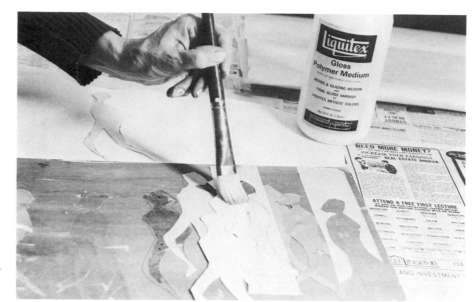

4. White creates other forms by cutting into the organza background, lifting the organza, revealing the Masonite, and then coating the Masonite with polymer medium to get a hard surfaced but slightly textured figure.

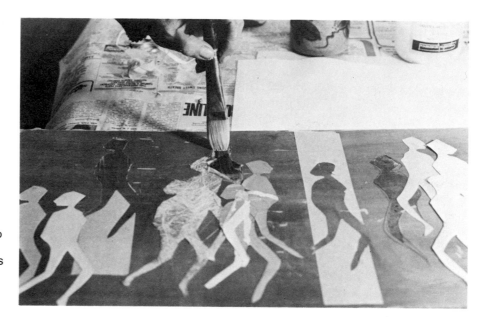

5. White brushes polymer medium onto the middle figure. The stencil—which used to be where the brush is now—has been removed because it was coated enough (three times) for the dim figure that the artist wanted.

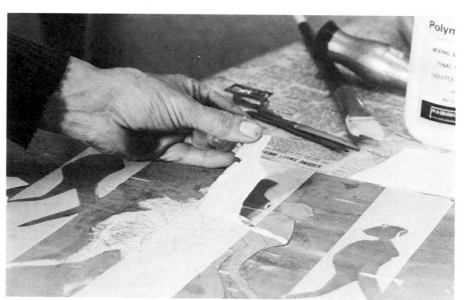

6. In this photograph you see White pulling off a form cut out of the tape in order to create another stencil which she will coat with polymer medium ten times so that the resulting figure will print brilliantly white.

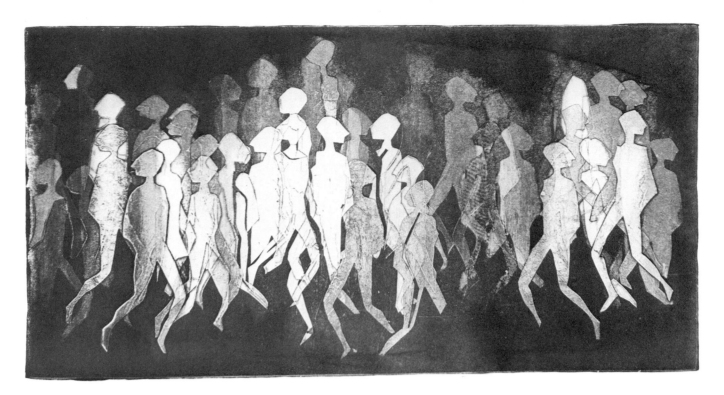

No Prince and No Leviathan. He is Made of Infinite Farewells. The final print shows how many variations of tones you can get by using stencils.

Mylars and Acrylics

1. In this photograph you see Ruth Rodman removing the paper backing from the adhesive underside of the Mylar, which has been cut to size, as she glues it to her plate. By taking the paper backing off this way, she avoids having the Mylar stick to her arm and to the side of the table. When you do this, you should put the plate covered with Mylar through your etching press before proceeding any further. And if any Mylar overlaps the edge of the plate, turn your plate upside down and cut the excess off with a mat knife.

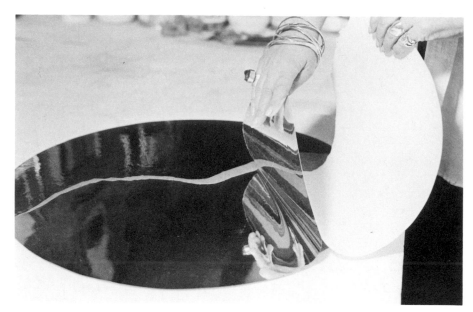

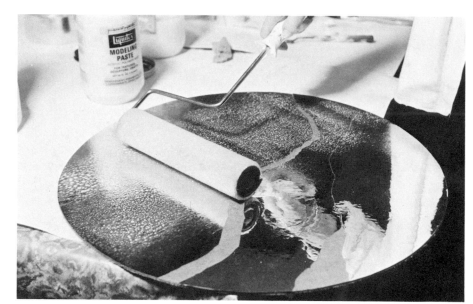

2. Rodman adds an ink-holding texture to her Mylar-coated plate with an ordinary paint roller coated with a fine film of polymer medium. You could also use a coarse sponge in place of the paint roller and/or modeling paste instead of the polymer medium.

3. Here you see Rodman working on a different plate, which also has a Mylar surface. She adds a wet strip of silk organza to the surface with the polymer medium. The soaked organza produces natural forms such as trees—organza is floppy and malleable when wet.

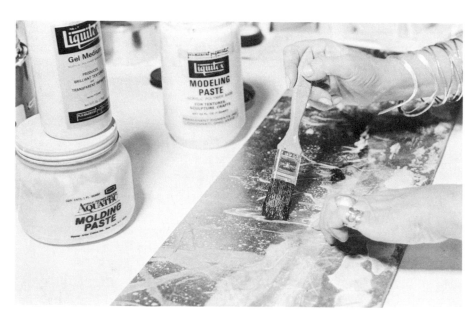

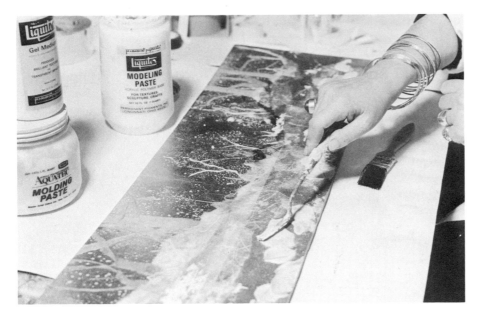

4. Rodman sculpts rock forms out of Aquatec modeling paste with a pointed palette knife.

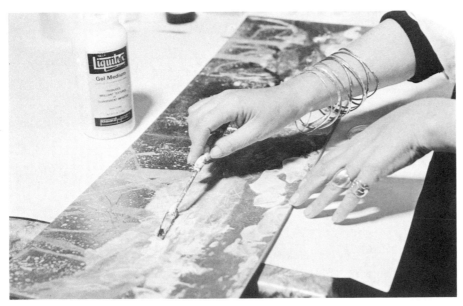

5. In this photograph you see Rodman creating light forms on the dark organza forest floor with gel medium, which has a shine surface when it dries. She starts to build her plate with a light Mylar background which will hardly hold any ink; she proceeds to make dark and medium tonal areas with organza and tissue papers, and ends with creating foreground reflections that will print light highlights. This play of light and dark areas is what collagraph printmaking is all about.

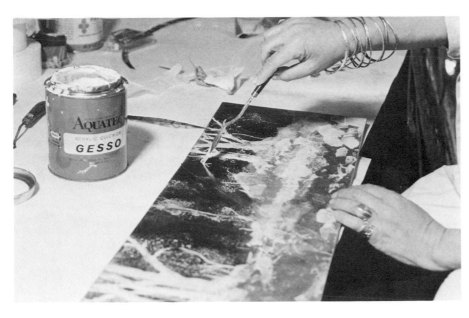

6. Rodman builds up delicate tree branches with acrylic gesso.

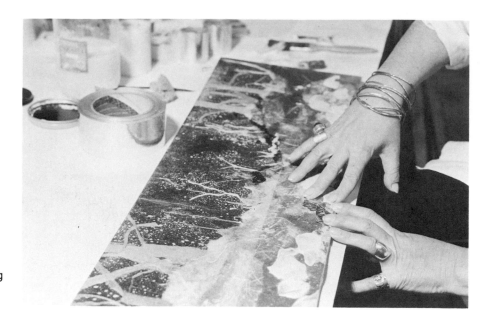

7. Here you see Rodman placing freezer tape over some of the rock forms previously formed with modeling paste. For the tape to stick, the modeling paste has to be completely dry.

Tin Foil

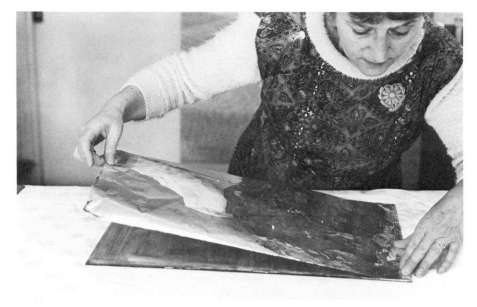

1. Eda Cascieri, demonstrating another method of working with a light background, glues heavy duty tin foil to her Masonite plate. She has already sandpapered the plate so that the foil will stick firmly. Then she coated the dull side of the tin foil and the plate surface with polymer medium. As she lays the foil on the plate, she smoothes the wrinkles that form.

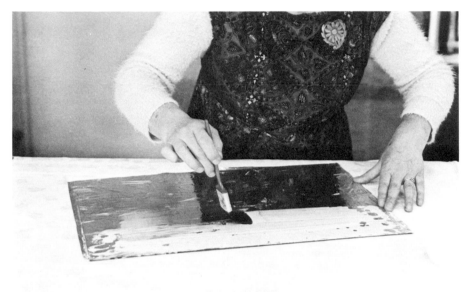

2. Now Cascieri covers the shiny side of the foil with thinned Elmer's glue—you could use polymer medium. This layer of glue will not affect your final image, but is a necessary step to make sure the tin foil will stick.

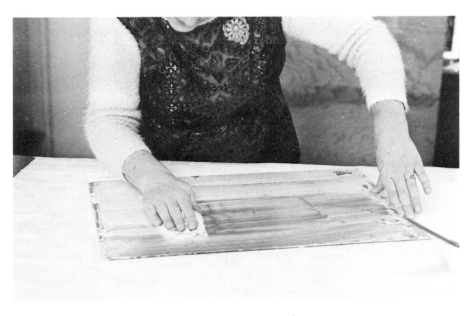

3. After the glue begins to dry, about 10 minutes after it is brushed on, Cascieri takes a cloth and wipes off the glue, leaving only a thin film on her plate's surface. When you do this, wipe your plate until the tin foil is dull and smooth. After the plate is completely dry, put waxed paper over the surface (to protect your etching blankets) and put the plate through the press, using only the pusher blanket. Or, you could keep your plate under weights overnight rather than putting it through the press.

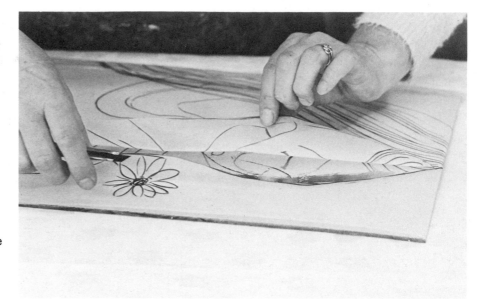

4. Using a tracing paper drawing turned upside down and taped to the edges of her plate, Cascieri cuts fine lines by cutting through the paper and the foil. She first cuts on one side of the line and then the other, making both thick and thin lines. She uses a fresh blade on her knife, an NT Cutter 405718.

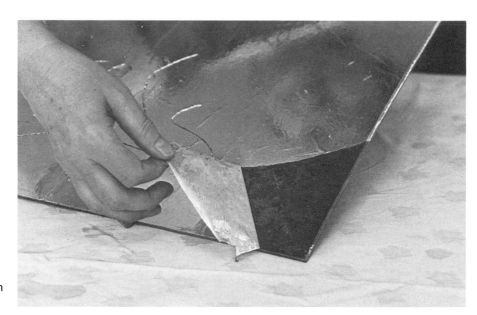

5. Cascieri lifts the foil from her plate, revealing a residue of glue which makes an interesting dark texture when the plate is inked and printed.

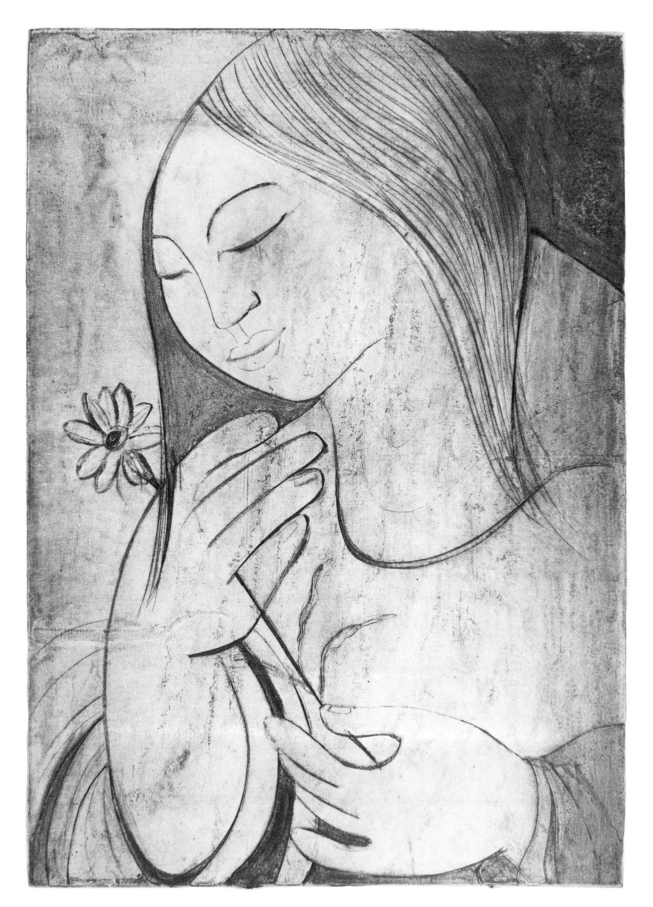

Fiore d' Amore by Eda Cascieri. Here is the finished print. The dark areas, such as those around the head, are formed by the residue of glue left on the Masonite. Notice the subtle dark lines due to the wrinkles in the tin foil.

20.
Mat Board Plates, Embossed and Segmented

In this chapter Jan Ehrenworth and I demonstrate two techniques: Ehrenworth prepares multi-level mad board plates, and I cut mat board into a segmented collagraph plate.

In both demonstrations the mat board plates are prepared in the same way. Several coats of thinned down acrylic gesso are sponged on *both* sides of the mat board. Each coat must dry before the next one is added. Then, two coats of thinned polymer gloss or matte medium are used to seal, again, *both* sides of the mat board. The polymer medium prevents the etching paper from sticking to the plate, and it also makes the plate easier to cut.

The embossed mat board can be used with or without color. Embossed surfaces without colors create interesting shadows. These are cast by the raised and lowered edges playing on the surface of your paper and they could be said to create a kind of color. If you use color, though, try just rolling flat color on the surfaces with small brayers. To get an intaglio effect with mat board plate you could try to build up the surface with acrylics, as I do in my segmented plate, *Sweet Morning*.

With a segmented plate, also, there is another element to deal with—the white lines that result from space between sections of the plate. When you print, you must assemble the pieces of your plate in jigsaw puzzle fashion on the press bed. As the plate goes through the press, the damp printing paper will be forced between the inked mat board pieces unless the plate pieces are held tightly in a template. The lines can add to the design of your image.

Mat board plates can be fun to work with. Experiment with them, as Ehrenworth and I do in the following demonstrations.

Embossed Mat Board Plate

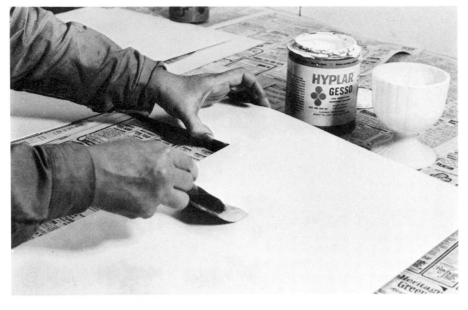

1. Ehrenworth prepares her mat board for cutting out her base plate by coating the board four times on *both* sides with a mixture of half water and half gesso. This process seals the board's surface so that the plate can be rolled with ink. Notice that she uses a foam rubber paintbrush so there will be no trace of brush marks. The gesso coatings also make the plate firm: it can be cut with ease using a mat knife with a new blade.

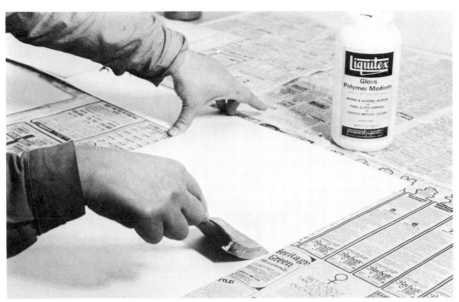

2. Now she coats the gessoed surface of the mat board with three coats of thinned-down gloss polymer medium. She also puts one coat on the back of the plate, so that the board does not curl up as the wet surface dries. The polymer medium prevents the printing paper from sticking to the mat board during printing and seals the surface further.

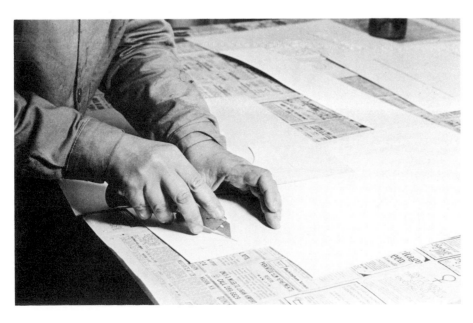

3. In this photograph you see Ehrenworth cutting a small shape which will be a part of the embossment. She began by drawing the design on tracing paper. Note that she has already cut out one of the two large base plates which is lying on the table.

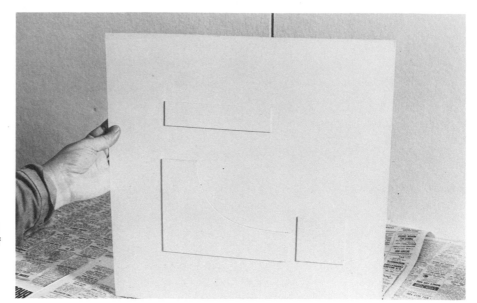

4. Ehrenworth holds up the first plate. It will be printed using a template made of the outside of the mat board from which the base plate was cut after she rolls a pale beige oil paint onto the raised shapes.

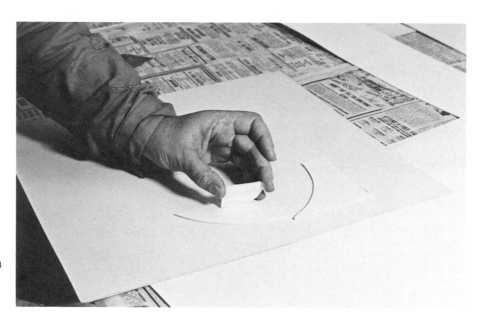

5. Here you see Ehrenworth attaching a mat board shape to the plate with masking tape that is sticky on both sides.

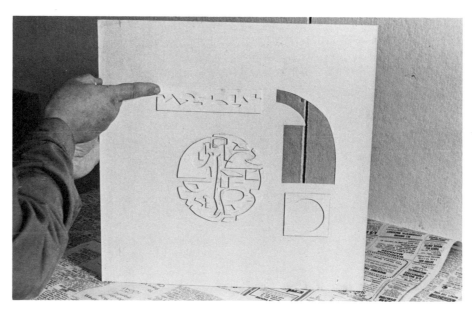

6. Ehrenworth holds up her second plate, which is ready for inking. The raised shapes will be rolled with lavender and green, except for the large, circular shape on the left which will not be inked. The curved shape on the right with the vertical line was cut out of the mat board of the base plate and holds no ink. It prints as a raised, embossed shape as do the negative parts of the large circle.

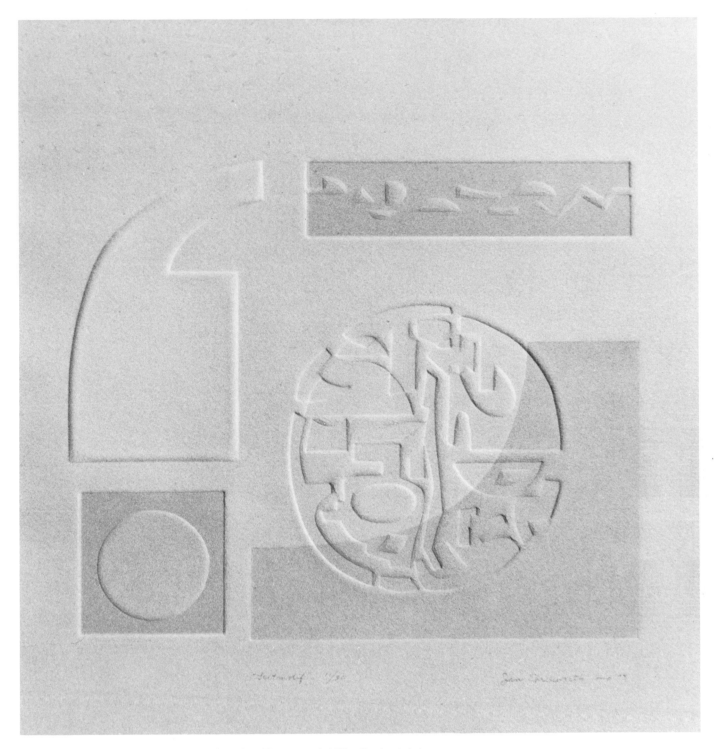

Leitmotif by Jan Ehrenworth (© 1973 by Jan Ehrenworth.) The final print shows a marvelous interplay of embossments, debossments and colors. After the three shapes on the first plate were printed in beige, the seond plate with lavender and green on its raised areas was printed. The low areas in the second plate remained beige, while in the raised areas with lavender and green, the color mixed.

Segmented Mat Board Plate

1. I begin making a segmented mat board plate on prepared mat board (see text) by transferring my drawing from tracing paper to the mat board. I turn the drawing upside down, put carbon paper between the tracing paper and the plate and trace the lines with a pencil.

2. Here you see me beginning to cut out parts of this plate with a mat knife that has a fresh blade. I hold the blade at an angle in order to bevel my edges slightly. Since the mat board has been coated with acrylics, it cuts easily.

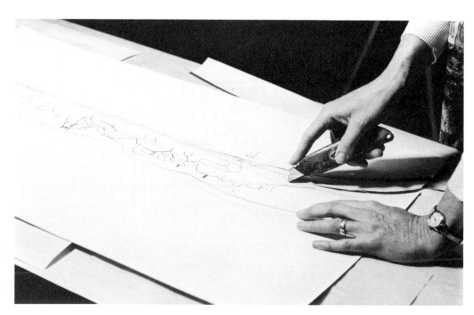

3. Here I cut another segment, beveling each edge *at opposing angles* to be sure that a white line will be embossed during printing by the paper pressing in between each segment.

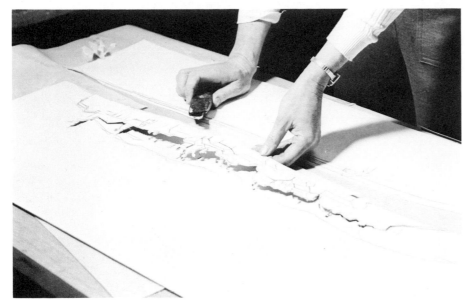

4. In this photograph you see the most detailed part of my image, the townscape. This section will be built up with acrylics such as gesso, gel, and modeling paste, inked with blue black etching ink, wiped with cheesecloth and then printed.

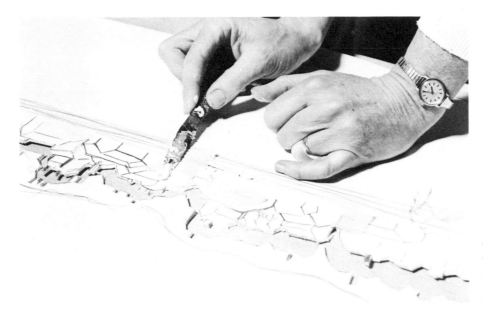

5. I block out certain areas of the townscape with masking tape to create the sharp edges of buildings, and then I apply modeling paste with a palette knife. I will also use gesso and gel to create other textures.

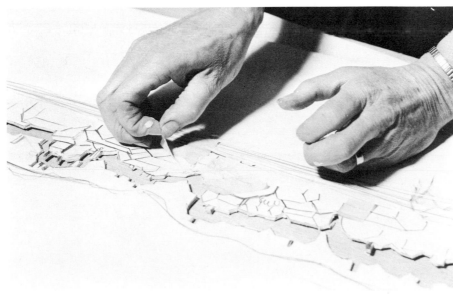

6. Here I pull off strips of tape, leaving a sharp edge on the modeling paste shapes to define the edge of a building.

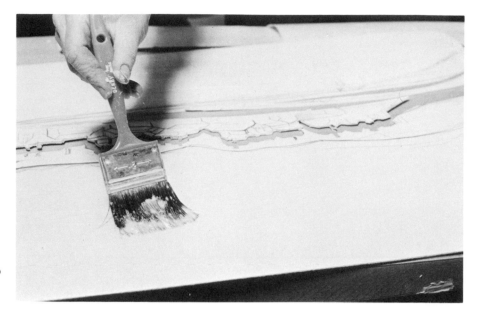

7. In this step, I brush acrylic gel on the top segment of this plate. When intaglio wiped, this slight build-up will read as a cloudy sky.

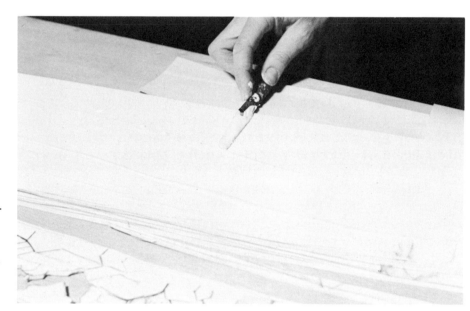

8. In order to suggest striations of the ice in this landscape, I add gesso with my palette knife to the bottom segment. Before rolling color on this section, I will have to add two coats of thinned polymer medium to make sure that the printing paper will not stick to the plate. The final print of this plate, *Sweet Morning*, can be seen in the color gallery.

21.
Review of Collagraph Printing Techniques

For my last chapter, I am going to demonstrate printing the plate I made in Chapter 4. This will be a good review of general print-making techniques discussed throughout this book.

This plate, *The Towers*, is inked, wiped and given two roll-ups. I must say that I find it impossible to get exactly the same effects in each print. I turn this limitation into an advantage by calling each print a unique print rather than a part of an edition (a large number of duplicate, or very similar, prints). Another possibility is to call the prints variations—Variation I, Variation II, etc.

Most collagraph printmakers don't make editions of more than twenty prints. This is because of the difficulty in wiping each plate the same way each time you print to get the same collagraph print. It is also due to the intensity of effort that goes into making each print—which might be compared to making twenty paintings, all the same.

I hope these last pictures will sum up for you how to print a collagraph.

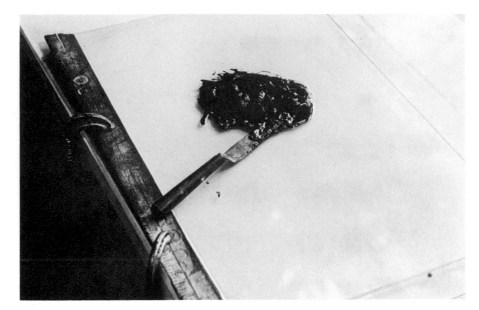

Setting Up. The glass slab with my ink is resting against a wooden ruler fastened to the table edge with two C-clamps. This arrangement allows me to use both hands as I ink and wipe my plate.

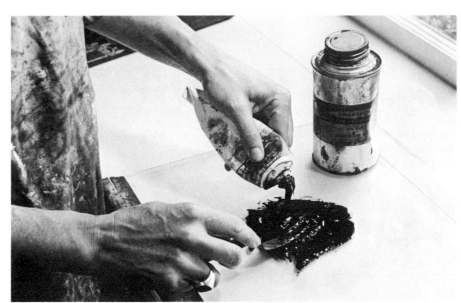

Mixing. I begin to print *The Towers* by mixing Graphic Chemical phthalo blue etching ink with burnt plate oil in a ratio of about five parts ink to one part plate oil.

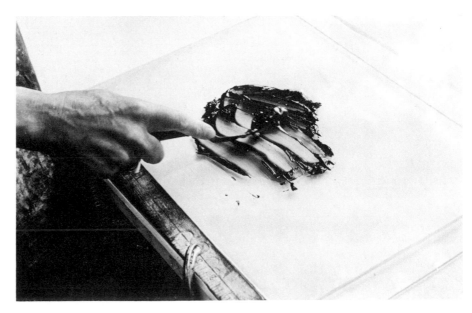

Warming. I warm, or soften, the ink with the plate oil by pressing the ink with the flat side of my palette knife onto the glass.

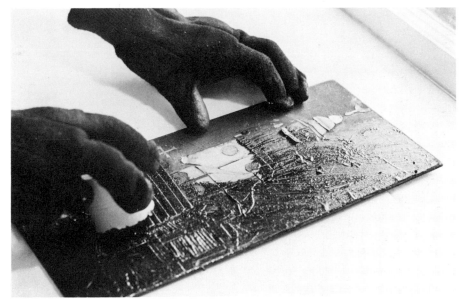

Daubing. As I ink my plate with a rolled felt dauber, I realize that several of the tapes glued to the plate have been loosened by previous inkings. They will have to be glued on again after I finish this print. Note that the edges of *Towers* are meant to be ink-holding dark lines. They will be covered with ink and wiped with cheesecloth like the rest of the plate.

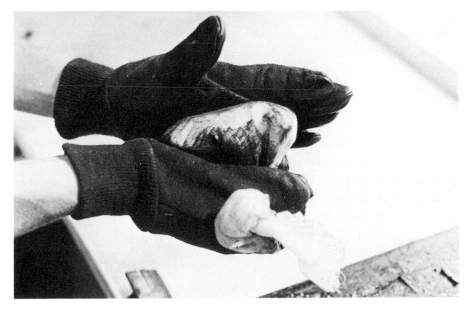

Making the Cheesecloth Ball. In this photograph I am preparing the cheesecloth I will use to wipe the plate by wadding it into a ball and then covering the ball with another square of cheesecloth. I tighten the outer piece of cheesecloth as I hold the ball flat against the palm of my hand. As I wipe the plate now, this outside cheesecloth can be moved around so that the flat side of the ball can always be more or less clean. Then the cheesecloth will pick up ink consistently from my plate. At some point, though, the whole wad will be covered with ink, and I will take a fresh ball of cheesecloth.

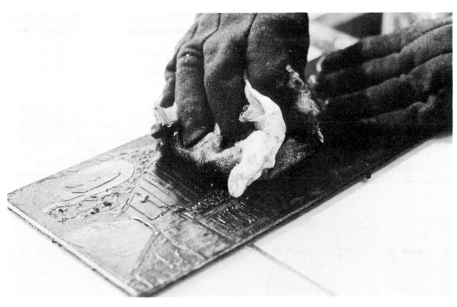

Wiping. Here I am wiping the plate with the cheesecloth in all directions. I will use two fresh wads of cheesecloth during this wiping process in order to pick up more ink. If I kept using the same wad, I would start putting ink back down onto my plate.

Paper Wipe. Here you see me demonstrating how to wipe a plate with newspaper. With the flat part of my left hand pressed to the plate, I pull the square of newspaper toward my body with my right hand. This process lifts ink from the top parts of my plate surface.

Setting Up the Roller. My large (16″) composition roller rests on holders in preparation for a roll-up. Oil paints—phthalo blue, burnt sienna, and raw sienna—are arranged for a modulated, rainbow roll. Notice how the lines of color overlap so colors will blend as they are rolled back and forth.

Rolling Ink on the Slab. You can see the colors blending. (Left) I push the roller out, away from myself, and then I pull it back towards my body. (Right) I twist, or flip, my roller slightly before moving it back across the glass. This process removes the seam line on the roller which forms when the roller is stopped at the edge of the glass slab nearest my body. If I didn't do this, the seam line would be rolled onto my plate.

Rolling Ink on the Plate. In this photograph I am beginning to roll the ink over my plate. The phthalo blue will go over the bottom section of the plate, burnt sienna will go over the middle, and raw sienna will highlight the church tower. The organza background of the plate, which holds phthalo blue ink from the intaglio inking, will absorb the inks rolled on.

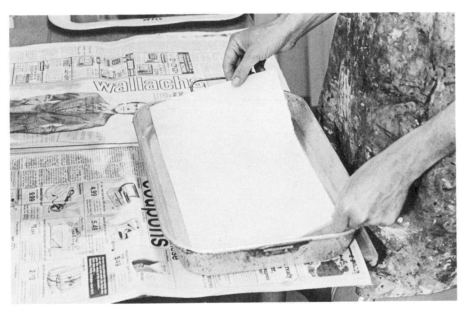

Soaking the Paper. I soak my German copperplate printing paper quickly. I just dunk it in and out of the warm water in my water tray. I will now put the paper between blotters to dry it off a little. Before printing with this paper, I will make sure that no water shines on its surface. Generally, I soak this paper and put it between blotters before inking my plate: the paper stays damp until I am ready to use it.

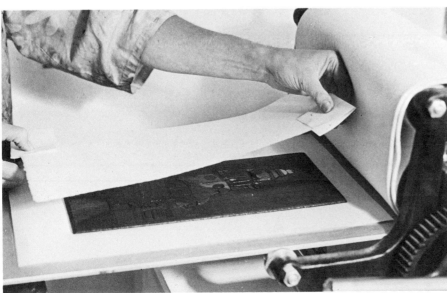

Placing the Paper on the Plate. Using tabs made of paper (you could use old playing cards,) I carefully place my printing paper over my plate.

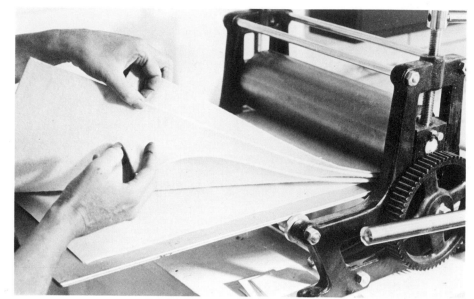

Checking Blankets. I check my press blankets to see if they are in their correct positions. The thinnest sizing blanket goes nearest the press bed, the soft cushion blanket lies in the middle, and the pusher blanket goes on top.

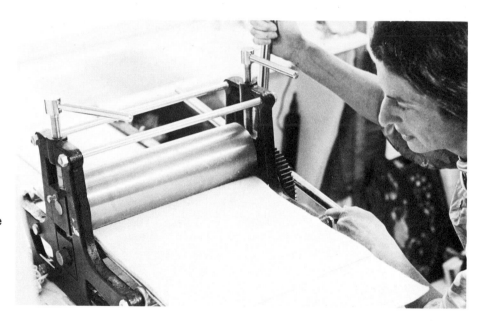

Printing. I begin moving the plate through the press by turning the handle toward me, hand over hand. I usually put my plates through the press at least two times so the print will get a full impression. On a larger press with more pressure, one time through the press would be enough.

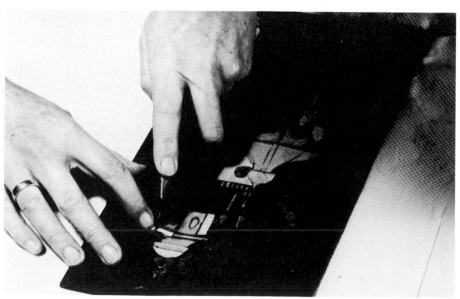

Repairing the Plate. As some of the plates for *The Towers* came apart during the printing process, I am adding more tape in a few spots. (I do this after I clean the plate thoroughly.)

22.
Storing and Signing Your Prints

Immediately after printing I air-dry my prints for about an hour by hanging them with clothespins on a clothesline strung through metal loops in the ceiling. I fasten them carefully at several points at the topmost edges of the paper. In this way I can refer to whichever print I like as I ink my plate for the next print.

The next step is to store the still damp prints under boards in order to keep the printing paper from wrinkling and buckling as it tends to do when it dries since paper shrinks slightly when it dries. Any type of wood, wallboard or Masonite would do for a board. I stack the boards with the prints between them and add some bricks on top to help flatten the prints. Separate the prints with first a layer of glassine, a shiny paper, and then a sheet of newsprint. Several prints can be simultaneously dried under one board. The newsprint underneath will absorb the water from the print above it as the print dries, and the glassine on top of the print will prevent ink from sticking. Replace the sheets of newsprint every two days until your prints are dry and flat. When everything is dry, remember to save the newsprint and the glassine. You can use them again next time.

Many printmakers use different systems. Jan Ehrenworth uses map pins to fasten her prints to the soft wallboard on the walls of her studio. The prints dry as they are pinned up. Another printmaker I know uses extra large printing paper. After printing he tapes each print to a board, and the paper dries perfectly flat. Then he tears off the tape and re-tears the paper, using a ruler as an edge to create an even rectangle.

After your prints are fully dried, store them carefully on a shelf or in a portfolio. Put tissue paper or onion skin paper between your prints. *Do save* your trial proofs and the prints that you think are pretty bad. You'll be surprised how good they'll look three months later.

When you are ready to exhibit your prints, you will want to know how to sign, number and designate them. First of all, sign them in pencil. Recently, a customer in our gallery questioned this practice, and noted that the signature could be erased. I replied that I felt that

the reason for signing prints in pencil was to prevent the signature from conflicting aesthetically with the print. Also, the tradition of signing prints with pencils stems from the fact that ink fades with exposure to light. Penciled signatures will not fade.

All marks on your collagraphs are customarily made in the bottom margin of the print near the image. Starting on the left, you give the name of your print. In the middle of the bottom margin you give the number of this print, a slash, and the number of prints in the total edition. For example, 5/30 means that this is the fifth print in an edition of thirty prints. Most printmakers do not make the total edition at one time. They decide what the largest number of prints they might make with this plate would be. In this case the number is 30. The artist then keeps a file card with the number of prints of the collagraph made so far, and he lists the gallery agent, buyer, or show to which each numbered print made has been sent, given or sold.

At the right-hand side of the bottom margin, sign your name and the date—the year or month and year—that you printed this collagraph. Because some printmakers have a print workshop pull their editions, artists sometimes write "imp." (from the Latin *impressit* meaning "has printed it") and the year after their name when they pull their own print. If another artist pulls your edition, he will emboss his seal or chop mark into the print.

When you mat and/or frame your prints, leave all marks in the bottom margin in plain view. If they are inscribed correctly, they will not detract from the aesthetic appearance of the collagraph. In fact, the name of the print and your signature give a finished look to your print.

By the way, I spend a *lot* of time thinking about the names of my prints. I often keep a pad and pencil with me in the car so I can jot down print names as I think of them at red lights.

There has been much confusion about some of the marks that you can add to the middle of your bottom margin *after* the numbering marks. We will talk about a few of the possibilities to help you be clear and accurate when you sign your collagraphs.

Artist's Proofs

Artist's Proofs, often signed A/P, are traditionally ten percent of the edition's total number. They are printed at the same time as the edition and kept by the printmaker for his own use as gifts or for sale. If the edition is very small, only five prints are printed as artist's proofs. However, I often have seen all prints pulled from a collagraph plate designated as artist's proofs. This seems to me to be incorrect marking. If you only print a few collagraphs from a particular plate, and you want to wait to see if this print will sell or get a favorable response, project an anticipated total edition number, for example, 50, and mark the prints as 1/50, 2/50, etc.

Another solution, since it really is difficult after drying prints to tell the order in which the prints were printed, is to simply write "ed. 50," rather than 1/50.

State Proofs

These are proofs that you pull as you are in the process of developing and changing your plate. As you make your plate, you should print the collagraph every so often to check the state of your print. This is called a *state proof*. Do this every time you rework a substantial section of your plate, and save these proofs. They are customarily numbered with Roman numerals to differentiate between the different stages in your collagraph's development.

Trial Proofs

Trial proofs are a type of state proof. The designation has to do with your *intention* in printing. For example, if you were trying a different method of inking or wiping your plate or if you were trying a roll-up instead of just an intaglio wiping, you would pull a trial proof. Please note that none of these designations—artist's proof, state proof, or trial proof—are considered as part of your edition.

Color Proofs

After the numbers in the bottom margin are given, the designations of *color proof, unique proof*, or *color variation proof* are often seen on collagraphs. This leads to a confusing question. It is almost impossible to do a uniformly wiped and printed edition of a collagraph plate. There are many variables, such as your arm pressure as you wipe and do roll-ups. Or, if you are blending colors, the tones tend to vary slightly from print to print. I feel you can include all slight variations within your edition. Only if you intentionally vary your colors should you write one of these notations—color proof, unique proof or color variation proof—on your print in the middle of the bottom margin.

For further information concerning signing and numbering your collagraph prints, try reading "Marks on Original Prints" in the Spring, 1974, newsletter from the Graphics Society, Box 444, Hollis, New Hampshire. Another source of information on this subject is *A Guide to the Collecting and Care of Original Prints* by Carl Zigrosser and Christa M. Gaede.

Supplies and Suppliers

Before discussing supplies and where to get them, I'd like to note that any product not mentioned here, such as the acrylic products, palette knives, and so on, can be purchased at most art supply stores, or in the case of Masonite, in most lumberyards. The materials I've listed are harder to find.

Printing Presses

When you're ready to buy and set up your own press, you'll need a place—a room or a corner of a room—where you can arrange your materials in a permanent way. My first setup was a source of such terrific happiness for me that I'd like to share the experience with you. I'd bought my first small, geared press from Sam Flax. To accommodate it, my husband and I arranged a printing corner by a large window that caught the afternoon sun. In front of the window was a glass-topped table for roll-ups. As I worked, the press was to my left, with a shelf for inks above. To my right was another work table for paper and blotters. The space was small, and so was the press, but at last I had a work area of my own! It was such a Eureka feeling to have this wonderful, sunny chunk of space for my own world. I would actually dream about the space and the ecstasy I felt about it. This light-radiating corner gave me more than just a place to work, it gave me new artistic powers.

Presses vary a lot in quality, size, and price. Try to borrow a press before buying one. Work in a workshop, or rent a press until you known exactly what you want. I've included this list, then, for printmakers who are ready to buy a press.

Kinds of Presses and Sources	*Remarks*
Boucher Press American French Tool Co. Route 117 Covertry, Rhode Island 02816	I have heard excellent reports about this press from many collagraph printmakers. Bed sizes from 24" x 48" to 36" x 60". Prices from $1,700 to $2,300.
Brand Press Charles Brand 84 East 10th Street New York, New York 10003	Superb, sensitive presses, with custom-made outsize rollers. Bed sizes from 12" x 24" to 36" x 60." Prices from $300 to $3,000.
Fox Press Craftsmen Machinery Co. 75 West Dedham Street Boston, Massachusetts 02118	Many New England collagraph printmakers use this press with excellent results. If you buy one of their presses, I recommend getting the short handle for moving the bed between the rollers rather than the large wheel which is on newer models. Bed size 24" x 48". Price around $1,2000.

Galaxy Electro Hydraulic Press
Galaxy Industries
Hollis, New Hampshire 03049

We photographed Cynthia Knapton in Chapter 14 using the 40" x 72" press designed for her needs by her husband. Her press, with its very sensitive, electro-hydraulic pressure controls, was engineered by Ken Knapton especially for the collagraph printmaker. It can be folded easily for storage. Bed sizes are from 26" x 48" to 40" x 72". Prices from $2,800 to $4,000.

Holbein Press
Sam Flax, Inc.
25 East 28th Street
New York, New York 10010

Purchase one of their small, geared presses. Bed sizes vary from 13" x 25" to 19" x 29". I ordered a longer, 36" Benelux bed for the small-bedded 13" x 25" geared press. Does a good job with my small collagraphs, except when I do a double roll-up. Then there is not quite enough pressure to pick up all layers of colors. Prices from $200 to $900, according to size.

Wright Combination Press
Charles Wright
Grand Junction, Michigan 49056

This is the press I use, with a 36" x 60" bed. The press is motorized and can be converted into a lithographic press by removing the etching roller and adding a scraper bar. Because the mainscrew for raising and lowering the top roller is in the middle of the press rather than on the two sides, I have had some trouble turning the side adjustment screws to get even pressure at all times. I have learned how to adapt to this, though, and an enjoying the multiple uses of this press. Price around $1,500.

Old-fashioned hand wringer, found in junkyards, dumps or attics

A hand-cranked old-fashioned clothes wringer in good condition really prints! My friend in New Hampshire sets her plate, printing paper, and two thick felt blankets on a thick piece of Masonite and slowly cranks her prints out.

Printing Papers

Our next consideration is printing papers. The composition of paper varies—some papers are made completely of torn rags, while others are made of wood pulp and rags. The higher the rag content of a paper, the less apt it is to yellow with age and the longer it will last. The paper with a high rag content will be tougher and will be more suitable for highly embossed prints.

Papers with a high wood pulp content, on the other hand, will absorb water quickly and stay damp for a long period of time. This kind of paper would be good if you wanted to print one image with multiple plates without resoaking the paper before each plate is printed.

Remember that paper varies in color. Some kinds are off-white, some are beige, and some are brilliantly white. Try them all, and try colored paper also.

Tear your paper *at least* 1″ bigger than the size of your plate. Try to wet any paper that needs to be soaked for a long time (see the list that follows for the soaking times for different papers) the night before and keep it damp by wrapping the paper in plastic until you print. Many printmakers use the wet-pack system. A wet pack is made by placing a sheet of wet paper between two sheets of dry paper until you have a stack of as much paper as you will need for your print run. This stack is placed in a plastic bag and left overnight. The paper is kept in the wet pack—and sheets are pulled from it as they are required—during the whole edition printing time.

Printing paper is available in your local art store or by mail order. If ordered in quantity, paper can be ordered from some suppliers (see *Paper Sources*) at great savings: 30–50% off list prices.

Kinds of Papers	*Remarks*
American Etching Paper 38″ x 50″	100% rag, largest size paper on the market. Does not erase well; requires heavy pressure and heavy inking. Takes color well. This stiff, heavy white paper was designed by Gabor Peterdi to act like Murillo (which only comes in cream color), but requires shorter soaking times: 1 or 2 hours, or may be left in a wet pack overnight.
American Rice Paper or Proof Paper Comes in many sizes	Sold in most art stores for any type of printing. Try using this paper dry as well as wet. Soaking time depends on type of paper. Although this paper is not ideal for collagraphs, it may be used if more suitable paper is not available.

Arches Cover
22″ x 30″; 29″ x 41″

Creamy white or buff, with smooth texture. 90% rag. Soak for 1 to 3 hours or wet for ½ hour and wrap in plastic overnight. Responds beautifully to transparent and pale colors and to delicate lines. Embosses fairly well.

Dutch Etching
22″ x 30″

Sensitive to fine lines and excellent for brilliant color or sharp black and white contrast. Best soaked overnight but can also be soaked for just 10 minutes and print fairly well. Surface "abrades" (pulls apart) easily when wet. Does not stretch much in printing, so that the shrinking and wrinkling problem in drying is eliminated.

German Copperplate
22″ x 30″; 30″ x 42″
Types: deluxe and ordinary

Creamy white paper with a high wood pulp content. Absorbs water immediately and does not require extended soaking. Becomes *very* soft after immersion in water—watch out for tearing. Also, this paper cracks easily in deeply embossed areas. Because it is so absorbent, colors soften and spread slightly—which makes this my favorite paper for collagraph printing.

German Etching
22″ x 30″; 30″ x 42″

Soft white, strong (75% rag) but pliable. Soak only for *1 minute*. Good for deep embossments. Colors print brilliantly. Surface pulls apart when printing conditions are not perfect. Tends to wrinkle when drying unless under great pressure.

Italia
20″ x 28″; 28″ x 40″

Extremely white, heavy paper with lovely, smooth surface. Recommended for transparent colors. Soak for about 1 hour. Cannot erase smudges when dry. Not very absorbent.

Murillo 27″ x 39″	33% rag, buff color. Strong, thick paper. Soak as long as possible and *at least* overnight. Sensitive to deep intaglio and heavy embossing.
Rives BFK 22″ x 30″; 29″ x 41″	100% white rag paper, available in most art supply shops. Must be soaked in advance for from 1 to 3 hours, or wet for ½ hour and wrapped in plastic overnight. Extremely sensitive to delicate areas on your plate. Also comes in large-size rolls (100 yards, 42″ wide). This larger size does not contain sizing and so will disintegrate easily if put into water and soaked in the usual way. The recommended method is to wind the paper around a roll of cardboard and dip it into water, then make a wet pack of three dry sheets between each wet one.
Rives Heavyweight 19″ x 26″; 26″ x 40″	Creamy white, smooth paper. Embosses beautifully. Soaking procedure same as for Rives BFK.
Strathmore 22″ x 30′j	100% rag, machine-made, white. Smooth texture which works well for collagraph and silk screen combinations. Soak for 1 to 2 hours.

Sources	*Remarks*
Andrews Nelson Whithead 7 Laight Street (on Canal Street) New York, New York 10013	A large variety of paper. Discount available for orders of 500 sheets or more at a time.
David Davis 530 LaGuardia Place New York, New York 10012	Many kinds of paper, including glassine.
Graphic Chemical & Ink Co. P.O. Box 27 728 North Yale Avenue Villa Park, Illinois 60181	Many kinds of paper. Discounts for orders of 50 sheets or more.

Rollers

I recommend composition or gelatin rollers for most roll-ups. The soft surface penetrates most surface variations of a collagraph plate and enable a layer of ink to be deposited on all parts of the plate. These rollers *must* be cleaned with kerosene because they *disintegrate* if water is used on their surface.

Durethane rollers, large hand rollers, are the most durable kind of rollers. They may be cleaned with any solvent including soap and water.

Rubber rollers can be ordered in various degrees of hardness. They are especially valuable for viscosity printing, where you need both hard and soft rollers. You can do as I did—I brought two rolling pins to Samuel Gingham Company in Woburn, Massachusetts, and had them covered inexpensively, one with hard rubber and the other with soft rubber. Clean rollers like these with kerosene.

Small rollers—1″, 2″, and 6″—are available in most art supply stores and are extremely useful. Clean them with kerosene to preserve their surface.

Always keep rollers in a holder or in a rack of some sort. Don't rest them on the table top in between prints. And *don't* let them fall off the table.

Sources

Sam Bingham Co.
Woburn, Massachusetts 01801

Galaxy Co.
Hollis, New Hampshire 03049

Graphic Chemical & Ink Co.
P.O. Box 27
728 North Yale Avenue
Villa Park, Illinois 60181

Inks and Oil Paints

Oil paints mixed with plate oil (which is available from Graphic Chemical Co.) can be used successfully for an intaglio inking. Oil paints mixed with burnt plate oil or boiled linseed oil can be used for roll-ups. Oil paints can be purchased at any art supply store.

Etching inks can be made from powdered pigments combined with boiled linseed oil. These inks also come in tubes or cans from various companies. Please note that you can add transparent white to any color ink to make that color more transparent. Also remember that to prevent the top layer of ink from drying and forming skin after you have opened the can, put a thin film of water on top of the ink or spray on Ink-o-Save before closing the lid.

You can also use commercial inks such as those from Louis Roberts or Superior in your collagraph. Vary their consistency by adding magnesium to make the inks thicker and burnt plate oil #100 or #3, according to the viscosity you want, to make them thinner.

Sources	Remarks
Charbonnel 13 Quai Montebello Paris V, France	Gorgeous, expensive colors.
David Davis 530 LaGuardia Place New York, New York 10012	This store carries Graphic Chemical etching inks.
Fezande & Sperrle 103 Lafayette St. New York, New York 10013	Dry colors. Send for price list #167.
Sam Flax, Inc. 25 East 28th Street New York, New York 10016	They carry the French Charbonnel inks as well as other types of ink.
Graphic Chemical & Ink Co. P.O. Box 27 728 North Yale Avenue Villa Park, Illinois 60181	My major source of etching inks. They respond to orders promptly.
Hanco Inks A.E. Handschy Co. 528 Worth Fulton Street Indianapolis, Indiana 46202	Inks recommended by Jim McLean. Order inks *without driers.*
Ralph Leber Co. P.O. 88700 Tukwila Seattle, Washington 98188	Rich-toned inks especially mixed for use with collographs. They are very thick and glow when printed.
Lorilleux-LeFranc & Co. 16 Rue Suger Paris V, France	Beautiful, expensive inks.
Lewis Roberts 250 West Broadway New York, New York 10013	Commercial inks in a variety of colors. Good transparent white.
Superior Printing Co. 295 Lafayette Street New York, New York 10013	Commercial litho inks in very vivid colors.

Printing Blankets

Blankets used by collagraph printmakers are made of woven woolen felt. They are available in several thicknesses according to the nature of the blanket. The sizing blanket should be 1/16" thick, the cushion blanket ¼" thick, and the pusher blanket ⅛" thick.

Wash them in Woolite or have them professionally cleaned.

A thick foam-rubber slab can also be used as a blanket for colla-graphs. And, I have used shrunken baby blankets and an old flannel skirt cut to the size of the press bed with some success.

If many printmakers share the press you use, each person might be responsible for their own sets of blankets. Messy blankets can be a source of friction in a workshop. Take blankets off the press between printing sessions and hang them on a rack to dry out com-pletely.

Sources	Remarks
Boston Felt Co. 149 California Street Newton, Massachusetts 02158	Specify that you want sizing, cushion, and pusher blankets. Also indicate size and thick-ness.
Continental Felt 22 West 15th Street New York, New York 10011	Again, specify type of blanket, size and thickness.

Cheesecloth and Tarlatan

I have been using old nylon curtains for the beginning stages of wiping my plates because cheesecloth gets increasingly costly. However, I recommend cheesecloth for its softness and for its abil-ity to lift ink from crevices and edges while distributing ink over the plate surface.

Cheesecloth, which is available in most hardware stores, comes in varying weaves. I recommend the medical type listed below be-cause the weave is tight and the holes are close together. The weave of loose cheesecloth rips apart as you wipe because of the roughness of the surfaces of the plate.

Tarlatan is starched cheesecloth and is used primarily by etchers. Some collagraph printmakers use tarlatan as an inking tool as well as a wiping tool. Remember, tarlatan must be kneaded before use to loosen its starchiness.

Sources	Remarks
A & S Textile Co. 236 West 27th Street New York, New York 10001	Cheesecloth gauze for wiping. Buy wholesale in 60 yd. lots, and ask for # 60-32-28.
Graphic Chemical & Ink Co. P.O. Box 275 728 North Yale Avenues Villa Park, Illinois 60181	Order by the yard.
Sparrow Chisholm Co. 120 Kingston Street Boston, Massachusetts 02129	Wholesale prices for cheese-cloth.

British Suppliers

Printing Papers

Greens Fine Paper Division
W + R Balston Ltd.
Springfield Mill
Maidstone
Kent

Suppliers of especially fine
handmade papers.

TN Lawrence & Son Ltd.
2–4 Bleeding Heart Yard
Greville Street
Hatton Garden
London EC 1

Hand- and machine-made papers.

AA Reckner & Co.
68 Newington Causeway
London SE 1

Handmade papers.

Winsor & Newton Ltd.
51 Rathbone Place
London W 1

Hand- and machine-made papers.

Rollers

Dryad
Northgates
Leicester

Rubber-covered rollers.

TN Lawrence & Son Ltd.
(see address above)

Excellent gelatin and
plastic rollers.

Inks and Oil Paints

Coates Brothers
Grape Street
Leeds 10

Ink suppliers to the trade.

Dane and Co. Ltd.
1–2 Sugar House Lane
Stratford
London E 15

Inks of unusual color.

Dryad
(see address above)

Oil paints and oil- and water-based
printing inks.

Winsor & Newton Ltd.
(see address above)

Oil paints and oil-based
printing inks.

Winstone Limited
150 Clerkenwell Road
London EC 1

Ink suppliers to the trade.

Glossary of American Terms for the British Reader

Automotive lacquer. Car spray paint.
Acrylic gel. Gel form of acrylic.
Acrylic gesso. Form of whiting and size in acrylic base.

Broiled. Grilled.
Burnt plate oil. Burnt linseed oil employed in making intaglio ink.
Brayer. Printing ink roller.

C-clamp. G-clamp; also referred to as D-clamp.
Carborundum powder. An abrasive powder used by printmakers for grinding litho stones.

Du Pont Protect. A barrier cream.

Elmer's glue. Equivalent to Copydex.

Flextex. An acrylic product with a texture similar to sandy putty. Opaque acrylic mixed with marble dust.

Gesso. A mixture of builder's whiting and size.

Kerosene. Paraffin.

Marble dust. Ground marble used as a filler.
Masonite. Hardboard.
Mat board. Mounting card.
Mineral spirits. White spirit, turpentine.
Modeling paste. A quick-hardening modeling material.
Mylar. Melinex.

Plate oil. See burnt plate oil.
Plexiglas. Perspex.
Polymer. Acrylic type of paint.
Popsicle stick. Iced lollypop stick.

Q-tips. Cotton wool buds set on a stem.

Tarlatan. A stiff open weave fabric.
Trichlorethelene. Solvent for oils and resins.

Papers

Arches. White or buff, beautifully textured, smooth finish, rag, mould-made.

Construction. Colored paper much used for crayon, ink, or watercolor.

Murillo. Buff-colored, strong, weighty paper, open texture, rag, mould-made.

Rives BFK. Allround white paper; even, smooth texture, rag, mould-made.

Tabeau. A tough paper used as a filter paper, machine-made.

Suggested Reading

Artists Proofs. Fritz Eichenberg, Ed. Printmaking annual published by Pratt Graphic Arts Center, New York.

Green, Peter. *New Creative Printmaking.* New York: Watson-Guptill, and London: Batsford, 1964.

Hayter, Stanley William. *About Prints.* Oxford University Press, 1962.

———. *New Ways of Gravure.* Oxford University Press, 1966.

Kampmann, Lothar. *Creating with Printing Material.* New York: Van Nostrand Reinhold, 1969.

Kent, Cyril, and Cooper, Mary. *Simple Printmaking.* New York: Watson-Guptill, and London: Studio Vista, 1966.

Knigin, Michael, and Zimiles, Murray. *The Technique of Fine Art Lithography.* New York: Van Nostrand Reinhold, 1970.

Peterdi, Gabor. *Printmaking.* New York: Macmillan, 1971.

Ross, John, and Romano, Claire. *The Complete Printmaker.* New York: Free Press div. of Macmillan, 1972.

Schachner, Erwin. *Step-by-Step Printmaking.* New York: Golden Press, 1970.

Sproul, Adelaide, and Erickson, Janet. *Printmaking Without a Press.* Art Horizons, 1968.

Index

Page numbers in boldface indicate reproductions of collagraph prints.